BYZANTINE MOSAIC
DECORATION

OTTO DEMUS

BYZANTINE MOSAIC DECORATION

ASPECTS OF MONUMENTAL ART IN BYZANTIUM

CARATZAS BROTHERS, PUBLISHERS

New Rochelle, New York

1976

First edition by Kegan Paul Trench Trubner & Co. Ltd 1948
Reprinted 1953, 1964 by
Routledge & Kegan Paul Ltd., London and Henley

First published in the United States of America 1976
by Caratzas Brothers, Publishers
246 Pelham Road
New Rochelle NY 10805

Printed in Great Britain

ISBN 0 89241 018 3

To My Friends in England
and Austria

CONTENTS

CONTENTS

III

LIST OF ILLUSTRATIONS

LIST OF ILLUSTRATIONS

X

LIST OF ILLUSTRATIONS

LIST OF ILLUSTRATIONS

FOREWORD

THIS book, short and slight as it is, took a long time to grow. It was first conceived in Greece, Sicily and Venice in the twenties and thirties; the first draft was jotted down in a Canadian camp in 1940 and the final text was written in 1945 in London shortly before my return to my native country. This text I wrote in what I hoped would turn out to be readable English: my hopes were, however, deceived, and it needed not only the kind help of two self-effacing friends, Dr. Marguerite Kay and John Bromley, M.A., but also a thorough revision by Mr. A. S. B. Glover to produce the present version. If the book is at all readable it is owing to this help.

My thanks are also due to the scholars of the Warburg Institute, London, and to my friend Gerhard Frankl for help, encouragement and criticism. Mrs. R. Wallis and Prof. David Talbot Rice have kindly helped me in reading the proofs. Dr. H. Buchthal gave me valuable aid in getting together and arranging the illustrations. The publishers have spared no effort to produce the book in a satisfactory form.

As to the contents of the book and the new viewpoints it propagates, they must speak for themselves. I should consider my task fulfilled if I had directed the attention not only of Byzantine scholars, but also of a wider public to a new possibility of artistic appreciation of Byzantine decorations. If my theses are accepted I shall feel flattered; if they start discussion on some of the problems I had in mind, I shall be content; and if they fall flat I shall console myself with the thought that the working out of them gave me a lot of fun in times in which fun was rather scarce.

O. DEMUS

THE CLASSICAL SYSTEM OF MIDDLE BYZANTINE CHURCH DECORATION

THE CLASSICAL SYSTEM OF MIDDLE BYZANTINE CHURCH DECORATION

INTRODUCTION

ONLY within comparatively recent times have historians of Byzantine art, abandoning a purely archæological and iconographical approach to their subject, begun to consider the monuments it has left primarily on their merits as works of art. The formal qualities of each image, the stylistic texture of each figure, have at last become their main centre of interest. These researches, in which Russian and American scholars are especially active, are encroaching more and more upon a branch of study which, until lately, had prided itself above all else on the closeness of its relationship with exact archæology, philology and theology. Points of view which, not so many years ago, were expressed only by word of mouth or in the informal lecture, are now finding expression in print, and are gradually transforming our whole attitude to Byzantinism.

The younger generation of art historians in this field have devoted most of their labours to analysing what might be called the "microcosm" of Byzantine art; the analysis of its macrocosmic style, on the other hand, has been almost entirely neglected. Yet in the case of an art which has left us some of the grandest and most homogeneous of decorations, this aspect is deserving of special study. If they are considered as isolated works, Byzantine monumental paintings lose something of their essential value. They were not created as independent pictures. Their relation to each other, to their architectural framework and to the beholder must have been a principal concern of their creators. In the case of church decoration—the field in which Byzantine art rose, perhaps, to its greatest heights—the single works are parts of an organic, hardly divisible whole which is built up according to certain fixed principles. In the classical period of middle Byzantine art—that is, from the end of the ninth to the end of the eleventh century—these principles seem to form a fairly consistent whole, in which certain features are permissible and even necessary, while others, considered out of keeping with them, are avoided. This system was not purely a formalistic one; it was the theologian's concern as much as the artist's. But its iconographical and its formal sides are but different aspects of a single underlying principle which might be defined, crudely perhaps, as the establishment of

an intimate relationship between the world of the beholder and the world of the image. This relationship was certainly closer in Byzantine than it was in Western mediæval art. In Byzantium the beholder was not kept at a distance from the image; he entered within its aura of sanctity, and the image, in turn, partook of the space in which he moved. He was not so much a "beholder" as a "participant". While it does not aim at illusion, Byzantine religious art abolishes all clear distinction between the world of reality and the world of appearance.

The complete realization of the formal and iconographic scheme which grew out of this fundamental principle is, however, an ideal or, at least, an optimal case. The nearest approach to this ideal, the classical solution, is embodied in the mosaic decorations of the great monastic churches of the eleventh century. The principles followed in these monuments of Imperial piety and munificence differ widely from those which underlie early Christian and pre-Iconoclast Byzantine, and still more Western mediæval decorations.

The first thing which strikes the student of middle Byzantine decorative schemes is the comparatively narrow range of their subject-matter (i, 42, 43). They show a lack of invention and imagination all the more remarkable when we realize that there existed at the same time in Byzantium a powerful current of highly imaginative art which had its source in the naïve imagery of the people. But this current seems to have found expression not so much in monumental painting (save in the provincial hinterland) as in the illustration of popular religious literature, homiletic or allegorical, even of Scriptural books such as the Psalter or liturgical compositions such as the *Akathistos*. In illustrating such texts as these the miniaturists could draw on the store of antique, sub-antique and Oriental imagery which lent itself to an associative elaboration of the written word. No such freedom was either claimed by or permitted to the artists who, as the representatives of official hieratic art, adorned the mosaic-decorated churches of the Byzantine middle ages. The moralistic vein which so greatly influenced the decoration of Western cathedrals, with their didactic and ethical cycles, was likewise entirely outside the Byzantine range. The occupations and labours of the months, for instance, the personified virtues and vices, the allegories of the liberal arts, the expression of eschatological fears and hopes, all that makes up the monumental *speculum universale* of Western decorations,[1] we shall look for in vain inside the magic circle of middle Byzantine mosaic compositions. These latter are to be taken as the Byzantine Church's representation of itself rather than of Greek or Eastern Christianity; as the product of abstract theology rather than of popular piety. There is nothing original, nothing individual, about middle Byzantine decorations if they are considered from the Western point of view, that is, with regard to their contents. The individual pictures do not aim at evoking the emotions of pity, fear or hope; any such appeal would have been felt as all too human, too theatrical, and out of tune with the

tenor of religious assurance which pervades the ensembles and leaves no room for spiritual and moral problems. The pictures make their appeal to the beholder not as an individual human being, a soul to be saved, as it were, but as a member of the Church, with his own assigned place in the hierarchical organization. The stress is not laid on the single picture in isolation: that is "common form" to the beholder, since it follows a strict iconographic type, like the suras of the Koran in Islamic decoration, which all the faithful know by heart. The point of interest is rather the combination of the single items of the decoration, their relationship to each other and to the whole. It is in this arrangement that we must look for the unique achievement of middle Byzantine decoration. The single pictures were more or less standardized by tradition; the ever-new problem for the theologian and for the artist was the building up of the scheme as a whole. This is true not only of the content of the pictures, but also of their visual qualities. In the latter respect it involves a mannerist approach to forms in so far as figures, pictures and ensembles are built up out of traditionally fixed details and units; for the content, it involves a preponderance of the systematic, the sociological interest in relations rather than a preoccupation with problems of ethics.

In these schemes of decoration all the parts are visible to the beholder, unlike those Western mediæval, especially Gothic, decorations, of which some essential constituents, once they were finished and set up in their inaccessible places, could never be seen by human eye. A majestic singleness of purpose runs right through the Byzantine schemes. Their authors seem to have had as their main aim to represent the central formula of Byzantine theology, the Christological dogma, together with its implications in the organization and the ritual of the Byzantine Church. There are no pictures which have not some relation to this central dogma: representations of Christ in His various aspects, of the Virgin, of Angels, Prophets, Apostles and Saints arranged in a hierarchical order which also includes temporal rulers as Christ's vicegerents on earth. Historical cycles and subjects from the Old and the New Testaments, or from apocryphal and legendary writings, are inserted in this hierarchical system not so much for their independent narrative value as for their importance as testimonies to the truth of the central dogma.

THE THEORY OF THE ICON

Every single picture, indeed, is conceived in this sense, and middle Byzantine pictorial art as a whole draws its *raison d'être* from a doctrine which developed in connection with Christological dogma. This doctrine was evolved during the Iconoclastic controversy of the eighth and ninth centuries.[2] The relation between the prototype and its image, argued Theodore of Studium and John of

5

Damascus, is analogous to that between God the Father and Christ His Son. The Prototype, in accordance with Neoplatonic ideas, is thought of as producing its image of necessity, as a shadow is cast by a material object, in the same way as the Father produces the Son and the whole hierarchy of the invisible and the visible world. Thus the world itself becomes an uninterrupted series of "images" which includes in descending order from Christ, the image of God, the *Proorismoi* (the Neoplatonic "ideas"), man, symbolic objects and, finally, the images of the painter, all emanating of necessity from their various prototypes and through them from the Archetype, God. This process of emanation imparts to the image something of the sanctity of the archetype: the image, although differing from its prototype κατ' οὐσίαν (according to its essence), is nevertheless identical with it καθ' ὑπόστασιν (according to its meaning), and the worship accorded to the image (προσκύνησις τιμητική) is passed on through the image to its prototype.

The Christological theme, however, dominated the doctrinal basis of Byzantine theory regarding images not only *per analogiam* but also in a more direct manner. One of the arguments against pictures and statues put forward by the Iconoclasts had been that any representation of Christ was impossible, since every representation (περιγραφή) must either depict Him as a mere Man, thereby denying His Godhead and falling into the anathematized error of Nestorius; or with His two natures, divine and human, intermingled (χύσις), thus following the heresy of Eutyches. The charge of heresy, however, was returned by the Iconodules, who maintained not only that it was possible to represent Christ without falling into heresy, but that denial of this possibility was itself a heresy. Christ would not have manifested Himself in human form if that form were indeed unfit to receive and express the Divine nature. To deny that He could be represented in the form He took in His Incarnation was to doubt the Incarnation itself and with it the redeeming power of the Passion. The Incarnation could not be considered complete, or Christ's human nature genuine, if He were not capable of being depicted in the form of man. The fact that a picture of Christ can be painted furnishes a proof of the reality and completeness of His Incarnation.[3] A painted representation of Christ is as truly a symbolic reproduction of the Incarnation as the Holy Liturgy is a reproduction of the Passion. The latter presupposes the former, and the artist who conceives and creates an image conforming to certain rules is exercising a function similar to that of the priest.

Three main ideas of paramount importance for the whole subsequent history of Byzantine art emerge from this reasoning on the doctrine of images. First, the picture, if created in the "right manner", is a magical counterpart of the prototype, and has a magical identity with it; second, the representation of a holy person is worthy of veneration; thirdly, every image has its place in a continuous hierarchy.

To achieve its magical identity with the prototype, the image must possess

"similarity" (ταυτότης τῆς ὁμοιώσεως). It must depict the characteristic features of a holy person or a sacred event in accordance with authentic sources. The sources were either images of supernatural origin (ἀχειροποίητα), contemporary portraits or descriptions, or, in the case of scenic representations, the Holy Scriptures. The outcome was a kind of abstract verism, governed by a sacred iconography which laid down, enforced and preserved certain rules. In the case of representations of holy persons, this verism made for portraiture in the sense of attaching distinguishing features to a general scheme of the human face and form; in that of scenic representations, for plausibility in the rendering of an action or a situation. If this was done according to the rules the "magical identity" was established, and the beholder found himself face to face with the holy persons or the sacred events themselves through the medium of the image. He was confronted with the prototypes, he conversed with the holy persons, and himself entered the holy places, Bethlehem, Jerusalem or Golgotha.

The second idea, that of the venerability of the icons, follows logically from that of magical identity.[4] The image is not a world by itself; it is related to the beholder, and its magical identity with the prototype exists only for and through him. It is this that distinguishes the icon from the idol. To establish the relation with the beholder, to be fit to receive his veneration, the picture must be visible, comprehensible, easy to recognize and to interpret. Single figures must be identified either by unmistakable attributes or by an inscription. So that they may receive their due veneration from the beholder they must face him, that is, they must be represented in frontal attitude; only so do they converse fully with the beholder (2). In a scenic image, which likewise must be characterized by an inscription (to fix its ὑπόστασις or meaning, which in this case is not a person but an event), everything must be clear for the beholder to perceive. Details must not detract from the main theme; the principal figure must occupy the most conspicuous place; meaning, direction and result of the action must be plainly shown; actors and counter-actors must be separated into clear-cut groups. The compositional scheme which best answers these demands is the symmetrical arrangement, which at the same time is in itself the "sacred form" *par excellence*.

Frontality, however, cannot always be achieved in scenic representations: its rigid observance by all the participants in a scene would make the rendering of an event or an action all but impossible. No active relationship between the figures could be established under such a limitation, and the law of plausibility, the demand for authenticity, would thus be violated. This was indeed a dilemma for an art which did not know or at any rate recognize pictorial space. Apart from spatial illusionism, the most natural way of rendering an active relation between two or more figures on a flat surface would have been to represent them in strict profile. The figures would then have faced each other, their looks and gestures would have seemed to reach their aims. But this would have severed their relation with the beholder.[5] The attempt was indeed made in

such scenes as the Annunciation, the Baptism, the Transfiguration, the Entry into Jerusalem, the Crucifixion, the Doubting of Thomas and the Ascension—scenes in which action counts for less than the representation of glorified existence—to depict at least the main figures in frontal attitudes. But in other scenes, where action is the main theme, this was impossible. For such cases, and for almost all the secondary figures in scenic representations, Byzantine art made use of a compromise between the attitude appropriate to action, the profile, and the attitude appropriate to sacred representation, the full face. The three-quarter view, combining both attitudes, was introduced; and this even became the dominant mode of projection in Byzantine art. Its ambivalent character allows of either interpretation; within the picture as a profile, in relation to the beholder as a frontal view.

In this system there is hardly any place for the strict profile; a figure so represented has no contact with the beholder. It is regarded as averted, and thus does not share in the veneration accorded to the image. Consequently, in the hierarchical art of icon painting, this aspect is used only for figures which represent evil forces, such as Satan at the Temptation, Judas at the Last Supper (3) and the Betrayal. From the point of view of form, the face drawn in strict profile is for the Byzantine artist only half a face showing, as it does, only a single eye. It is drawn exactly like a face in three-quarter view in which the half-averted side has been suppressed. This method of constructing a profile gives the face a curious quality of incompleteness (23). Formally, something is missing—just as the otherwise indispensable relation to the beholder is left out as regards the meaning. But the evil figures must not receive the venerating gaze of the beholder, and they themselves must not seem to be looking at him: iconographic theory and popular fear of the "evil eye" go hand in hand. Outside the strictest school of Byzantine iconography the pure profile is also, though seldom, used for secondary figures. Full back views do not occur at all in the classical period of middle Byzantine art; for to the Byzantine beholder such figures would not be "present" at all.

As a result, the whole scale of turning is toned down in classical Byzantine art. It is as if the figures were somehow chained to the beholder; as if they were forced as much as is compatible with their actions into frontal positions. The generally lowered key gives, on the other hand, a heightened importance to the slightest deviations from strict frontality. The eye, expecting frontal attitudes, registers deviations in posture and glance much more strongly than it would if frontality were the exception, as it is in Western art. The projection used in scenic images is, from the formal aspect, a qualified *en face* rather than a real three-quarter view.

But even this three-quarter view, apparently, did not seem to the Byzantine artist an entirely satisfactory solution. The gestures and gaze of the figures still miss their aims: they do not meet within the picture, half-way between

figures engaged in intercourse, but in an imaginary point of focus outside, that is, in front of it. There is a dead angle between the actors in a scene, an angle which is not quite bridged even by oblique glances. The action takes on a stiff frozen air. To remedy this, to give plausibility and fluency to the representation, two correctives were applied, at first separately, in two different realms of Byzantine art, but from the twelfth century onwards more or less indiscriminately. On flat surfaces, especially in miniatures, ivories, and the like, movements and gestures were intensified in order to bridge the gap between the figures as the actors in the scene. In a field of art which made use of neither pictorial space nor psychological differentiation, gestures and movements could be intensified only, so to speak, from outside, by a heightening of tempo. Intensity of action was preferably conveyed by locomotion. The figures run towards each other with outstretched hands and flying garments (3). The Angel of the Annunciation rushes towards Mary, the Baptist climbs the bank of Jordan with hasty strides, executioners fell their victims in full career, martyrs receive the death-stroke as they fall (61b). These are not the baroque exaggerations of a late phase, but attempts to establish the necessary contacts and to save the picture from appearing as a disconnected row of single figures. There is a definite tendency in this method of rendering action to point forward in time, to make the result of the action apparent together with the action itself, and so not only to connect the figures of one picture among themselves, but also to establish a relation between the successive pictures of a narrative cycle.

This remedy, however, satisfactory and fertile as it was in illustrative pictures of small size, was hardly applicable to monumental paintings on the grand scale. The violent movements would have seemed too undignified, the whirling forms too contorted and complicated. Another means was therefore needed by the Byzantine decorators to bridge the dead angle and save the threatened coherence. The solution they found was as simple as it was ingenious. They placed their pictures in niches, on curved surfaces. These curved or angular surfaces achieve what an even, flat surface could not: the figures which on a flat ground were only half-turned towards each other could now face each other fully without having to give up their dignified frontality or semi-frontality. Painted on opposite sides of curved or angular niches, they are actually facing each other in real space, and converse with each other across that physical space which is now, as it were, included in the picture. The curvature in the real space supplies what was lacking in the coherence of the image (4).

The firm position of the painted figures in physical space makes spatial symbols in the picture itself unnecessary. No illusion is needed in pictures which enclose real space, and no setting is required to clarify the position of the figures. The whole of the spatial receptacles (such the pictures really are) can be devoted to the figures themselves and to such motives as are required from the iconographic point of view. Restrained gestures and movements are sufficient to

9

establish the necessary contact. A large part of the golden ground can be left empty, surrounding the figures with an aura of sanctity. This golden ground in middle Byzantine mosaics is not a symbol of unlimited space; it need not be pushed back, as it were, in order to leave sufficient space for the figures to act. They move and gesticulate across the physical space which opens up in front of the golden walls. The shape and the confines of this physical space are not dissolved, but rather stressed and clarified, by the solid coating of gold. The setting of the gold is close and firm, producing a metallic surface whose high lights and shades bring out the plastic shape of the niche.

There is no need, in this formal system, for the figures engaged in intercourse of whatever kind to approach close to each other. On the contrary, they had to be placed at some distance apart in order that they might be brought opposite each other by the curving of the ground. The resulting distances and empty spaces are filled with a tension, an air of expectancy, which makes the event depicted even more dramatic in the classical sense than violent action and gesticulation, or a closely knit grouping, could have made it. The *cæsuræ* contribute also to the legibility, to the plausibility of the image. The main figure is clearly discernible, because comparatively isolated, and presents itself unmistakably as the main object of veneration.

But the venerability of the icon did not affect its composition alone; it also influenced the choice of material. Controversy about the "matter" (ὕλη) of the images played a large part in the Iconoclastic struggle. It was but natural that, to counter the arguments of the Iconoclasts regarding the incongruity of representing the Divine in common and cheap material, the Iconodules should have chosen the most precious material for this purpose. Mosaic, with its gemlike character and its profusion of gold, must have appeared, together with enamel, as the substance most worthy of becoming the vehicle of divine ideas. It is partly for this reason that mosaic played so important a part in the evolution of post-Iconoclastic painting, and indeed actually dominated it. It allowed of pure and radiant colours whose substance had gone through the purifying element of fire and which seemed most apt to represent the unearthly splendour of the divine prototypes.

ARCHITECTURAL AND TECHNICAL CONDITIONS

These prototypes themselves, to the Byzantine mind, stand to each other in a hierarchic relation, and so their images must express this relationship. They must occupy their due place in a hierarchy of values in which the image of the All-Ruler occupies the central and most elevated position. Clearly, a hierarchical system of images based on the principles which governed the Byzantine Church's own organization could be fully expressed only through an architec-

tural framework that furnished a hierarchy of receptacles within which the pictures could be arranged. A purely narrative sequence of pictures, in the Western sense, or a didactic scheme could be displayed on almost any surface in almost any arrangement. Whether it was used to decorate portals, façades, interior walls or stained-glass windows did not greatly matter. But a Byzantine programme always needed a special framework, namely that in which it had grown up, and which it was developed to suit. This framework was the classical type of middle Byzantine ecclesiastical architecture, the cross-in-square church with a central cupola.[6]

The shaping of this architectural type was a lengthy process, and the final solution was arrived at by several concurring paths. The essential idea seems to have been conceived as early as the sixth century. Architects with widely different traditional backgrounds approached the problem from different sides: from the centralized plan of the free cross, the octagon, the basilica with a central cupola, the semi-basilican plans of Salonica and Ancyra, etc. Temporary solutions which lay in the general direction of development, such as the Constantinopolitan type with five naves, the ambulatory church, or the tri-conchos, were tried out, as it were, and finally abandoned for the classical type of the cross-in-square. The history of this development allows of an almost teleological interpretation. There is evidence of a conscious search for a final solution in accord with the liturgical needs and the æsthetic ideals of the time. Local differentiations gave way before the quest for this ideal type; and, when finally elaborated, it was never abandoned, and remained the basis of the whole of the subsequent development. Even changes of scale did not greatly affect the dominant idea. The final type, fully evolved by the end of the ninth century, was something strangely perfect, something which, from the liturgical and from the formal points of view, could hardly be improved upon.[7] This high perfection might have resulted in sterility, had not the central architectural idea been flexible enough to leave room for variation.

The plan was, in short, that of a cruciform space formed by the vaulted superstructure of transepts arranged crosswise and crowned in the centre by a higher cupola. The angles between the arms of the cross are filled in with lower vaulted units, producing a full square in the ground-plan but preserving the cross-shaped space in the superstructure. Three apses are joined to the square on the east and an entrance hall (sometimes two) stands before it on the west. The most characteristic feature of this architectural scheme is its elasticity, inherent in the fact that the spatial conception finds its complete fulfilment in the vaulted superstructure of the building: it is a conception expressed in vaults, and not in the elements of the ground-plan. The latter, indeed, can vary a good deal without affecting the guiding idea. The cross with the central cupola can be imposed on almost any ground-plan, even on that of a basilica; or rather almost any ground-plan can be subjoined to the ideal system of

vaulted space. The configuration of the vaults itself remains invariable; it is the image of the changeless and perpetual celestial world set over against the varying earthly sphere of the ground-plan which was conditioned by terrain, space, special purpose and changing fashion. However different the ground-plan (the space in which the beholder moves) may have been, his upward look always meets the familiar configuration of golden vaults (in what may be called the optical space). The cupola always dominates the impression. Even the modern beholder directs to it his first glance. From the cupola his eye gradually descends to the horizontal views.

This process of successive apperception from the cupola downwards is in complete accord with the æsthetic character of Byzantine architecture: a Byzantine building does not embody the structural energies of growth, as Gothic architecture does, or those of massive weight, as so often in Romanesque buildings, or yet the idea of perfect equilibrium of forces, like the Greek temple. Byzantine architecture is essentially a "hanging" architecture, its vaults depend from above without any weight of their own. The columns are conceived æsthetically, not as supporting elements, but as descending tentacles or hanging roots. They lack all that would make them appear to support an appropriate weight: they have no entasis, no crenellations, no fluting, no socles; neither does the shape of the capitals suggest the function of support. This impression is not confined to the modern beholder: it is quite clearly formulated in contemporary Byzantine *ekphraseis*.[8] The architectonic conception of a building developing downwards is in complete accord with the hierarchical way of thought manifested in every sphere of Byzantine life, from the political to the religious, as it is to be met with in the hierarchic conception of the series of images descending from the supreme archetype.

The cross-in-square system of vaults is indeed the ideal receptacle for a hierarchical system of icons. Each single icon receives its fitting place according to its degree of sanctity or importance. Just as Byzantine architecture is primarily an architecture of vaults, and is therefore concerned especially with the upper parts of the structure, so Byzantine decoration is primarily at home in the vaulted parts of the church. The lower the icons descend, the more they leave their proper sphere. Especially does mosaic unfold its finest qualities in the vaults, on curved surfaces. This is equally true of the qualities of technique, form and hieratic content. Technically, the mosaic is more safe and solid on curved surfaces, where it forms a kind of vault in itself, and, as has become apparent during modern restorations, is often sufficiently supported by the tension of the vault-like arrangement of the cubes on the curved surface even when they have become detached from the real vault by the corrosion of the mortar that joins them. On flat surfaces, on the other hand, there is no such tension, no mutual support between the cubes; loose parts crumble and fall off. This can be seen in almost all mosaics; the curved parts are generally better preserved

than the flat ones. Mosaicists who had to work on flat surfaces, in flat lunettes for instance, even went so far as to curve the setting-bed slightly, or at least to incline it out of the vertical and to undulate the plane surface,[9] in order to provide some sort of tension and to bring out the formal qualities. For these too are greatly enhanced by curved or undulated surfaces. Only on such surfaces can the sparkling of the enamel cubes and the glitter of the gold be brought out as essential factors. Just as stained glass must be seen against bright light, so a mosaic displays its peculiar charm under the play of light on the curved surface. On flat walls mosaics look comparatively dull: either they are wholly dark and lustreless, or the golden ground is lit up while the figures stand out as dark and colourless silhouettes (5).

THE ICON IN SPACE

The fact that middle Byzantine mosaic painting came to maturity, and found its proper place, on curved surfaces also influenced the shape of the cubes and the way in which they were set. These surfaces did not admit of the use of the large, irregular pieces of stone and enamel which were employed for early Christian wall mosaics, in which each tessera stood for one distinct patch of colour, and took the shape of that patch. The curved receptacles of middle Byzantine mosaics called for small uniformly shaped cubes, fitted together in a close network whose lines run in form-designing curves. The tension of these curves mirrors the tension of the rounded receptacles. In this way the spatial character of middle Byzantine mosaic painting expresses itself even in the technical procedure.

To describe these mosaics, encased in cupolas, apsides, squinches, pendentives, vaults and niches, as flat, or two-dimensional, would be inappropriate. True, there is no space behind the "picture-plane" of these mosaics. But there is space, the physical space enclosed by the niche, in front; and this space is included in the picture. The image is not separated from the beholder by the "imaginary glass pane" of the picture plane behind which an illusionistic picture begins: it opens into the real space in front, where the beholder lives and moves. His space and the space in which the holy persons exist and act are identical, just as the icon itself is magically identical with the holy person or the sacred event. The Byzantine church itself is the "picture-space" of the icons. It is the ideal iconostasis; it is itself, as a whole, an icon giving reality to the conception of the divine world order. Only in this medium which is common to the holy persons and to the beholder can the latter feel that he is himself witnessing the holy events and conversing with the holy persons. He is not cut off from them; he is bodily enclosed in the grand icon of the church; he is surrounded by the congregation of the saints and takes part in the events he sees.

This feeling of the reality of space developed in Byzantine painting at the time when Byzantine sculpture died, as a result of the Iconoclastic controversy. Much of the spatial quality of sculpture in the round, which may be said to exist in the same space as the beholder, went into the development of Byzantine painting. Byzantine monumental painting was, indeed, the legitimate successor of monumental sculpture.

If, however, the icons were to exist in, and to share, a space which is normally the domain of the beholder, it was more than ever necessary to place them in individual receptacles—in spatial units which are, as it were, excrescences of the general space. Moreover, since the images are not links in a continuous chain of narrative, they must not flow into one another: they must be clearly separated and each must occupy its own place in the same manner as the events and persons they represent occupy distinct places in the hierarchical system. The formal means to this end is the separate framing of each single receptacle. The single units are set off either by their characteristic shapes as spatial units, especially in the upper parts of the building, or, in the lower parts, by being embedded separately in the quiet colour foil of the marble linings. This marble entablature with its grey, brown, reddish or green hues covers practically all the vertical surfaces of the walls in middle Byzantine mosaic churches, leaving for the mosaics only niches in which they are placed like jewels in a quiet setting. Nothing is more alien to the monumental mosaic decorations of these churches in the central area than the almost indiscriminate covering of the walls with mosaic pictures which is found in the twelfth century in Sicily, Venice and other colonial outposts of Byzantine art. In Byzantium itself the mosaics never lose the quality of precious stones in an ample setting. The icons never cease to be individually framed spatial units; their connection with one another is established not by crowded contiguity on the surface but by an intricate system of relations in space.

THE IDEAL ICONOGRAPHIC SCHEME OF THE CROSS-IN-SQUARE CHURCH

These relations were governed, in the classical period of the tenth and eleventh centuries, by formal and theological principles. These have been analysed and interpreted by a number of scholars, above all by Gabriel Millet.[10] The methods used are sometimes open to criticism, as when, in order to reconstruct the "ideal" scheme of middle Byzantine church decoration, observations drawn from monuments of widely different dates are combined with others gleaned from such varying sources as the writings of iconologists and iconographers from Theodore Studites and John of Damascus down to Simeon of Thessalonike and John of Euboea, the *ekphraseis* of exegetes like Constantine

14

Rhodius, Nicholas Mesarites, or late painters' guides such as the Athonite Hermeneia. For scholars to seek for an actual monument embodying the "ideal scheme" recalls Goethe's quest of the *Urpflanze*. But it is possible to find guiding principles if that phrase be taken to cover not only theological and ecclesiastical conceptions differing according to date, locality and special destination, but also the exigencies of varying architectural schemes. For such an analysis, it is not the particular interpretations given by different iconographers to the whole or to the parts of the Byzantine church building and to its decoration that matter, so much as the fact that such interpretations were proffered at all, and that some of them became the guiding principles of middle Byzantine hermeneutics. Seen from this angle, we can distinguish three systems of interpretation which are found interlinked in every Byzantine scheme of decoration of the leading, centralized type.

The Byzantine church is, first, an image of the Kosmos, symbolizing heaven, paradise (or the Holy Land) and the terrestrial world in an ordered hierarchy, descending from the sphere of the cupolas, which represent heaven, to the earthly zone of the lower parts. The higher a picture is placed in the architectural framework, the more sacred it is held to be. The second interpretation is more specifically topographical. The building is conceived as the image of (and so as magically identical with) the places sanctified by Christ's earthly life. This affords the possibility of very detailed topographical hermeneutics, by means of which every part of the church is identified with some place in the Holy Land.[11] The faithful who gaze at the cycle of images can make a symbolic pilgrimage to the Holy Land by simply contemplating the images in their local church. This, perhaps, is the reason why actual pilgrimages to Palestine played so unimportant a part in Byzantine religious life, and why there was so little response to the idea of the Crusades anywhere in the Byzantine empire. It may also account for the fact that we do not find in Byzantium reproductions of individual Palestinian shrines, those reproductions of the Holy Sepulchre, for instance, which played so important a part in Western architecture and devotional life.

In the realm of topographical symbolism, however, more than in any other, over-interpretation set in fairly soon, more than one symbolic identification being applied to one locality or even to a single object of church furniture. Examples of this can be found in the *Ecclesiastical History* of the Patriarch Germanos[12] or in the writings of Simeon of Thessalonike.[13] They make it clear that we are confronted in these speculations with *ex post facto* interpretations and not with guiding principles. But such principles did exist, even if every single case called for a new adaptation of them, and they are shown in the fact that certain parts of the building were more or less consistently chosen for the location of certain icons.

The third kind of symbolical interpretation was based on the Calendar of the Christian year.[14] From this point of view, the church is an "image" of the

festival cycle as laid down in the liturgy, and the icons are arranged in accordance with the liturgical sequence of the ecclesiastical festivals. Even the portraits of the saints follow to some extent their grouping in the Calendar, and the arrangement of larger narrative cycles is frequently guided by the order of the Pericopes, especially as regards the scenes connected with Easter. Thus the images are arranged in a magic cycle. The relationship between the individual scenes has regard not to the "historical" time of the simple narrative but to the "symbolic" time of the liturgical cycle. This cycle is a closed one, repeating itself every year, during which, at the time of the corresponding festival, each image in turn comes to the front for the purpose of veneration, to step back again into its place for the rest of the year when its magic moment has passed. The profound contrast between this conception of time and that implicit in Western decorative schemes is obvious: in the latter a series of scenes illustrates an historical sequence of events, with its beginning and end clearly marked and with a definite direction parallel with the unrolling of the story. In the strict arrangement of Byzantine decorations the time element is symbolical; it is interlinked with the topographical symbolism of the building, and therefore closely connected with the spatial element. The flow of time is converted into an ever-recurring circle moving round a static centre. These two conceptions of time correspond to the two dominant architectural types: the Western to the basilican type,[15] with its rhythmic movement from entrance to apse, from beginning to end; the Byzantine to the domed centralized building which has no strongly emphasized direction, and in which the movement has no aim, being simply a circular motion round the centre.

All three Byzantine systems of interpretation, the hierarchical cosmic, the topographical and the liturgico-chronological, are so closely accommodated to the dominant architectural type of the cross-in-square church that they must, in fact, have been elaborated for such a building. Only within this framework could a scheme devised after these principles be satisfactorily placed. Every attempt, therefore, to adapt such a programme to other types of architecture must have met with great difficulties, and must consequently have resulted in a weakening of the original concepts, as can actually be seen in the provinces.

THE THREE ZONES

The most obvious articulation to be observed in a middle Byzantine mosaic decoration is that which corresponds to the tripartition into heaven, paradise or Holy Land, and terrestrial world. Three zones[16] can be clearly distinguished: first, the cupolas and high vaults, including the conch of the apse; second, the squinches, pendentives and upper parts of the vaults; and thirdly, the lower or secondary vaults and the lower parts of the walls. These three zones are, in

most cases, separated by plastic *cosmetes*—narrow bands of carved stone or stucco which run round the whole edifice.

§ Cupolas and Apses

The uppermost zone, the celestial sphere of the microcosm of the church, contains only representations of the holiest persons (Christ, the Virgin, Angels) and of scenes which are imagined as taking place in heaven or in which heaven is either the source or the aim of the action depicted. Byzantine art from the ninth to the end of the eleventh century made use of only three schemes of cupola decoration: the Ascension (6), the Descent of the Holy Ghost (8), and the Glory of the *Pantocrator* (7), the All-Ruler. This peculiarity distinguishes the strict scheme of the Middle Ages from early Byzantine as well as from Italo-Byzantine decoration. In the five cupolas of the Justinianic church of the Apostles in Constantinople,[17] for instance, there had been five different representations, each forming part of the narrative cycle which filled the whole church. After the Iconoclastic controversy, however, and in connection with the subsequent emergence of the symbolic interpretation of the church building, the cupolas were strictly set apart from the narrative cycle. From the ninth century onwards they contained only representations in which the narrative character had been displaced entirely by the dogmatic content. The three themes above-mentioned dominated Byzantine cupola decorations after the Iconoclastic controversy to such an extent that others were scarcely thinkable; even the small cupolas of entrance halls were decorated with them. Examples can be found, for instance, in Chios,[18] and later in the Kahrieh Djami in Constantinople,[19] where the scheme of the Pantocrator cupola was adapted to the special contexts,[20] and where Mary has supplanted the central figure of Christ.

The Ascension, Pentecost and Pantocrator themes fulfil, moreover, the formal conditions of middle Byzantine cupola decoration in that they contain an organic centre round which the composition could be arranged radially. Apostles, Angels or Prophets are placed like the spokes of a wheel round the medallion with the ascending Christ, the *Hetoimasia* (prepared throne), or the bust of the Pantocrator respectively in the centre. But the decoration of a middle Byzantine cupola was not conceived, primarily, as a flat design. The dome was thought of as enclosing real space, of a bell-shaped form, and the decoration is in reality a spatial arrangement. The standing or seated figures are quite actually standing or sitting around and below the elevated central motif. The cavity of the cupola is a perfect equivalent of the imagined spatial arrangement which the figures would occupy if the scenes were being enacted in reality; it is a receptacle which exactly fits the spatial conception. Under these circumstances there is obviously no room for illusionistic picture-space in this art: the exigencies of spatial realism are more directly fulfilled by this means

than they could have been by the cleverest tricks of illusionism. The figures stand or sit at the limits of the physical space, or rather they form and underline these limits. If there is no appreciable space behind them, behind the picture plane, there is, on the other hand, space, the real space, in front.

A special rhythm, different in kind and degree from the rhythmic movement of figures in a flat design, binds the figures together and connects them with the elevated central motive. Complicated attitudes, especially in the representation of the Ascension, create a rhythmical movement, almost a dance, round the cupolas; and glances, gestures and intermediary motives (e.g. the trees in the Ascension and the rays of light in the Pentecost) lead upward to the centre. This formal conception, however, is not radially symmetrical in the strict sense. The close relationship between icon and beholder enforces a definite orientation in accordance with the main optical axis. The central medallion (Christ, Hetoimasia, Pantocrator) is so arranged as to appear upright in the view from west to east; and the lower parts of the cupola are also composed so as to fit in with this line of vision. Not only are the main figures, iconographically speaking, assembled in the eastern half, so that they look westwards and confront the beholder in an almost frontal attitude; they are, in addition, arranged symmetrically along the middle axis of this view, offering to the beholder a hieratic icon: Mary with Angels and with Peter and Paul in the Ascension, Peter and Paul frontally enthroned in the Pentecost, and frontal Archangels and Prophets in the Pantocrator cupolas. The eastern part of the cupola is, so to speak, the façade of the pictorial edifice; it contains the quintessence of the image. The figures in the western, the averted, half of the cupola, on the other hand, are shown in more agitated and less frontal postures, even positions which, in the lowered key of Byzantine projection, appear almost back views. In the Ascension these figures are looking upwards at a steep angle, making this part of the cupola appear steeper than the seemingly flatter façade which faces the beholder. The spatial structure of the composition is thus built up to suit the beholder who faces east and looks up into the cupola. To such a beholder the cupola would appear steeper in the western half and flatter in the eastern. If he stands under the western foot of the cupola, he has almost to turn round and look upwards at a steep angle in order to get a view of the "averted" side; his physical and spiritual attitude is mirrored in the postures of the figures placed in this part of the cupola or the drum. The structure of the whole cupola, which in reality is regular and radially symmetrical, thus appears to be asymmetrical in accordance with the dynamic of the beholder's view.

One difficulty, however, always faced the Byzantine artist with regard to the central motif in the zenith of the cupola. A full-length figure placed there could not be represented as upright without the help of illusionistic perspective, unknown to Byzantine painting. An unforeshortened figure would necessarily have appeared to the strict spatial feeling of the Byzantines as lying face down-

18

wards. This resulted in a certain awkwardness, and the attempt was made to resolve it by connecting the central figure of the Ascension, for instance, with the "upright" eastern half of the cupola by inserting a pair of flying angels supporting the enthroned Christ from below, and surrounding the central figure with a circular halo as if with a medallion frame. This frame softened the realistic implications of the figure, as it were, making it appear as an axially symmetrical motif. But even so this solution was apparently felt to be unsatisfactory, and this was perhaps one of the reasons why, in the classical period of middle Byzantine decoration, the Ascension as a cupola composition was soon abandoned in favour of the Pantocrator scheme, which, with a half-figure enclosed in a medallion, offered no such difficulties. The abstract symbol of the Hetoimasia in the Pentecost could be arranged satisfactorily from the beginning.

The iconic art of cupola decoration was the most magnificent achievement of middle Byzantine monumental painting. It was the fullest realization of the idea of the monumental icon, conceived as a configuration in real space. The figures move and are arranged in this spatial receptacle according to the dynamics of the beholder's vision. This solution—that of making the physical space the action-space of the figures—was seldom employed either before the ninth or after the thirteenth century. The conception of space and picture coinciding with it is the basic principle of classical middle Byzantine art. The art of the West made use of this conception of real space only for a short time, about 1500, when cupola decoration became once more a main problem of monumental painting. Leonardo in his Sala delle Asse and Correggio in his decoration of the Abbess's chamber at Parma tried to stress the confines of the actual space by encasing it with forms whose position in imaginary space coincided with their situation in physical space. But very soon the Western idea of spatial illusion led to an imaginary widening of the physical space by windows opening into unlimited pictorial space. In the Byzantine decorations of the classical period this never happened. The enclosed space, the confines of the spatial icon, were never pierced by illusionistic means. The icon always kept its well-defined shape.

The three themes of classical Byzantine cupola decoration—Ascension, Pentecost and Pantocrator—were hardly ever represented in three cupolas of the same building, except in monuments of "colonial" character, such as St. Mark's, Venice[21] (6, 8, 9), or except as a result of later changes, as in the Holy Apostles at Constantinople.[22] The reason for this is that, in the main line of Byzantine evolution, the cupola scheme of the Pantocrator[23] replaced that of the Ascension. The theological content of the new scheme must have been originally very similar to that of the older. It depicted Christ in Glory after the Ascension. The feeling that the two themes are identical was so strong that they were not represented together in a single scheme. In Pantocrator churches, for instance in Hosios Lukas, the Ascension was even omitted in the series of pictures recalling

the Church festivals. In the outposts and provincial backwaters of the empire, however, the Ascension cupola scheme lived on for some time, especially in Cappadocia,[24] Italy[25] and Russia.[26] The Ascension cupola was connected, on the whole, with a more narrative character in the whole programme. It is thus essentially pre-Iconoclastic, in contrast to the abstract and dogmatizing representation of the Glory of the Pantocrator which became the natural centre of hieratic post-Iconoclastic decorative programmes.[27] The two cupola schemes excluded each other. To use them side by side in the same church, in view of their almost identical content, would have been a kind of pleonasm; it would also have involved confusion between two different lines of thought. The decoration, by being given two centres, would have been deprived of its unity. Whenever this happened, as in some cases it actually did, we may be certain that the programme in question was laid down by provincial theologians with little understanding of the dogmatic clarity of metropolitan iconography.

The Pentecost, on the other hand, goes well with either of the two main cupola schemes. It was never the centre of a whole programme, and could be attached either to the Ascension or to the Pantocrator, provided there was a second cupola to fill. If this was the case, as in Hosios Lukas,[28] the theme was given in full, above the sanctuary and the main altar. This position indicates that it was not primarily intended as an illustration of the "historical" event in the course of a narrative cycle, or even as one link in the cycle of feasts, but as an allegory of the divine inspiration of the Church whose priests officiated below. This becomes even clearer in those cases (as in the majority of the surviving monuments[29]) in which there is no cupola above the altar. In these cases only an abridged version was used for the decoration of the presbytery-vault, showing the central motif alone of the full type, the Hetoimasia, as the seat and source of Divine inspiration. With this the representation lost even what was left of its scenic character. It became a symbol which, by virtue of its very generality, was apt to take on a new and wider meaning—even an eschatological implication. The two (or four) adoring angels almost invariably added underline the generalizing character of the symbol,[30] which at last became so far removed from an illustration of the historical Pentecost scene that another icon illustrating the Descent of the Holy Ghost could be added to the festival cycle without apparent duplication. Pantocrator and Hetoimasia are, in fact, parallel results of a single development—that from the historic scene to the dogmatic symbol. A third example of the same process is the substitution of the Deesis for the Last Judgment, which in its fully developed form was not frequently used within the framework of central Byzantine cross-in-square church decoration. It is found, however, like the Ascension in its full narrative version, in the outlying provinces such as Russia[31] and Italy.[32]

The substitution of abridged symbols for complete versions, however, is not confined to the classical era of middle Byzantine painting. It can be traced

similarly in western Gothic art (Pietà for the Descent from the Cross, Christ and St. John for the Last Supper, Christ riding on the ass for the Entry into Jerusalem, etc.) and in the Italian High Renaissance (Santa Conversazione for the fuller type of the Maestà). Iconographically, it means the preponderance of abstract over concrete, of idea over event; formally, the reduction of the composition to its innermost core, its most simplified form, which allowed of a highly abstract treatment, of perfect symmetry and absolute clarity.

Nevertheless, it was only for a comparatively short time that these abstract symbols reigned supreme. As soon as their origin and their special message were obscured or forgotten, the historical images were reintroduced, to figure side by side with their symbolic abbreviations.[33]

The narthex of the middle Byzantine church has its own heavenly zone, marked by the image of the Pantocrator over the main entrance and by one or more cupola representations dedicated to the Emmanuel or to the Virgin. To the heavenly zone of the church itself belongs also the conch of the main apse. In churches of the dominant cross-in-square type this invariably contains the figure of the Virgin, either seated in the type of the *Panachrantos* or standing in the types of the *Orante Platytera* or the *Hodegetria*. In the period immediately after the Iconoclastic struggle the standing figure would seem to have been preferred; this may have been adopted because the pre-Iconoclastic type of the Virgin enthroned was too open to charges of idolatry from the Iconoclasts. In the course of the tenth or the eleventh century, however, when all controversy had died down, the iconographers and the artists reverted to the seated image. The standing figure was relegated to the outlying provinces[34] and, perhaps, to Palace chapels, where the *Orante* was imbued with a special meaning as the Protectress of the ruler.[35] In the period from the ninth to the end of the eleventh century Mary is represented alone in the golden conch of the apse. Adoring angels are placed in the high niches of the presbytery walls or in the vault above the sanctuary, where they seem to be connected as much with the Hetoimasia as with the Virgin. But later on, in the twelfth and thirteenth centuries, they were moved into the conch itself, to attend on the enthroned Virgin.

There was, however, another type of Byzantine apsidal decoration which showed Christ in the conch (49). This had been very frequent in pre-Iconoclastic times, and it survived after the controversy in the provinces. In Byzantium itself and in Greece this type was restricted after the year 900 to longitudinal churches with no cupola, where the apse is the "highest" and holiest place for an icon. In cupola churches the apse holds the second place, and was consequently the fitting site for the image of the Virgin, second in rank to that of Christ (10a).[36]

The side apses were not subject to such strict rules as the main apse; but they were mostly connected with the "pre-history" of Christ and the Redemption, showing either Mary's parents, Joachim and Anna, or John the Baptist as

forerunner of the Messiah. It is in keeping with this customary programme that the prothesis was interpreted by the iconographers as symbolizing the place of Christ's birth, the cave of Bethlehem.

§ The Festival Cycle

The second of the three zones of the Byzantine church is dedicated to the Life of Christ, to the pictures of the festival cycle. It harbours the monumental calendar of the Christological festivals and is the magical counterpart of the Holy Land. The cycle of feasts was gradually developed by selection from an ample narrative series of New Testament scenes. It is very probable that the decorations which immediately followed the re-establishment of icon worship did not include any festival icons in the naos. But the austere ideal of the early post-Iconoclastic period was relaxed in the course of the tenth and eleventh centuries. Hosios Lukas, dating from the beginning of the eleventh century, displays four festival icons in the naos, four more being exhibited in the narthex; Chios, from the middle of the century, has eight (and six in the narthex); and Daphni, dating from the end of the century, displays thirteen icons of the feasts in the naos and a further Christological and Marianic cycle in the narthex (42, 43).[37] The growth of the festival cycle can also be followed in contemporary ecclesiastical literature: there the number rises from seven to ten, twelve, sixteen and even eighteen pictures, the full development being reached from the twelfth century onwards.[38] The classical cycle of the eleventh century comprised, at least in theory, twelve feasts, the *Dodekaeorta*: Annunciation, Nativity, Presentation in the Temple, Baptism, Transfiguration, Raising of Lazarus, Entry into Jerusalem, Crucifixion, Anastasis (Descent into Hades), Ascension, Pentecost and Koimesis (Death of the Virgin). To this series were frequently added, in pictorial cycles, a few images which elaborated the story of Christ's Passion, namely the Last Supper, the Washing of the Apostles' Feet, the Betrayal of Judas, the Descent from the Cross and the Appearance to Thomas. Other developments were attached to the story of Christ's infancy (the story of His parents, the Adoration of the Magi, the Flight into Egypt, etc.) and to that of His teaching (the cycle of the miracles and parables). These developments are easily recognizable for what they are, whereas the scenes from the Passion are treated as equal to the twelve main festival images. The gradual enlargement of the series of Christological scenes in the naos led, ultimately, to the dissolution of the liturgical cycle of the festivals, the icons being merged in a fuller illustrative cycle which retains only a few elements characteristic of the hierarchical programmes of the tenth and eleventh centuries. Such traits, which survived into the twelfth and following centuries, are the separation of the miracles from the festival cycle even in its enlarged form, the emphasizing of the Crucifixion and the Anastasis as the two key points of the Christological cycle,[39] and a few

customary rules (fostered by hermeneutic speculation) affecting the distribution of the images. Apart from these survivals, the twelfth century shows a tendency to return to the narrative character[40] prevalent in pre-Iconoclastic times.

This development was made easier and probably inaugurated by the fact that the compositional schemes of the Christological icons, unlike those of the cupola compositions, had not been developed within the sphere of monumental painting. They were taken over from small-scale pictures on a flat ground, from portable icons, miniatures, or narrative wall-paintings. These models had, originally, none of the characteristics of the "spatial" icon; they were merely flat compositions which had to be adapted, sometimes laboriously, to the new spatial receptacles and to the new liturgical rôles which they had to play in the new contexts. They tended, consequently, to relapse into their original forms as soon as the hierarchical system had outlived its prime. Even in their adapted shapes within the hierarchical cycles these pictures retained something of their original narrative character. Only in deeply curved niches, as in the squinches of the great eleventh-century churches, did they assume some of the characteristics of compositions in physical space, though not, indeed, to the same degree as compositions in the cupolas. The niches are not closed in on all sides; being half-open, they do not completely surround and enclose the space within their curved walls. But their depth makes it possible to represent in them figures standing to the left and right of the centre as they might face each other in real space. The Angel of the Annunciation, for instance, stands in actual fact opposite to the almost frontal figure of the Virgin (4). The spatial distance between the two figures expresses the theme of the meeting of two different spheres. The spiritual distance between the Angel and Mary had often been naïvely expressed in flat icons by inserting a door or a column between them. In the spatial arrangement of the monumental icons this naïve symbolism was unnecessary: the spatial gap sufficed to indicate the spiritual separation of the two figures. Another frequent method of representing the Annunciation in middle Byzantine churches is especially interesting in this respect. It shows the Angel on the left and the Virgin on the right spandrel of the triumphal arch, the two figures being separated by the wide opening of the arch (2). In this way a large part of the church is included in the image. In the Nativity, the concave landscape with the open cave in the centre is adequately fitted to the physical cavity of the niche in which it is placed (10b, 11). The adoring Angels bow in the most actual sense to the Child who, in the centre of the composition, is sheltered and surrounded by all the other forms and figures. The Presentation in the Temple furnished the opportunity to oppose two groups of figures right and left of the centre, which again is occupied by the Holy Child (14). And in the Baptism the angle of the niche made a fitting frame for the river Jordan (12). Only in this spatial setting does the bell-like or conical shape of the river take on an air of spatial reality: the Angels and the Baptist are really standing on its opposite banks, separated

by the gulf of the enclosed space. Moses and Elijah, in the Transfiguration, could be made to turn towards the Christ in veneration without abandoning their semi-frontal attitudes. The arrangement of the figures has a spatial reality, with the main personages displayed in a semicircle and the three Apostles below and in front. A diagram of the actual places occupied by the figures in the spatial receptacle would almost coincide with a diagram of the reconstructed event in physical space.

The scope of this feeling for the reality of space can be gauged by the fact that scenes which called for frontal representation and did not include opposed and correlated groups, or those which, if spatially reconstructed, would take the form of a row of figures posturing or passing by on a narrow stage, were hardly ever set in deep niches. In these cases such a spatial setting would have been meaningless; and this is probably the main reason why we never find the Entry into Jerusalem, the Crucifixion or the Anastasis (13) depicted in the deep angular squinches of the naos. These scenes, demanding flat emplacements,[41] were shifted either to the transepts or to the narthex. But there is another, and purely formal, consideration which may have played its part in excluding such themes as the Crucifixion and the Anastasis from the cycle of the deep niches: the long straight lines of the Cross, which appears in both scenes (as also in the Descent from the Cross), would have looked broken or contorted had they been displayed on a strongly curved surface.[42] It is one of the aspects of the Byzantine conception of forms in space that forms were taken at their face value: a line which appeared broken or curved owing to secondary optical effects was taken by the beholder to be really angular or curved. Lines, on the other hand, which were to be taken as straight, because they were meant to depict straight objects, could not be placed in situations which would destroy their appearance of straightness. The impression made on the beholder was, in fact, the ruling consideration in Byzantine monumental art as much in its formal as in its spiritual aspect. It was his standpoint and the position from which he would generally view it that determined the compositional arrangement of the picture. And as the main viewpoints lay, for liturgical reasons, along the middle (west–east) axis of the building, the compositions were shaped and placed with express regard to this axis, both thematically and formally. This becomes especially clear if we analyse the compositional arrangement of the festival icons in the deep angular squinches of Hosios Lukas or Daphni. The main figure of the scene—Christ or Mary—is invariably represented as turning towards this central axis, that is, towards the beholder. This is why, in the icon of the Presentation in the Temple in Hosios Lukas (14),[43] the normal direction of the narrative, from left to right, was reversed. Had it been otherwise, Mary would have seemed to be moving away from the beholder, or walking out of the church.[44] As it is, she comes to stand, in an almost frontal position, with the Child in her arms, on that part of the angular niche which faces east. The same is the case in the

Baptism in the same church (12a). All the compositions, in fact, are so arranged that the main figures and motifs are placed in those halves of the triangular niches which stand at right angles to the main axis (the walls facing east and west respectively). The other halves, on the north and south walls, are treated as secondary parts of the images, as their "averted sides". This is a feature similar to that which has been noticed in the composition of the cupolas: just as these had a main view, a "façade", so had the spatial triangles of the squinches. Not only do the main views contain the principal figures; they are also richer in colour and fuller in form (11).

But this was not the only compositional rearrangement which the placing of the pictures in the deep angular niches of the naos required. A thorough overhaul of the models was necessary. Verticals, for instance, which were meant to be seen as such, had to be particularly stressed and specially placed so as not to appear bent or broken. On the other hand, a seeming curve could be produced on the curved surface by judiciously placed straight lines. On the whole, the models were simplified; the painters could do without most of the motifs which, in flat compositions, were necessary in order to establish pictorial coherence: motifs, for instance, which enveloped and echoed upright figures and groups of figures in order to bind them into a closely woven texture of compositional pattern. Such patterns, indispensable in the flat, would have had a bewildering effect on the curved surfaces which by their own tension alone performed the function of binding the figures together. The spatial compositions had to be more straightforward than those of contemporary miniature painting. But the fact that an essential part of the enlivening movement of the composition was achieved, not by the flat design, but by the effects of spatial projection, imparted to these icons a tense and thrilling quality, something of the charm of pictures *in statu nascendi*.

In view of the fewness of the niches available in the naos, only a certain number of a more comprehensive cycle of icons could be placed in spatial receptacles. There were no fixed rules to decide which these favoured icons which were to be placed in the squinches and deep niches of the naos should be; but several factors influenced this choice and brought about the final distribution. The first was the architecture of the church; for that decided how many images could be placed in niches. A second factor was the formal character of the compositions; those which lent themselves to being fitted into curved receptacles were preferred. Theological considerations formed the third and final factor. The rank and dignity of the icons had to be considered, and a certain sequence observed among them in accordance with the liturgical calendar. At length a more or less firm tradition grew out of these determining factors. This tradition would favour, for instance, the placing of the Annunciation in the north-eastern angle of the naos, forward left of the beholder, that is, either in the north-eastern squinch of the cupola or in the spandrels of the triumphal

arch, beginning on the left with the figure of the Angel. The Nativity would follow in the south-eastern squinch. But there the regularity ended: different images made up the rest of the naos-cycle in different churches.

The scenes which could not be placed in the niches of the naos had to be shifted to secondary parts of the interior—the transepts for instance—or to the narthex. They were placed, as far as possible, in framed lunettes embedded in the marble linings of the walls. Crucifixion and Resurrection tended to confront the eastward-looking beholder on walls facing west, in an arrangement symmetrical to the central axis. The Koimesis was usually represented above the main entrance, on the west wall of the naos. In churches which had no squinches or niches in the naos, the whole evangelical cycle had to be represented in the transepts; this became the dominating type in the twelfth century and after. Subsidiary cycles were scarce in the monuments of the classical era of middle Byzantine decoration: they comprised only the Life of the Virgin (generally in the narthex) and a few Old Testament scenes which were meant not as illustrations of a comprehensive narrative but as typological prototypes, and were placed in the side chapels of the sanctuary (42, 43).

§ The Choir of Saints

The third and lowest zone of centralized decorations does not contain any scenic images: single figures alone make up the "Choir of Apostles and Martyrs, Prophets and Patriarchs who fill the naos with their holy icons" (15).[45] These figures are distributed in accordance with two iconographical principles which intersect each other: one that of rank and function, the other that of calendrical sequence. It is the former of these which predominates. Sainted priests and patriarchs are placed in or near the main apse, in a hierarchical order which descends from the Patriarchs of the Old Testament, by way of the Prophets and the Doctors of the first centuries of Christianity, down to the humble priests of the Eastern Church. The Martyrs fill the naos, arranged in several groups: the holy Moneyless Healers (the Anargyroi) next to the sanctuaries, the sacred Warriors on the pillars and the arches of the central cupola (16a), and the rest mostly in the transept, distributed in groups according to the dates of their festivals in the liturgical calendar. The third category comprises the holy Monks, who are placed in the western part of the church, guarding the entrance of the narthex and the naos. Holy women and canonized emperors are depicted in the narthex. But this order is by no means rigid; it allows of variation according to the dedication of the particular church and to its architectonic type. One main variant is to be found in churches whose central cupola rests not on large squinches (which afforded space for scenic representations) but on smaller pendentives which could be decorated only with single figures. These four single figures are invariably the four Evangelists, seated on thrones in the act of writing

their Gospels. The narrow arches which support the cupola in churches of this type are filled with medallions of the ancestors of Christ or of holy Martyrs.

But variable as was the arrangement of the single figures in Byzantine churches, there were nevertheless strict rules of æsthetics governing the manner in which they were represented in keeping with their different architectural settings and iconographical significance. The figures can be divided into four main groups: seated figures, full-length standing figures, busts, and medallions. Seated figures occur on curved surfaces only: the only persons represented as single figures in seated postures are Christ, Mary and the Evangelists.[46] The first two (in apses and so on) are always fully frontal, facing the beholder. The Evangelists, on the other hand, are invariably rendered in an oblique position, a three-quarter view which is a formal corollary of the oblique position in space of the spandrels on which exclusively they appear.[47] It is in accordance with the Byzantine feeling for the implications of position in real space that the figures should express, and to some extent correct, by their projectional attitude their emplacement in physical space with regard to the beholder. Frontality is conceived with regard to the main axis: so that if the surfaces on which the figures are painted are oblique to this main axis then the figures have to be turned so as to appear frontal with relation to their real position in space. The projectional obliquity of the figures corrects the oblique position of the diagonal spandrels (16b).

The standing figures find their proper places on vertical walls, in barrel vaults and on the vertical parts of arches. One main rule applies to these figures: "standing" is taken literally, that is, they are thought of as standing vertically in physical space; they are so placed that they stand with their heads up and their feet pointing downwards. Any other arrangement would be felt to violate the strict Byzantine feeling for the reality of space. Consequently, we never find at Byzantium figures which are meant to be standing depicted in the horizontal axis of a barrel vault or in the apex of some other vaulted roof—a peculiarity often found, of course, in Romanesque wall paintings or even in Italo-Byzantine mosaics, such as those of St. Mark's in Venice.[48] Such figures would have appeared to the Byzantine beholder, who considered the actual position of the figures in physical space, not as standing up, but as lying. The vertical position of standing figures, however, was not enough by itself to satisfy the subtle and strict æsthetic code of middle Byzantine decoration. The surfaces on which such figures appear must, in addition, have a clear connection with the floor of the church, the standing-place *par excellence*. Standing figures, therefore, are usually excluded from closely framed units which are clearly cut off from the floor; for example, receding niches rising from shelving horizontal bases, or "hanging" spandrels. Such emphatically framed elements would have been felt to isolate the figures too much from the common standing-ground. Figures so placed would not give the impression of belonging to the great choir of

27

Saints which fills the church. In a higher degree than of any other parts of the decoration, it can be said of the Saints, the single figures, that they share the space of the church with the beholder. They are closest to him, both actually and spiritually; they are his ideal representatives in the hierarchy of the Kosmos. Needless to say, the scale of the standing figures and the height of their emplacement vary in accordance with their rank within this hierarchy.

Full-length figures stand in many cases on a narrow strip of ground which is sometimes just a band of variegated dark colour, sometimes a "meadow" with plants and flowers, and sometimes a suppedaneum or footstool with a special shell-shaped pattern. These three different designs of the ground-strip correspond to three different degrees of sanctity, the last of the three being reserved for Christ, Mary and Angels. The shell pattern on the suppedaneum has a long history. It derives from the shell-shaped pattern of pavements, which, for technical reasons, became the rule in the setting of the ground of mosaic floors from the later fourth century onwards. From this it became, still later, an abridged symbol for "floor", standing-ground *par excellence*, and was accorded to figures of special importance. In the course of the twelfth and thirteenth centuries the original significance of the pattern was gradually forgotten, but not its habitual connection with especially venerable figures; it was used, accordingly, as a flat background (instead of a golden ground) for figures of the Virgin, and so on.

Standing figures are mostly represented frontally, unless they are meant to be members of an interrelated group, as is sometimes the case with Angels who, even as isolated figures, are often thought of as connected with Christ, Mary or other objects of worship: the Angels are, for this reason, often rendered as turning and bowing towards some object. Other exceptions are the rows of Apostles, in apses like those at Cefalù and Monreale, or in the narthex of Hosios Lukas (19, 17) where the twelve single figures of the Apostles, deployed on different pillars and arches, are gathered, as it were, into a homogeneous group by the simple means of slight turnings and quarter views. It is important to note that all these movements point towards the image of the Pantocrator above the main door, as a common centre. It is by these subtle deviations from rigid frontality that the Apostles are singled out from the numerous group of other figures (all frontal except the Angels) and related to each other as well as to the common centre.

Next in dignity come the half-figures or busts. These appear exclusively on vertical parts of the architecture which are definitely framed and have a strongly emphasized base, by means of which the figures are cut off. Lunettes, shallow and low niches, and parts of spandrels are the ideal places for figural representations of this kind (18a). They are never found on large surfaces which have no definite delimitation at the bottom. Half-figures floating in the golden ground do not appear in middle Byzantine painting, except for those of Angels in scenic

representations (the Crucifixion, etc.), where the absence of the main part of the body has a theological significance, as stressing the spiritual nature of these heavenly beings. The portraits of the holy Stylites, their upper bodies rendered as emerging from a column or as planted on it, are half-figures of a special kind. This abbreviated mode of representation was doubtless fostered by reminiscences of sculptured busts on columnar socles. In the formal arrangement the figures of the Stylites are treated like full-length figures: they are used on narrow vertical strips of walls or, for preference, pillars (49).

The remaining parts of the building, especially cross-vaults, spandrels, narrow horizontal strips of wall, etc., are usually filled with medallions (18b). The triangular segments of cross-vaults, for instance, never show any other kind of figural decoration. It was felt, apparently, that a bust, whose spatial reality was softened, as it were, by a circular frame, and which did not imply the conception of "standing" in real space, was the only kind of figural motif which could satisfactorily be placed in the nearly horizontal parts of the vaulting. The circular shape of the medallions needed, on the other hand, the support of an architectonic or linear framework, into which they could be fitted so that they did not seem to be rolling or floating insecurely. This is why medallions are hardly ever found on large unbroken walls, and are always enclosed in narrow strips, in triangles, spandrels and such like. In the summits of arches medallions were arranged so as to have their heads pointing towards the beholder; thus they appear erect and help to fix the main point or axis of view. The heads generally point, therefore, towards the centre of the naos, that is, towards the centre of the square which is surmounted by the main cupola. In the summits of lateral arches they point either towards the middle axis or westwards, facing the beholder. The former is the case when the ground-plan of the church is strictly centralized, the latter if it is to some extent longitudinal.

In the strict system of Hosios Lukas the half-figures of the medallions are strictly frontal, as with full-length figures, and with the same exception, that of Angels whose "adoring" attitude was an iconographically fixed formula (19, 27). At Daphni, on the other hand, strict frontality has ceased to be the exclusively dominating principle. Slightly oblique views of the faces were introduced, as befitted the new conception of larger decorative units to be treated as "pictures". At Daphni three or more medallions make up a vivid group. Possibly this loosening of the firm structure, which took place at a comparatively early date, was helped by the fact that the medallion as a mode of representation was an integral part of the Hellenistic inheritance which had to some extent withstood the influence of the strict mediæval system and readily reasserted itself when this influence showed the first sign of relaxing.

BYZANTINE MOSAIC DECORATION

FORMAL UNITY

In the three zones of the Byzantine church building the decoration is differentiated as regards both the idea of action expressed in the images and the conception of the images themselves. An eternal and holy presence is manifest in the paintings of the highest zone, to the suppression of all narrative and transient elements. There, the timeless dogma is offered to the contemplation of the beholder. The decoration of this zone may be said to consist neither of "pictures", in the normal sense of the word, nor of single figures. What is given is new and specifically Byzantine compositional units in physical space, not depicting but constituting magical realities: a sacred world, beyond time and causality, admitting the beholder not only to the vision but to the magical presence of the Holy. In the middle zone the timeless and the historical elements are combined in accordance with the peculiar character of the festival icon, which simultaneously depicts an historical event and marks a station in the ever-revolving cycle of the holy year. In this zone the pictures are so composed as to offer a flat image to the beholder while not losing the character of a spatial receptacle for the holy figures. The pictures are enriched with single traits which help to complete the narrative. The Nativity, for instance, often contains secondary scenes, such as the Journey and the Adoration of the Magi, the Annunciation to the Shepherds and the bathing of the new-born Child. But these details are not arranged with regard to continuity in space or time. Their relation to the main theme is in thought only; they complete the principal scene inasmuch as they include all the motifs connected with it in the Gospel narrative.[49] Isolated as holy icons and, at the same time, related to their neighbours as parts of the evangelical cycle, the paintings in the second zone are half picture and half spatial reality, half actual scene and half timeless representation. But in the lowest stratum of the church, in the third zone, are found neither narrative scenes nor dogmatic representations. The guiding thought in this part of the decoration—the communion of All Saints in the Church—is realized only in the sum of all the single figures. They are parts of a vast image whose frame is provided by the building of the church as a whole.

§ Space

The images of middle Byzantine church decoration are related to each other and welded into a unified whole not by theological and iconographical concepts alone, but also by formal means which create an all-embracing and homogeneous optical unity. The optical principles used for this purpose aim, broadly, at eliminating the diminution and deformation of perspective. The most obvious of them is the "staggering" in size of the images and figures according to their

height or distance from the beholder's viewpoint. There is some difficulty, it is true, in appraising the part played by this anti-perspective optic in the general staggering of size, which extends from the lower reaches upwards to the zenith of the cupola, because the staggering was in large degree due to the existence in Byzantine iconography of a direct ratio between sanctity and height as well as between sanctity and size. Furthermore, several different scales and proportions exist within the variegated system of the decoration: one for festival icons, another for standing figures, yet another for medallions, and so on. The optical differentiations due to anti-perspective devices can be clearly ascertained, therefore, only within each of these categories separately (15). The modern beholder, it is true, has the feeling that the ratio of "stagger" throughout the church is somewhat excessive and that the pictures in the upper zones are certainly larger than he would expect; but this feeling is too vague to afford a firm basis for conclusions about the part played by the specifically anti-perspective enlargement. Fortunately, however, there are cases in Byzantine decorations where images of equal importance and dignity, belonging to a single homogeneous cycle, were placed one above another for reasons of space. Any differences of scale between the parts of such a cycle can have nothing to do with iconographic differentiation, and must be explained as an optical device. This device was used above all in narrow parts of the building, as, for instance, on the walls of the side chapels of Monreale (Lives of SS. Peter and Paul), which cannot be seen from a normal angle but only from almost immediately below. If the walls were divided into layers of equal height, the upper ones would appear to be smaller, narrower than the lower. Staggered as in reality they are, they appear to the beholder as of equal size (20). This expedient is used in narrow spaces only; but when a long-distance view is possible and the effects of foreshortening do not occur of necessity, then the superimposed layers retain their equal heights.

The Byzantine principle of staggering the sizes of superimposed layers for anti-perspective reasons was not practised in the West. There, walls were either divided into layers of equal depth or consisted of strips arranged in accordance with an organic idea of growth, with the heaviest and broadest layer at the bottom, the lightest and narrowest at the top. Here we meet with a fundamental difference between the two conceptions of decoration: the Western architectonic and organic, illustrating the ideas of growth, weight and poise; the Byzantine optical and hierarchical, with the primary aim of preserving the essential size of the image from optical distortion.

But the tendency towards eliminating the effects of perspective foreshortening goes further than mere staggering of size. The proportions of single figures were also affected by this process (21). Middle Byzantine mosaic figures are often described in studies on Byzantine paintings as "elongated", "ascetic", "emaciated", and so on. They have, indeed, all these characteristics (from which modern authors too often proceed to draw conclusions as to the "psychology of style"), if they

are viewed or photographed from a level from which they were not meant to be seen—figures in cupolas from high scaffolds, for instance. In reality, however, the proportions of these figures are in tune with the point of view of the beholder. Seen from below they appear in normal proportions—that is, they appeared so to the Byzantine beholder who, from what we know of his reactions, must have registered the optical facts in a more straightforward way than the modern spectator, who is apt to see more analytically and to correct perspective distortions automatically if he has a chance to measure distances and angles.[50] In Byzantine decorations the painters themselves anticipated the distortions which would appear to the view from below and corrected them by elongating the figures accordingly. They also adjusted the proportions of the figures with regard to the curved surfaces on which they were painted. Thus the legs and lower parts of figures in cupolas or in vaults were elongated more than the upper parts, because the upper parts, being placed in the more curved sections of the cupolas or vaults and consequently on surfaces which stand approximately at an angle of ninety degrees to the optical axis, suffer less from distortion than do the lower parts in the more vertical outer ring of the cupola or the more vertical parts of the vault. In this connection it is interesting to note that the seated Apostles in the Pentecost cupola of Hosios Lukas show hardly any of these preventive distortions. The reason is that they were not meant to be seen from immediately beneath, being placed just above the sanctuary, which was generally inaccessible to beholders; they can be seen from further back (west) only, at a flatter angle, and there they present themselves in a normal undistorted view. That this cupola really belongs, optically speaking, to the naos is also evident from the fact that it is surrounded by heavy framework in the east, south and north alone, and remains "open" to the view only from the west. Unbroken golden ground guides the glance of the beholder smoothly from west to east, without any cæsura which would indicate a change of the viewpoint.

In apsidal mosaics another kind of preventive distortion is to be found. Figures on the outer edges of the semicylindrical niches of the main apses, for instance, would appear to the beholder who can see them from the centre of the church only (a nearer view being barred by the iconostasis and the inaccessibility of the sanctuary) much reduced in breadth and therefore abnormally slender. To counteract this effect of foreshortening, such figures were made broader and more "thick-set" than their neighbours which could be seen at a more normal angle (22).[51] In cases in which it was iconographically possible and which admitted of both distant and near views, the corrective broadening of figures on the edges of semicircular niches was effected by broadly expanding postures, which give the additional breadth required without spoiling the normal appearance of the figures for the near view. Hosios Lukas offers striking examples of this solution, in the two semicircular niches of the narthex, with the Washing of the Feet and the Doubting of Thomas.[52] The figure (St. Andrew?)

at the right edge of the former is represented as walking into the picture from the right, in an ample stride, with garments spread out in breadth and accentuated by broadening motives round shoulders and hips. The Apostle (St. Luke) at the left edge of the niche is depicted in the act of unbinding his sandals, resting one foot on a chair and thereby assuming a very broad pose (23). In the Doubting of Thomas the figure at the extreme left is made to look broader than the preceding ones by the simple expedient of showing it whole, whereas the others are partially hidden by the backs of their neighbours (24).

The broadening of figures on the edges of apses which can only be seen at an oblique angle occurs once again in the development of monumental painting, namely in the Italian High Renaissance, when similar concepts were revived, probably, not without knowledge of Byzantine solutions. One of the chief of these later examples is the sketches by Sebastiano del Piombo for the fresco decoration of the first chapel to the right in San Pietro in Montorio in Rome.[53] The tradition may in this case have been handed down by Venetian art.

Other and more complicated oblique preventive distortions are to be found in the figures and faces on the barrel vaults of sanctuaries, like those of the Angels in the sanctuary of the Haghia Sophia in Constantinople.[54] These figures look badly distorted from the near view (25), but quite normal and undistorted if viewed at an oblique angle from below. Even the technical processes took account of the "correct" point of view; the cubes, for instance, which make up the mosaic tympanum above the main door in the narrow narthex of Haghia Sophia, visible only at a steep angle from below, are set obliquely into the wall so as to have their surfaces standing normally (at an angle of 90 degrees) to the optic axis of the spectator.[55]

Underlying these corrective distortions and technical processes is a principle closely akin to the dominating principle of middle Byzantine iconography: the picture is drawn into a close relationship to the beholder. Every care is taken that it should appear to him undistorted; and a very subtle system of perspective lore was evolved and used to achieve this aim. This lore, however, never became a systematic science as it did in the Western Renaissance; it always remained a purely artistic and formal principle without any codified laws. It did not aim at rigid consistency, but it had the effect of establishing formal unity throughout the main parts of the decoration. Byzantine "perspective" might be described as "negative" perspective. It takes into account the space which surrounds, and is enclosed by, the image and which intervenes between the image and the beholder; and it aims at eliminating the perspective effects of this space on the beholder's vision. The Western artist, by contrast, subjected his figures to the laws of perspective in order to make them appear as real bodies seen from below, with all the distortions which this view brings about. He created an illusion of space, whereas the Byzantine artist aimed at eliminating the optical accidents of space. The result of the Western practice is a picture

of reality; the aim of the Byzantine artist was to preserve the reality of the image. The Byzantine image escaped the casualness and haphazardness of spatial projection; it always remained an "image", a holy icon, without any admixture of earthly realism. By eliminating the perspective effects of space the Byzantine artist was able to bring out the emotional values of height and remoteness in their purest form. The beholder of Byzantine decorations, who sees the image undistorted in spite of the great height at which it appears, feels lifted up to its level, high above the ground, to which the beholder of Western decorations is firmly fixed—pressed down, as it were, by the "frog-perspective" of the *di sotto in sù*. In this way, not only spiritually but optically also, the Byzantine beholder was received into the heavenly sphere of the holiest icons; he participated in the sacred events, he was admitted to the holy places of which the icons are the magical counterparts. Moving along the main axes of the church and viewing thence the holy icons above him he was able to perform a symbolic pilgrimage. He was not fixed to one point like the beholder of Western decorations, whose illusionistic and perspective constructions seem to "stand up" from one particular viewpoint only; as he moved along the liturgical axes of the church the rhythm of the cupolas and vaults moved with him, and the icons came to life without losing their iconic character.

Only those parts of the building which the Byzantine beholder was not allowed to enter were presented to him as fixed projections. But even these fixed projections are connected with the rest and take part in the movement. The beholder's glance is led from one part to the other, round the conch of the apse and down the semicircular walls. Everything in the vaulted parts of the building is gently connected with its neighbouring forms, no hard limits or accents stop the wandering gaze.[56] Even the edges are rounded so as to lead the eye from one wall to another. That this is no mere impression of the modern beholder projected into the past, but a conscious achievement of Byzantine decorative art, is made quite clear by those documents of contemporary æsthetic appreciation, middle Byzantine Ekphraseis.[57] These Ekphraseis stress again and again that the glance of the beholder is not to rest on one part of the decoration, but must wander on in ever-changing directions. The very words of these descriptions, in verse and prose alike, suggest a dynamic movement round the centre of the church. Gregory of Nazianzus speaks of the church built by his father as "a temple returning into itself on eight columns", as "radiating downwards from the cupola" and as being "surrounded by ambulatories". Procopius, in his description of the Haghia Sophia, underlines the fact that the eye of the beholder is not allowed to rest on any of the parts of the church but as soon as it has settled on one is attracted by the next. Photius, in his Encomium of the Nea, is even more explicit: "The sanctuary seems to revolve round the beholder; the multiplicity of the view forces him to turn round and round, and this turning of his is imputed by his imagination to the building itself."

There is another point on which the contemporary Ekphraseis offer elucidating comment. The descriptions of pictorial decorations are couched in terms which suggest the presence in reality of the scenes and persons depicted. The Encomiasts did not write: "Here you see depicted how Christ was crucified", and so on; they said: "Here Christ is crucified, here is Golgotha, there Bethlehem". The spell of magical reality dictated the words. This magical reality of the decoration which, formally speaking, expressed itself in the spatial character of the whole and in the life imparted to it by the movement of the beholder in space, cannot be rendered satisfactorily by photographs. Byzantine church decorations reveal their supreme qualities only in their own *ambiente*, in the space in and for which they were created.

§ Light

To this spatial *ambiente* also belongs the actual light. Just as the Byzantine decorator did not represent space but made use of it by including it in his icons, just as he took into account the intervening space between the icon and the beholder, so he never represented or depicted light as coming from a distinct source, but used real light in the icons and allowed for its effects in the space between the picture and the beholder's eye in order to counteract its disturbing influences. The first resource is illustrated by the inclusion of shining and radiating material in the picture, especially gold, which is so arranged as not only to produce a rich coloristic effect but also to light the spatial icon. The deep niches under the cupolas of Hosios Lukas and Daphni are effectively lit by highlights appearing in the apices (4, 10b). These radiant highlights separate Mary from the Angel in the Annunciation and they surround the Divine Child in the Nativity, the landscape background of which is interspersed with gold in those places where the golden cubes collect the light in the focal region of the niche. Generally speaking, colours indicating solid forms were interspersed with golden cubes only in places where the gold is apt to shine owing to the curving of the surface. This economy contrasts strongly with the indiscriminate use of golden highlights in the colonial sphere of Byzantine art. In Byzantium proper the golden cubes stress only the formal and iconographic foci. The centres of iconographic interest and those of formal composition, which in classical Byzantine art are identical, are stressed by the strongest light. It surrounds the main figures as with a halo of sanctity. The reflexions shift with the movement of the beholder and with the course of the sun, but thanks to the nature of the spatial receptacles of the icons they always play round the main figures. At night, the light of the candles and lamps creates fitful reflexions on the golden surface from which the figures stand out in significant silhouette.

It is not only the derivative light of gold which is included and used in Byzantine icons, but also the more direct light of windows which open in the

grand icons themselves, in the cupolas and apses. The effects of this were noticed—as the Ekphraseis again prove—and reckoned with.[58] The same was true of the light conditions under which the icon is seen by the beholder. Regard was had to these conditions not only in the emplacement, but also in the shaping and colouring of the icons. Hosios Lukas provides an especially interesting example. An icon of Christ on one of the secondary vaults (26), whose forms would have been swallowed up by the splendour of the surrounding golden ground lit by a neighbouring window, was executed in a singular kind of modelling which, in spite of the almost blinding radiance around, brings out forcibly the vigorous relief of the face. This special kind of modelling recalls the inverted tonality of photographic negatives: the face itself is comparatively dark, with greenish highlights which contrast strongly with the reddish brown of the main features. Yet the highlights do not appear on the raised motifs of the face-relief, in the places where one would expect to find them in normal modelling; they do not belong to the same conception of lighting as, say, the footlights in a theatre. Their arrangement is altogether unrealistic. They are concentrated in the grooves and furrows of the facial relief—almost, in fact, in those places where one would expect to find the deepest shadows. But these lights delineate the pattern of the face more clearly and forcibly than a normal modelling could have done. It is as if light were breaking through the features, as if it radiated through the relief at its seemingly lowest points. The arabesque of these highlights is strong enough to bring out the features despite the radiance of the golden ground, whose disturbing effect is further heightened by the fact that only one half of the vault is brilliantly lit, whereas the other is always in dim shadow. Three more images in the same compartment (Mary and two angels) are similarly treated. That the singular conditions of lighting were indeed the reason for this choice of extraordinary means becomes quite clear if the medallion of Christ already described is compared with a corresponding image of Christ in the other transept, set probably by the same artist. In this the light is much quieter and the artist could, in fact did, employ the normal positive modelling with the shading of the face from light to dark (27, a, b).

Quite apart from its practical value as clarifying the form, the inverted modelling of the first of these two icons produces a peculiar effect which, at least to the modern beholder, has something mysterious and even "magical" (in the modern sense of the word) about it. Later Byzantine painters were quick to perceive and employ this effect. The inverted modelling with flashing highlights played indeed an important part in Palæologan and especially in Russian painting.[59] As happened so often in the course of the development of Byzantine art, a particular practice, employed by earlier artists only under particular conditions, was later seized upon as a means of conveying a certain expressive quality—a by-product originally, but now sought after for its own sake. A purely optical technique became a vehicle of expression.

THE CLASSICAL SYSTEM

§ Colour

In other cases the artists regulated the effect of too much or too little light by the use of darker or lighter shades of colour.[60] Although the basic colours were more or less fixed by iconographical rules,[61] there was always ample room for differentiation in the shades actually employed. In choosing these the artists took the spatial conditions into account in order to achieve clearness of form and thought. The general arrangement of tones follows the partition of the building into three zones. Thus the lightest hues are to be found in the uppermost zone of the cupolas and high vaults, where tinged white and gold preponderate. The light colours correspond to the idea of immaterial heavenly splendour, but they are at the same time necessary in order to bring out the modelled forms at the great height, surrounded as these are by the colour-destroying, glittering gold. Darker shades would tend to produce mere silhouettes, opaque islands in the sea of gold. The next zone, that of the festival cycle, admits of a greater wealth of colour. Even so, the colours here have a bloom and lightness, and dark and heavy tones are excluded. These tones do, however, dominate the lowest layer, that of the Saints, where dark brown, dark green, deep blue and violet make up the main scale, fitting in well with the tones of the marble lining. Thus the arrangement of colours helps to underline the hierarchical structure of the whole decoration.

§ Modelling Technique

The technique of modelling is subject to a differentiation resembling that observed in the realm of colour. Writers on Byzantine art have repeatedly pointed out that several different "styles" (that is, different techniques of modelling) are frequently to be found in a single and otherwise homogeneous mosaic decoration, some of the images showing continuously graded modelling while others are accentuated by hard and sharp contrasts which break up the draperies and often even the faces of the figures (28). Images of the latter kind seem to be composed of splintery, disconnected fragments of forms; the bodies seem deeply furrowed by cuts and dark holes. It has been surmised that this style belongs to an earlier phase in the evolution of Byzantine art, that it is "older" than the graded modelling and that figures executed in this way are either earlier in fact or at least deliberately "archaizing". In truth, however, the two "styles", with all the intermediary forms, are strictly contemporary as regards not only historical date but also stylistic phase.

The application of different techniques in one single decoration was made necessary by the great differences in size between the single icons and the great variety of optical conditions. Graded modelling with cubes of given sizes and of a limited gamut of tones is technically and æsthetically advisable only within

a certain, not too wide, range of size. There are difficulties, for instance, when the forms are under "normal" size, because in this case there is no room for deploying the whole necessary range of gradation. To solve this difficulty the middle Byzantine artists of the classical period had recourse to a peculiar technique of alternating light and dark cubes within one single row, achieving by this chessboard-like mingling of light and dark the rapid transition from light to shade called for by the smallness of the forms.[62] This could be done successfully, however, only if the image so treated was not accessible to close scrutiny and if the mosaicist could rely on the effect of the mingling of the alternating tones in the eye of the beholder (29).

Although the mosaicist could thus solve the problem of undersized forms by shortening the range of tones, he could not use the opposite method in the case of oversized images. The limited scale of tones at his disposal did not permit of the modelling of large-scale forms—a fold, for instance—by means of a continuous succession of shades. He had only four or five different shades of a single colour. If more than two rows of each shade were required to fill the allotted space, the effect would be one, not of continuous modelling, but of a "striped" surface (30).[63] If, on the other hand, the mosaicist used the normal succession of one or two rows of each shade, he would quickly have exhausted his whole range of shades near the edges of large-scale forms, and in the middle parts he would be left with a uniformly light (or, as the case might be, dark) tone. The resulting impression would have been one of a very flat relief intersected by sharp and narrow grooves. The artist could, it is true, make the single component forms, such as folds, as small as possible, and this was actually done in the late twelfth century, as in the large half-figure of Christ in the apse of Monreale (31).[64] But this invariably entailed a loss of monumental greatness. The total figure, which is now beyond question more than lifesize, appears to be covered with, or composed of, a minute network of folds, or rather wrinkles, which look petty. The organic relation in size between the total and the single constituent forms is lost. So the mosaicists of the classical period found quite another solution for the problem. They achieved the effect of plastic relief, which could not be obtained by normal and continuous modelling, by the abrupt juxtaposition of contrasting shades of light and dark without any attempt at continuity. In this way they effected a treatment of the surface which, seen from a distance, especially in the scanty light of a Byzantine church, suggests a relief more powerful than could be produced in the normal way. Ultimately, of course, this practice was rooted in late antique illusionism. It demanded from the beholder a faculty of seeing in an illusionistic way, of himself supplying the transitional shades and so connecting the contrasting tones with each other.

Although at the beginning this technique was a more or less optical device, it took on an iconographical significance in the course of time. The reason for this lay in the fact that the figures so treated (that is, the largest and most distant

images in the cupolas and the apses) were at the same time the most sacred, thanks to the parallelism between remoteness (in height or in distance from west to east) and sacredness. But the holiest, largest and remotest of these images were, of course, the Pantocrator in the zenith of the cupola and the Virgin in the conch of the main apse, and so it came about that the abrupt manner of modelling was gradually associated iconographically with the holiest images—more especially with those of Christ and the Virgin. From the twelfth century onwards these images retained their abrupt modelling even when there was no technical or optical need for its application, even, that is, in small portable icons and in miniatures. That the abrupt modelling was originally an optical device in spatial decoration was gradually forgotten, and it became more and more a mark of distinction, of sanctity—a process probably fostered by the abstract and anti-naturalistic character of the broken forms themselves. For these forms were apt to be filled with the expressive meaning of unearthly holiness. If in Byzantine art forms offered themselves to expressive interpretation, we may be certain that the opportunity was accepted, especially if it favoured those spiritual qualities towards which all religious art in Byzantium tended. It must be added that, on Byzantine soil, the original optical significance of the broken modelling was sometimes rediscovered, especially in periods when the sources of antique illusionism began to flow again, as they did, for instance, in the Palæologan era. The mosaics of the Kahrieh Djami in Constantinople[65] (32b, 33) or the frescoes in the Cathedral of the Transfiguration at Novgorod (1379)[66] are examples in which both the illusionistic significance and the expressive value of the broken modelling were combined. It is nevertheless difficult to realize that the golden network which forms the draperies in Italian Dugento panels is, in the last analysis, a legacy of Hellenistic illusionism (32a).

The translation of an optical device into an element of hieratic expressionism which occurred in the course of the twelfth century is quite in keeping with the general development of twelfth-century art in Byzantium. Not only did Hellenistic illusionism cease to be understood: the whole optical system of church decoration was gradually losing its consistency at that time, one of the most crucial periods in the development of Byzantine art.

HISTORY OF THE MIDDLE
BYZANTINE SYSTEM

HISTORY OF THE MIDDLE BYZANTINE SYSTEM

ITS SOURCES

§ Greek

THE monumental painting of the middle period was one of the purest of the creations of the Byzantine spirit. The subtle art, easier to appreciate than to analyse, by which the various parts were welded into a single macroscopic whole recalls classical Greek devices such as the curvatures of the Doric temple[1] or the rhythmical symmetries in the construction of the Attic drama.[2] Like these, too, it for a long time escaped analysis. The devices of the Byzantine painters which went furthest to achieve an optical union between the individual parts, the anti-perspective corrections, can be traced back to Greek theorists of a period which was at least the heir of classical antiquity. It was the Neoplatonic tradition which, if not the source, was certainly the upholder of the tradition of anti-perspective lore. The fifth-century philosopher Proclus[3] defined perspective (*skenographia*) as the art of preventing an image from appearing distorted by the distance or the height of its emplacement. It is characteristic that this lore, originally evolved for the use of monumental sculpture, should have been applied in middle Byzantine art to monumental painting, which, as pointed out above, took the place of sculpture in the round after the Iconoclastic controversy. But it is difficult to say whether the application of anti-perspective corrections in the ninth century was due to a direct transmission of theory or to a spontaneous renaissance in the artistic sphere.

§ Oriental

The Greek element was, however, only one of several factors in the new middle Byzantine system. It played the part of a formal artistic means designed to achieve optical unity. But the Byzantine monumental system is above all a spiritual affair. The central conceptions of the system may be summarized as the identity of the icon with its prototype, the reality of the icon in the space of the naos, and its venerability—conceptions which may all be described as "magical realism". This magical realism, which may have had its roots in the sculptured idol, first appeared in monumental painting in the religious art of

Eastern Hellenism, probably in Parthian or, more generally, Iranian art.[4] The question is bound up with that of the appearance of frontality in religious painting. The original home of hieratic frontality, as the only convincing method of representing magical presence, is sought by most scholars in Northern Mesopotamia or in Iran.[5] The Parthians seem at least to have played an important part in disseminating it throughout the Near East. In any case, the earliest complete representation in painting not only of the God but also of priests and donors in frontal attitudes is to be found in Mesopotamia, at Dura-Europos.[6] The figures of the priest Konon and his bystanders at Dura have been rightly called "Oriental forerunners of Byzantine painting",[7] and the widespread influence of Parthian art in the Near East, especially in Syria and Anatolia, seems to have been responsible for the sovereignty, in Byzantine painting, of the frontal figure.[8] The Oriental factor in the formation of Byzantine art brought with it not only frontality itself, with its various consequences— the handicapped gestures, hanging feet, etc.—but also its corollary, frontality in spatial projection: the elimination of depth behind the picture plane, the simplicity and distinctness of outline, the flat relief of the interior design tending towards linearism and, perhaps most important of all, the communication of the painted figures with the real space in front of them. This communication is brought about, among other means, by making the feet of the figures overstep the lower boundary line of the picture plane. The fact that the frontal figures surround the room on all sides makes the empty space in the middle seem their real domain. It needed only the driving force of a central idea to elaborate this magic realism of Parthian art into the spatial cosmology of the Byzantine church. This central idea was furnished by the theory of representation which grew out of the Iconoclastic controversy.

ITS DEVELOPMENT

These factors, Greek and Oriental respectively, are the main roots of the middle Byzantine system. But the roots are not everything; they do not explain the process. In this case, as with all complicated phenomena, the historian who considers the roots only is in danger of oversimplification. Nothing could be falser than to imagine a historical process as cognate with a simple chemical reaction; yet such seems to be the common practice of the Byzantine archæologist. The dialectical method holds almost unbroken sway over the historiography of Byzantine art. Some convenient polarity is seized upon—Hellas and the Orient, as with Strzygowski, or, in a more modernized and sophisticated form, Atticism and Alexandrianism as with Morey—and put forward to explain everything. The polar factors—thesis and antithesis—are seen as local, national, or racial forces, and the synthesis is represented as the result of their interaction.

This view could be countered by showing that more than two factors entered into the process and that the polar conception consequently oversimplifies matters. But even this would only serve to elaborate one side of the equation without solving it. We must not forget that in every evolution a continually changing factor enters the combination—the totality of the process itself, the sum of forces which constitute the truly creative element and their ever-changing equilibrium. We cannot hope to explain this ever-changing element. All we can do, if we are to avoid the common error of hypostasizing certain arbitrary elements in what is a highly complicated process of evolution and then treating them as the operative automatic causes in a mechanical series, is to describe the evolution itself as faithfully as possible. This can be done here in rough outline only.

§ Early Christian Period

When, in the fourth century, Christian churches were first given monumental decorations, their elements were taken over from other spheres. Patterns evolved in the art of pavement mosaics were applied to vaults (34), as in the ring-vault of Sta. Costanza at Rome;[9] scenic representations with the character and scale of easel paintings or of magnified miniatures were affixed to the walls, sometimes hardly visible from below, as in the nave of Sta. Maria Maggiore; and even cupolas (Sta. Costanza) and apses (Sta. Pudenziana) were filled with pictures bearing little relation to the shape of the dome or the conch. There is hardly any consistent scheme of decoration to be observed in these early buildings, either formally or spiritually. There is hesitation between the symbol— a relic of the late antique underground existence of the early church—and the straightforward narrative. The mosaics or frescoes do not themselves make up the decoration; they are secondary elements fitted into a pre-existing system of articulations which employs architectural and plastic motifs in order to give the walls the character of "inner façades". Formally speaking, the mosaics set into the framework of these façade-structures are little more than patches of colour which enrich the surfaces without seriously affecting their preponderant artistic character of articulated reliefs. The two main walls of the nave—which, after the apse, bear most of the decoration—are as independent of each other as the façades of two buildings of similar character placed face to face. The open-roofed architecture of the basilica does not make for a formal connection between the two opposite walls. The beholder is hardly made conscious of the fact that the two walls are the confines of an enclosed space. Nothing induces him to look from one wall to the other; he follows the simple thread of the narrative in the series of framed pictures, their succession leading him on the left wall from west to east and on the right wall from east to west, as if he were following the arcades of an open courtyard or cloisters.

BYZANTINE MOSAIC DECORATION

§ Fifth Century and Justinianic Period

In the course of the fifth century, however, new ideas emerged. The simple sequence of historical scenes began to give place to a new and more complicated conception, that of the concordance of the Old and New Testaments. The two rows of pictures on the opposite walls of the nave are now connected not only along their length, from left to right, in the direction of the unfolding of the story, but also across the nave in accordance with their relation as types and anti-types. The beholder has to look from one wall to the other; his glance has to traverse the nave, shifting from left to right and, at the same time, progressing from west to east. Thus he is made aware of the space of the nave. This was the time when efforts were made to shape the interior of the basilica as a homogeneous spatial unit by introducing the barrel-vault connecting the two main walls. The mosaic spreads over the greater part of the inner surface, often covering it entirely; it takes on the character of a continuous incrustation. The architectural and plastic articulations, the relief of the walls, disappear, and new articulations are introduced in the mosaic surface itself. Elaborate motifs in mosaic serve as frames for larger panels which, individually, give up a good deal of the self-contained character of easel pictures, and are subordinated to a wider, formal and iconographical coherence. All those parts of the walls and vaults which are not taken up by figurative compositions or framework are filled with ornamental patterns. The three different categories of décor—panels, frames, and filling patterns—are judiciously balanced so as to build up a formal organism dependent on the functional character of the several architectonic parts. Rising walls, lunettes and apses, for instance, are usually set aside for framed figurative compositions, while vaults are mostly filled with conventional patterns. Even the patterns themselves tend to reflect the functionalism of the architecture. The amorphous all-over patterns of the fourth century yield to motifs illustrating the ideas of growth, spreading, winding, and so on. In the figurative panels the figures become larger and less encumbered with the details of setting and landscape which in illusionistic fourth-century ensembles had all but swallowed them up. They stand boldly outlined against the dark blue or golden ground. Formally and iconographically they seem to belong not only to their immediate context but to the entire scheme of the decoration. The figures of the apses especially begin to dominate the whole of the interior. The beholder's eye is led from figure to figure by a subtle movement or rhythm. A cupola, for instance, is now composed as a homogeneous unit and at the same time connected with the rest of the decoration (36, 38).

The Apostles in the Baptistery of Bishop Neon at Ravenna (449–452),[10] for instance, are represented as large-size figures walking round the cupola in two opposed rows, led by St. Peter and St. Paul. Seen, however, from the point of view of middle Byzantine cupola decoration, the composition falls short of com-

46

plete consistency. The movement of the two rows of Apostles has no real aim; it does not lead round the whole of the cupola, but comes to a standstill for no apparent reason at the axis between the two leading figures. Between the Apostles are ornamental candelabra of floral design which admit of no iconographic interpretation. Furthermore, there is no formal or factual connection between the Apostles and the framed picture of the Baptism of Christ in the zenith of the cupola. This medallion is fitted in as an "emblema" was fitted into the elaborate framework of a late antique mosaic pavement. The scale is different, and the medallion is separated from the Apostles by hanging curtains (*vela*) which, by stressing the *Opaeon* character of the central motif, place it in a category different from that of the Apostles. Below, outside the Apostles, is a further ring of architecturally designed framework. It is as if the fifth-century artist had been obsessed by the idea of framing. But the formal character of this outer frame goes to show that the composition of the whole was not designed for a cupola at all. The outer ring is made up of sections of basilicas (with an apse and altar or throne flanked by aisles), and its formal effect is that of an arcade stretching under the Apostles' feet. The whole decorative system of the cupola is nothing but a transplantation of the decorative system of a basilica wall, including the arcade of the nave. This also explains the inconsistency of the central medallion, which had no place in the basilican system. The fifth century was still an age of basilica decoration. To decorate a cupola, a basilican nave-decoration scheme had to be adapted to the new conditions, and the difficulties of the adaptation can still be seen.

The sixth century improved on this scheme. The Baptistery of the Arians[11] in Ravenna (37) is a step towards the rationalizing and functionalizing of the décor. The candelabra between the Apostles were changed into palm-trees and a significant motif was placed between the two converging rows of Apostles headed by Peter and Paul, namely, the Hetoimasia, which gives the procession a new meaning. The Vela above have disappeared, and the scale of the central medallion is nearer to that of the surrounding Apostles than was the case in the Baptistery of Neon, although the orientation of medallion and cupola ring is different, a result of a break in the execution. Finally, the outer ring of basilican motifs, the most tell-tale sign of the ultimate derivation of the whole layout, has been dropped.

No monument of the fifth century survives which could be regarded as the direct basilican prototype of the two Baptistery cupolas. But the decoration of the nave of S. Apollinare Nuovo at Ravenna,[12] though dating more than half a century later than the Neon Baptistery, gives some idea of what this prototype must have looked like. The mosaics themselves are of the sixth century, and, though mutilated and set in at least two different periods, they offer the grandest example of consistent functional decoration of a basilican interior (35). Two long rows of figures, male on the one side and female on the other, are represented

on the two opposing walls of the nave in ceremonial procession towards the eastern end, where Mary and Christ are enthroned to receive their homage. These martyrs and holy women, who, issuing from Classe and Ravenna, move towards the goal of the apse, are the ideal representatives of the worshippers, whose spiritual attitude they exemplify. At the same time they embody the noble formal rhythm of the arcaded columns with their measured procession towards the apse. The statuesque figures of prophets above, between the windows, accentuate this rhythm. Surmounted as they are by conchs in flat mosaic, these figures perpetuate elements of an earlier, originally plastic, conception, as carried out, for instance, in the stucco reliefs of the Neon Baptistery (38). The mosaic decoration of the sixth century has finally fused together all the other decorative techniques, still occasionally used side by side in fifth-century decorations. Plastic elements are now no longer used, no purely architectural articulations are left. The whole walls are given over to mosaic. The scenes from the Life of Christ above the windows, though remnants of an earlier illustrative system of small narrative pictures, are arranged in two iconographically opposed cycles, the one illustrating the Teaching, the other the Passion of Christ—both following the sequence of the Easter pericopes of the Ravenna church.[13]

There is no well-preserved sixth-century decoration of a centralized building to set beside the ideal longitudinal décor of S. Apollinare Nuovo. What we know of the decoration of the Church of the Apostles at Constantinople does not give us an undisputedly clear picture of its Justinianic shape.[14] If we strip it of all those elements which may be supposed to belong to the ninth or even to the twelfth century (the Pantocrator in the central cupola, for instance) we are left with a purely narrative scheme which probably to a large extent perpetuated the decoration of the Constantinian basilica of the Apostles, and is, therefore, characteristic of one side only of Justinianic art—i.e. of the archaizing trend which harks back to the Constantinian epoch.[15] To form an opinion of the new and progressive trends in the decoration of centralized buildings in the sixth century, we have to content ourselves with small provincial monuments (which might be misleading as evidences of the tendencies of Constantinopolitan art) or with fragmentary decorations.

Of these latter the most important is San Vitale at Ravenna,[16] where only the mosaic decoration of the presbytery has been completely preserved (40, 41). Here the structural function of the architecture is fully brought out by the mosaics, which, except for a socle, cover the whole interior. Lunettes, spandrels, rising walls, arches, niches and vaults are effectively differentiated by varying types of décor. The groins of the rising vault, for instance, are accentuated by floral stems, while figures of Angels, impersonating the strength of the upholding structure, support the central medallion. The function of the triangles of the vault is aptly illustrated by acanthus scrolls which spread out to fill them. Conventional motifs occupy large spaces in accordance with the architectural charac-

ter of the decorated parts, whether carrying, rising, hanging or filling. The functional rôles are interpreted with subtle feeling. There is even, at times, a trace of something new which transcends the æsthetic rules of mere functional decoration. Thus the figures in the two dedicatory images of Justinian and Theodora are represented as actually entering the church from the sides and walking towards the altar. In this there is a feeling for the significance of the position of the figures in the physical space of the church. But this feeling is not consistently expressed throughout the whole. Each part is treated almost independently, the main unifying element being the colour and a sense of the functional fitness of the single motif in its allotted space. There is no uniform optical system, no uniformity or even consistent progression or gradation of scale. The size of the figures and other motifs is dictated solely by the sizes of the various panels they occupy; scenes, isolated figures, emblems and floral patterns may occur side by side in a single panel. There is, generally speaking, a profusion of floral motifs throughout the decoration, which indicates that uppermost in the minds of the artists was the idea of decorating the architecture, not the intention of creating by pictorial means a self-contained system of religious thought in images. Very characteristic of Justinianic decoration is the use of semi-ornamental motifs which belong neither to the world of representation nor to that of purely ornamental design, as for instance the flying Angels who carry the medallions with the Cross or the standing ones who uphold the central medallion with the Lamb. This intermediary kind of figural décor would be unthinkable in the magical realism of the middle Byzantine system. These motifs are survivals of Hellenistic decoration. Their use is bound up with the political and cultural *renovatio* of the idea of the Roman empire. They are Victories in Christian garb.

In Justinianic decorations, moreover, there is no strict iconographical scheme to which every detail is subjected. Attempts at finding such schemes in Justinianic churches have failed, not from any lack of ingenuity on the part of the scholars who have made these attempts,[17] but because the iconographical systems of these decorations are too loose to admit of consistent interpretation. The individual items which make up the decoration of the presbytery of San Vitale, for instance, namely, Antitypes of the Eucharist, scenes from the Life of Moses, Prophets, Evangelists, Angels, Saints, dedicatory images, Christ and His cortège in the conch, animals and floral motifs, can hardly be brought under one heading in the sense in which every single part in middle Byzantine decorations was an element in a significant and consistent organism. Other Justinianic and post-Justinianic examples seem even more haphazard in their combination of widely different subject-matter. In Hosios Demetrios at Salonica, for instance, there occur purely haphazard juxtapositions of dedicatory images without any governing programme. Here the dominating idea in each case was rather the dedicatory destination of the individual building, or even picture,

than a central and all-governing scheme of iconography which, *mutatis mutandis*, could be applied to any church.

§ Post-Justinianic Period

What little we know of Byzantine decoration in the seventh and early eighth centuries seems to imply that the Justinianic system, erected as it was on the basis of functional fitness with regard to the architecture, gradually lost what formal and iconographical consistency it possessed. There is, however, one characteristic tendency which, though already present in the preceding centuries, seems to emerge more and more clearly in the course of the later sixth, the seventh and the beginning of the eighth. This is the idea of strict frontality as expressing the awful presence of the sacred Persons and as furnishing a means of conversing with them through the image. The figures in the mosaics of S. Apollinare in Classe[18] are renouncing the variety of slight movements and turnings in order to become rigidly frontal even in scenic representations. And the seventh-century figures in Hosios Demetrios at Salonica,[19] represented in flat, symmetrical frontality, give full embodiment to this idea. The realization of the magical meaning of frontality must have had the most profound effect on Byzantine decoration. The aim of "beautifying" the interior of a church by an agglomeration of decorative motifs and patterns was thoroughly inconsistent with the new trend, however dimly perceived it was as yet; and we find, in fact, a considerable shrinkage of the wealth of floral and geometrical patterns which had overspread the walls of fifth- and sixth-century churches. Thin, sober frames were all that remained. The empty ground claims more and more space.

The old narrative compositions still surviving into the Justinianic epoch were finally broken up by the new rigidity. A new and impressive art of significant linear design in flat composition was gradually developing to replace the closely woven texture of late antique painting. Step by step this new style of flat design freed itself from the last remnants of the spatial *double entendre* of Hellenistic tradition. Subtle and austere, it was destined to become an important factor in post-Iconoclastic composition. Still, these new elements were not enough in themselves to create a new scheme of decoration. The old coloristic unity, broken up by the shrinkage of pattern and by the isolation of the figures, was not as yet supplanted by a new unifying principle. The seventh and eighth centuries did not produce the fresh impetus needed for shaping a new formal unity. This period was living, after all, on the past, on the artistic and iconographical heritage of the Justinianic epoch which it was gradually transforming. The influence of the new elements, therefore, was at first rather negative. It served to break up the earlier system. And the gap in representational religious art brought about by the Iconoclastic controversy tended still further towards

the abolition of the surviving traditions and, by establishing a void, to clearing the ground for a new departure.

§ Iconoclastic Period

This void, however, did not involve a complete absence of artistic or even representational activity: it extended only to religious representational art. Other activities, in particular the decoration of secular buildings with profane subjects[20] and the beautifying of churches with conventional motifs of floral or animal design, continued and were even intensified. For these activities Iconoclastic art drew on two mighty sources: the secular art of antiquity and the non-representational art of Iran and early Islam.[21] Most of the decorations of this epoch are destroyed, but some can be reconstructed from literary sources,[22] and a general idea of them can be gained from later works like the mosaics of the Sicilian palaces[23] (39a) or the frescoes of Kiev.[24] More directly useful are the few monuments preserved on Islamic soil, especially at Damascus,[25] Jerusalem,[26] and Bethlehem.[27] Nowhere is the intermixture of Hellenistic and Oriental elements so clearly perceptible, and nowhere has it produced such magnificent results, as in the architectural landscapes of the Umayyad mosque at Damascus (39b).[28] In these mosaics Hellenism makes its reappearance in the picturesque combinations of fantastic architectural motifs, in the interplay of light and shade on the buildings depicted and in the perspective effects of foreshortened obliquity. Oriental tendencies can be seen at work in the discrepancies between the two elements of landscape and architecture; in the failure of the mosaics to achieve the homogeneous character of an architectural landscape; in the rigid symmetry of the primary objects—the great porticoes and *tholoi* which have lost alike their plastic relief and their spatial depth, and have become flat stage decorations; in the "frontality" of the trees, whose branches are spread out in flat designs and modelled symmetrically so as to present shaded contours on both sides with a ridge of light in the middle axis; and, lastly, in the compositions themselves, which develop symmetrically from a central axis and are piled up in a way as far as can be from all notions of organicism. Never before had the two contrasting elements, Hellenistic and Oriental, been brought so close together without either of them losing its own character. Yet the art which produced these mosaics was not a hybrid art. It was a synthesis possible only in the sphere of non-realistic decoration—of non-representational art. There is one formal quality at least in these pictures which seems to foreshadow a change in the general rôle of mosaic decoration. The panels contain only elements which, in earlier ensembles, were used as framework and as parts of the functional décor of the architecture. Yet now these elements make up "pictures" and are themselves framed. The rôles are changing, and the mosaic is becoming, formally at least, more and more independent of the architecture, more and more emancipated from its former ancillary function.

The Iconoclastic decorations so far mentioned contain hardly anything which could be called Christian, or even religious,[29] though some of them were meant for the adornment of churches. The specifically religious decorations of the Iconoclastic period were few and far between. Nevertheless, they seem to have left a deep imprint on subsequent development. Almost the only religious motif which the Iconoclasts allowed of in church decorations was the Cross. In some cases the Cross replaced earlier figures, especially those of Christ and the Virgin in the apses.[30] But a cross, however richly it be executed in gem-studded splendour, is rather a scanty filling for the large golden niches of Byzantine apses; and the economy thus forced upon the monumental painters of the Iconoclastic period was an incentive to them to produce the greatest possible decorative effect with the slight means at their disposal. The golden ground now entered upon its fullest sway. It was given brilliance by curving or variegating the surface, even on vertical and smooth walls. The cubes were set at inclined angles in order to produce special effects. Varying tints of gold were used. Gold, in short, acquired its supreme coloristic value and power. It became the substratum, the canvas against which all other colours were displayed. The colours themselves became darker, deeper in the dye; and a habit grew on the artists of reducing the positive forms to be set against the brilliant golden ground to simple shapes with telling outlines. Economy of form and a supreme skill in achieving the greatest possible effect with the most parsimonious means were the outcome of the discipline forced on the artists by the handicap of the Iconoclastic tenets. It was at this time, and in this manner, that the churches were converted into golden shrines ready to receive the new schemes which were the final outcome of the Iconoclastic controversy.

§ Post-Iconoclastic and Classical Periods

When figurative art for the purpose of religious decoration was once more officially encouraged, it made its appearance, not with an onrush of profusion, but step by step. The first representational elements to be admitted to the decorative ensemble were isolated figures; and for some time these remained the only figurative elements in post-Iconoclastic decorations. Mary in the apse, Christ and Angels in the cupola, Apostles, Prophets and Saints in the naos, and a few almost non-representational symbols such as the Hetoimasia—these were the chief elements of ninth-century decorations. Scenic representations, with the exception of the Ascension and, possibly, of the Pentecost in the cupolas, were still excluded. In this the formal heritage from the Iconoclastic period certainly played a large part; but the theoretical attitude towards the pictures as it had been evolved during the controversy also had its influence. The controversy itself had, after all, centred on the "Portrait"—on whether representations of Christ and the other sacred Persons were permissible. When victory was won

for the icons, it happened (as so often in the history of controversies) that, to begin with, only the paradigmatic point was remembered. The clergy and the artists were content, at the beginning, to restore the most sacred icons to the places where they were again legitimate. The figure of the Virgin, for instance, once more took the place of the Cross in the main apse. An inscription like the " ΣΤΗΛΟΙ ΝΑΥΚΡΑΤΙΟΣ ΤΑΣ ΘΕΙΑΣ ΕΙΚΟΝΑΣ " in the Presbytery of the Church of the Koimesis at Nicaea[31] sounds the triumphant note of the Iconodule victory. The accompanying ensemble—the four Archangels and the Hetoimasia—is austere and economical, but it embodies, together with the figure of the Virgin, a subtle theological programme. The accent lies on the idea of the Trinity and its relation to the Incarnation and the rôle of the Theotokos.[32] To this the naos must have added the idea of the All-Ruler whose image united the three Persons of the Trinity.[33] This grand and simple scheme is typical of the beginnings of the new iconography. An even more archaic version is in part preserved in the Haghia Sophia at Salonica,[34] whose cupola belongs to the end of the ninth and not, as often stated in handbooks, to the eleventh century.[35] The mosaics of the apse are even older; the Virgin is probably the only surviving document of the short iconophile period under Irene, at the end of the eighth century.[36] The simplicity of the scheme makes it appear to be of one piece, although the main parts, the apse and the cupola, date from different periods about a century apart. The scheme of the cupola, with the Ascension instead of the Pantocrator, seems more archaic than that of the apse, though later in date. It was probably owing to the provincial situation of Salonica that the new type of the Pantocrator had not yet found entrance into the decorative system of this church. Considered from the point of view of style, however, the mosaic of the cupola presents itself as more mature than the Virgin in the apse, whose figure is heavy and broad, its proportions showing no regard for the optical distortion of the forms caused by the semicircular niche. The Madonna's head is much too large, her body and the Child much too small. It seems that the new lore of anti-perspective correction was so far unknown to the eighth-century artist. In the cupola, on the other hand, we find the negative perspective of the middle Byzantine optical system almost fully developed. The long legs of the figures—the parts, that is, which appear in the more or less vertical and consequently strongly foreshortened part of the cupola—the shorter upper bodies, the small heads, are all as they should be in order to appear in normal proportions from below. Even the somewhat strange aspect of the seated Christ in the zenith of the cupola falls into line; the figure appears to the beholder almost undistorted, and has, in consequence, smaller and fuller proportions.[37] The awkwardness is caused by the fact that the problem of representing a seated figure on a horizontal surface seen from below was wellnigh insoluble for a Byzantine painter. Later generations evaded the difficulty whenever they could; but they could not solve it either, as may

be gathered from the twelfth- and thirteenth-century cupolas at Venice and in Russia.

The decorations of both Nicaea and Salonica are not completely preserved and are not homogeneous. We have, in fact, no complete and homogeneous decoration of the ninth or even of the tenth century. In default of intact monuments the best idea of an early Macedonian decoration can be formed from Photius's description of the Nea, the New Church of Basil I, consecrated in 881.[38] This description mentions the Pantocrator with the angelic host in the central cupola, the Virgin (in the Orante type of the Platytera) in the apse, the "Choir of the Apostles and Martyrs, Prophets and Patriarchs" in the naos and a portrait of the founder Basil in one of the secondary naves. This description has been thought to be incomplete because it contains no mention of scenic images. Some authors are of the opinion that Christological scenes were represented in the transept. But it is almost certain that no scenic representations were included in the decorative and theological scheme of this paradigmatic monument of the Macedonian renaissance. Other surviving remnants of decorations in the provinces show an equal lack of scenic imagery.[39] Furthermore, Photius would hardly have passed over scenic representations in silence, since descriptions of these were the favourite themes of Byzantine Ekphraseis. Lastly, the inclusion of scenic images would hardly have been consistent with the whole character of early decorations so far as we can reconstruct them. We must not forget what the newly won freedom of icon painting and icon worship must have meant to the Byzantine people of the ninth century: to be face to face once more with the images of holy Persons, images which had been unseen for more than a century, and which, by their very novelty, must have taken on a compelling charm, quite apart from the new conception of the function of the icons which saw in them not mere representations but substitutes for the holy Persons themselves. The feelings evoked by these magical portraits must have been strong enough to exclude the almost theatrical display of scenic representations. To converse with the holy Persons, to venerate them through their images, to give oneself up to the mysterious sensations evoked by the awful presence of the Numinous—all this helped to create an attitude more direct and immediate than was compatible with the contemplation of scenic images. There is a certain primitive grandeur in these early decorations, a purity and single-mindedness which was in a way watered down by the subsequent widening of the schemes. What took shape in the Nea was the austere spirit of the ideological struggle.

Photius has very little to say, of course, about the formal arrangement of the decoration. Two points only emerge from his encomiastic description: that the vaults were resplendent with gold and the walls covered with multicoloured marble. Photius's words imply not only a clear formal differentiation between vaults and walls, a differentiation which was to become one of the characteristic features of the middle Byzantine system; they lead also to the conclusion that the

gold was the prevailing element in the upper part of the building, where it appeared on large surfaces, in the character not so much of a background as of a continuous coating from which the figures stood out. The walls, on the other hand, presented the aspect of multicoloured marble, unbroken by mosaic. We may conclude from this that the mosaic in the Nea was already restricted to curved surfaces, or that it was, at least, placed in framed niches and so set apart from the face of the walls. This, at any rate, is the decorative system as we know it from contemporary and later monuments. It is the result of an important change in the rôle of mosaic in the decoration as a whole. The element which in the Justinianic system was destined to cover the whole interior with variegated forms and colours, and to bring out the various functions and shapes of the architectural parts—the element which, in other words, had been subservient to the architecture—has now become, thanks to the influence of iconoclasm, something of importance for its own sake. Instead of framing and decorating the architecture of the interior, it is itself framed by that architecture. The whole interior of the church becomes one vast icon framed by its walls. The formal change is the corollary of the icon's new dignity. Only from this time onwards can we speak of "icons" in the strict sense of the term.

The beginnings of Macedonian church decoration set the course for the whole subsequent development. The single figures which made up the grand icon of the naos were the first and foremost objects of the magical realism of the new iconography. The next step (almost contemporary with the first) was the inclusion of compositions made up of single figures without scenery, without even picture-like grouping: compositions which were meant not as narrative scenes but as embodiments of dogmatic truths like the Ascension and the Pentecost. Abridged symbols were developed instead of the corresponding scenes. Even simple groups were cut down to something like hieroglyphs, as, for example, when the Deesis was reduced to three medallions set in a row, showing the heads of Christ, Mary and the Baptist. This economy looks like a heritage from the iconophobia of the past centuries. But it is an iconophobia springing from distant roots: representation had become so sacred that only the most economic use was to be made of it.

The cupola compositions of the Ascension and the Pentecost may have had forerunners in early Byzantine, even in early Christian, monuments. These forerunners would not have been found in the capital, where even the cupola of the Haghia Sophia was decorated with conventional patterns only, stressing the functional tendencies of the architecture, the rise and the tension of the vault, but in the Christian East. It is, after all, to the East that we should look for the forerunners of the magical realism of Byzantine art. The cupolas of the Palestinian churches erected over the reputed sites of the Ascension and the Descent of the Holy Ghost, contained mosaics which must have had the peculiar quality of magical realism from the very beginning.[40] The compositional

schemes of these cupolas, as reconstructed from descriptions and from the abridged reproductions on the Palestinian ampullæ, must have recommended themselves to the post-Iconoclastic iconographers as the most "authentic" representations because of their high antiquity and of the special sacredness of the places in which they appeared.

The economical and austere systems of the ninth century could not remain unchanged for long. The rebirth of Hellenism, which from its original sphere of book illumination spread rapidly over other realms of art, called for a more animated and more flexible scheme, for a programme which was more humane and more comprehensive. Specifically Greek elements began to transform the rigid austerity of the decoration. There was, first, the tendency to connect the single figures by optical devices, by livelier attitudes and coloristic grouping; secondly, the intrusion of scenic representations in the form of festival icons. It has been pointed out above that the progress of both these tendencies can be followed from the tenth century onwards, and that it led first to the richest and most organic configurations and later to the gradual dissolution of the system. The schemes gradually enriched themselves until they actually burst their frame. The growth in the number of scenic representations in the naoi of the chief monuments of the eleventh century stands in direct proportion to the progress of time. Hosios Lukas, from the beginning of the eleventh (or the very end of the tenth) century, has four festival icons in the naos; Chios, of c. 1040, has eight; and Daphni, dating from the end of the eleventh century, thirteen. The number of scenes in the narthexes of the three churches shows a parallel increase. At the same time, the single figures grow fewer; from more than a hundred and fifty in Hosios Lukas to less than fifty in Daphni (making allowance for destroyed images).

Hosios Lukas (42) exhibits the strictest iconographical system of all the surviving monuments. The arrangement of the mosaics is perfectly symmetrical with regard to the east–west axis; even the attitudes, costumes and colours of secondary figures in secondary compartments of the church are correlated according to their emplacement with regard to this axis. The low-roofed chapels in the transepts, for instance (27), have schemes which complement each other: the decoration of each consists of Christ, two adoring Angels, and a Saint in the medallions of the vault, a half-figure of the Madonna with Child in the eastern lunette, a locally venerated saint in the western, and three medallions of saints on each of the arches, southern and northern. Both figures of the Virgin are turned towards the centre of the church; but as she must simultaneously look towards the divine Child in her arms, she holds Him on her left arm in the northern transept and on her right in the southern. Christ is brought together in the one vault with James, the Lord's brother, traditionally the first Bishop of Jerusalem; his portrait standing, in this connection, for the founder of the Christian Church. In the other vault, Zacharias takes the place of James, indicating that in this

connection Christ is to be taken as the completer of the cycle of the Old Covenant. Thus the two chapels express one great idea: Christ is presented as the end and fulfilment of the Jewish Church and as the beginning of the Christian. The mosaics of the two chapels, which are formally differentiated with regard to the lighting conditions,[41] are but a small detail in the elaborate programme of the whole, but this detail goes to show how intricate, well ordered and grand the programme is. The scheme contains features which seem to go back to early Byzantine reminiscences, and are certainly archaic from the point of view of the eleventh century. Among these features are the (originally four) Old Testament scenes in the side-chapels of the Sanctuary, two of which—Daniel in the Lions' Den and the Three Children in the Furnace—are preserved in the lunettes of the southern chapel. These two scenes prefigure the Resurrection of Christ; it is to be supposed that corresponding scenes in the northern side-chapel (now destroyed) typologically prefigured His Passion, probably with the stories of Melchisedec and Abraham as sacrificial antitypes. In this way a parallelism was created which connected the Crucifixion and the Anastasis in the western-most part of the church, the narthex, with the antitypes from the Old Testament in the easternmost part, the sanctuary. In other cycles of the eleventh century the typological connection of the Old and New Testaments was indicated by single figures or medallions only. In Hosios Lukas it is almost as explicit as in early Christian schemes. But the most obvious feature in the programme of Hosios Lukas is neither its archaism nor its theological subtleties, but its monastic and local-provincial character, which betrays itself in the great number of monastic saints, especially those who were venerated locally. Such saints as Lukas Stiriotes (the titular of the church) (18a), Lukas Gournikiotes, Nikon Metanoites and others, occupy conspicuous places which in other monuments were usually taken up by the Fathers of the Church. These figures remind us that Hosios Lukas, although an imperial foundation (Romanus II, died 963), was a rustic monastery far remote from any urban centre.

This monastic and rustic character is also clearly manifest in the style of the decoration. The whole is pervaded by a spirit of monkish austerity which is especially obvious in the colour. Of the formal means which contributed most to create the homogeneous character of the decoration, those which are connected with liturgical considerations predominate: those arrangements of the compositions, for instance, by which the main figures of the icons were brought into strict relation with the liturgical axes, those shiftings of the main figures on to the main (eastern or western) halves of the triangular niches, etc. The artists were also fully alive to the possibilities of negative perspective and to the "picture-creating" power of spatial curvatures. But they were rather slow to make use of coloristic differentiation and of enlivening variation in pose and gesture: there is an almost disheartening drabness about the more or less uniform figures of saints. To make up for this the artists over-emphasized the modelling.

Consequently, the formal character of the whole is somewhat rigid and austere (14).

The style of the narthex decoration of Hosios Lukas is more pliable, more intimate, as befits its smaller scale. The leading artist of the workshop responsible for these mosaics exhibits a more fine-grained sensibility. He may have come from Constantinople itself. There is, for instance, the linking of the Apostles' figures into a connected group by means of subtle turnings; there are the compositional refinements in the mosaics of the small apses; and there is a greater profusion of framing ornament resulting in a richer gamut of colours. The flat compositions of the Crucifixion and the Anastasis (13a), both placed in shallow lunettes, called for a bold design with speaking gestures and expressive curves. The curve of Christ's body in the Crucifixion and the enveloping sweep of His robe in the Anastasis produce something of the tension which in the naos was supplied by the curvature of the niches themselves. To appreciate this achievement to the full it should be compared, for instance, with the stiff, lifeless juxtaposition of figures in the tenth-century dedicatory image of Hosios Demetrios at Salonica.[42] The colours in the narthex mosaics of Hosios Lukas are softer than those of the naos mosaics, yet without losing that somewhat severe dignity which seems to have been the peculiar note of the early eleventh century.

The Nea Moni of Chios goes one step further (43b). Like Hosios Lukas, it was a *basilike mone*, an Imperial foundation. But the mosaics of Chios are one generation later; Chios, moreover, was nearer to the metropolis and the church lies in the neighbourhood of what was once an important seaport. Since it is smaller —the church has no proper transepts, only niches, and no corner-rooms—the Nea Moni has a much simpler scheme, especially as regards the secondary cycles of single figures or medallions. The distinguishing feature of the architecture, however, is the fact that the cupola rests not on four niches, but on eight. The cupola itself has been destroyed; together with the spandrels and the eight niches it must have given the impression of one huge golden baldachin, rising from a multi-lobed basis. The naos is, in fact, a unique creation, almost a freak in middle Byzantine architecture and decoration. But in its originality (frequently imitated later) it is the purest realization of the idea of a centralized and homogeneous interior, radially symmetrical, covered with multicoloured marble up to the springing of the vaults and shining all over with gold above. The niches are filled with Christological scenes, four in the axes and four in the corners. The corner-niches are deep and narrow, and the compositions for them must have presented some difficulties. The main accent lies, therefore, on the axial niches, which are flat and spacious, and contain the four great festival icons: Nativity, Baptism, Crucifixion, and Anastasis. These compositions had to be more closely knit than those of Hosios Lukas, on account of the flatness of their emplacements. They contain a comparatively large number of figures, some of them even not necessary from the iconographical point of view, like the

bystanders in the Baptism. Landscape elements, too, play a large part. But the icons are richer not only in content, but in colour also. The coloristic modelling plays in a masterly fashion with abrupt contrasts of light and dark; sudden flashlights seem to illuminate the scenes, giving the figures an almost dæmonic power of expression. Complicated preventive distortions for the oblique view—St. John in the Baptism, Solomon and the Baptist in the Anastasis, the Centurion in the Crucifixion, and so on—show that the artists were well aware of the anti-perspective canon.

The small triangular spandrels between the niches and the lower rim of the cupola are filled with Seraphim whose wings (six each) fit closely into the available space. The upper and middle zones of the decoration are thus knit closely together. The third and lowest zone is altogether relegated to the narthex. But the narthex also has a cupola of its own. From the formal point of view, this cupola is an echo, an abridged edition of the golden baldachin which crowns the naos; the eight niches which in the naos form the multilobed basis of the dome are here part of the cupola itself, and are hollowed out of the dome, so that the ground plan of the narthex cupola is not a circle, but a figure composed of eight lobes or segments of smaller circles. These shallow, bulging niches are marked by an arcading on eight columns in mosaic, and filled with standing figures of saints, the calotte containing a medallion of the Virgin. Everything in the architectural planning and in the décor of this cupola is one stage simpler, one step lower down in the hierarchical ladder of form and content. The whole forms one of the most interesting examples of the mirroring of a complicated, large-scale arrangement in a simpler and smaller one. The Christological scenes of the narthex vaults are treated as flat designs, accessible as they are to the near view without any firmly fixed optical axis. The compositions are animated, thronged and coloristically differentiated in a much higher degree than is the case in spatial icons. The medallions, mainly of monastic saints, are linked together in strings—the earliest surviving example of stringed medallions in monumental mosaics.[43]

The remains of other decorations of the mid-eleventh century add interesting touches to the general picture as we see it in the mosaics of Chios. The decoration of the Haghia Sophia at Kiev[44] (before 1054) may be taken as following the model of the Nea to the same extent as the architecture itself: the Pantocrator with four Archangels and the Apostles in the cupola, the "Orante" Virgin in the conch of the apse, and figures or medallions of Saints are the main parts of this scheme. But these are not all. The four Evangelists are placed in the pendentives in their characteristic oblique postures; the two figures of the Annunciation fill the spandrels of the triumphal arch; and the semicircular wall of the apse contains a grand icon depicting the sacred Liturgy, the Distribution of the Sacrament to the Apostles, by Christ, assisted by Angels (44a). All the other Christological and Marianic scenes are relegated to the aisles and transepts, and

are executed not in mosaic, but in painting—probably as an afterthought superimposed on the severe scheme of the Nea.

The most interesting composition from our point of view is that of the sacred Liturgy. The striving after perfect symmetry called for the duplication of the figure of Christ, who dispenses the Sacrament on both sides of the altar baldachin depicted in the centre. This duplication has nothing to do with the Hellenistic method of repeating the main figure in successive phases of a story— the continuous mode of narrative. On the contrary, it aims at eliminating the time element (in the sense of historical time). The mosaic is, in fact, one of those non-narrative, dogmatic compositions which otherwise are found only in cupolas. But the rhythm of the figures differs widely from that found in cupola decorations (Ascension). The Apostles are not conversing with something above, but moving towards the figure of Christ in the central axis of the curved wall. The row is enlivened by the alternating step of the figures and by the descending garland of their hands. The two hands of each figure approach each other more and more closely until in the innermost figures they are shown clasped. This is only one of several artifices employed in order to make the figures "move" towards the centre. Another, already resorted to in the dome of the Ravenna Baptistery, is the ampler stride of the inner figures in comparison with those on the outside. The inner figures are also more bent forward than the outer ones and, most important of all, they are more isolated. This, with the optical foreshortening of the outer portions of the curved wall, gives the impression of a moving column starting with a crowded group in the outer parts and resolving itself into single figures at the head of the procession—an age-old solution which was known to Roman sculptors as well as to Northern masters like the embroiderers of the Bayeux Tapestry.

The mosaic of the sacred Liturgy in the apse of the Haghia Sophia at Kiev thus provides an example of the use which Byzantine painters made of perspective foreshortening (or rather of crowding) in order to achieve a compositional effect. That this interpretation is correct can be gathered from a later example of the same theme, in the Monastery of St. Michael at Kiev,[45] which was set at a time when the feeling for perspective refinements was already waning (44b). There, the Apostles in the outer parts of the cylindrical wall are really thronged close together. The later artist could no longer rely on the optical effect of foreshortening to press the figures together; he had literally to crowd them, one figure overlapping the other. The difference in date between the two Kiev mosaics is but little more than half a century; but this length of time, from the middle of the eleventh to the beginning of the twelfth century, saw the gradual loosening of the middle Byzantine system. The most important monument of this phase is the decoration of Daphni.

The mosaics of Daphni (43a), another royal foundation, illustrate a stage in which considerations of decorative spacing have become more important than the

principle of hierarchical staggering. The less important scenes of the Birth of the Virgin and the Adoration of the Magi, for instance, are placed *above* the Crucifixion and the Resurrection, on the walls of the transept. Undisguised narrative tendencies are coming into the foreground in the Marianic cycle of the narthex, where two consecutive scenes, the Annunciation to Anne and the Message to Joachim, are fused into one continuous composition. The pictures themselves are composed in a manner almost independent of their situation in space: the figure of Mary in the Adoration of the Magi, for instance, turns away from the main axis of the naos—a liberty which the masters of Hosios Lukas would not have taken. Some of the pictures are little more than enlarged miniatures; they are self-sufficient, like easel paintings, quite unlike the austere groupings of Hosios Lukas. Almost all the single figures and medallions are represented in easy attitudes, turning slightly sideways, and thus making for picturesque variety. The Hellenistic means of differentiating and connecting single figures, the sidelong glance,[46] which had been eclipsed by Oriental frontality for almost five centuries, makes its return in a new wave of Hellenism.[47] Thus the ideal of Hellenistic elegance is gradually replacing that of hieratic grandeur. The original fervour of the Iconodules has worn off. The new art is slipping out of the hands of the monks and is seeking favour with the Hellenistic Court circles. The mosaicists are forgetting that the service they perform is almost a priestly one; they become versatile artists, seeking to please.

ITS DISSOLUTION

The classical system, as we have sketched it, was confined to a comparatively short period and to the central parts of the Byzantine empire. Like all classical phases, this too was an episode. And like all classical systems, the middle Byzantine contained within itself the germ of dissolution. But this dissolution was facilitated by several factors.

§ The Fresco

There is, first, the fact that the decoration of churches by wall-painting gradually replaced mosaic decoration. This was a natural result of the spread of metropolitan art to the provinces and of the gradual impoverishment of the Byzantine world. Sometimes we find a mixture of mosaic and wall-painting, as in the Haghia Sophia at Kiev, where the central square and the apse display the classical scheme of mosaic decoration, while the aisles and transepts are filled with a painted cycle. In other instances (Mt. Athos) the mosaics are restricted to single icons—the Annunciation or the Deesis—and the tone of the main decorations is set by wall-painting. The substitution of fresco for mosaic or the

dilution of mosaic decorations by wall-painting had far-reaching results. The subtle balance between marble encrustation and pictorial decoration, which was one of the chief artistic achievements of mosaic churches, could no longer be upheld from the moment when wall-painting invaded the churches. Fresco tends to spread over a whole interior, to create a continuous surface, interrupted only by its division into a network of pictures. These large surfaces could not be filled by the sparse schemes of the classical system. They demanded continuous narrative cycles going round the whole building in several layers, one below the other. Now these layers[48] do not correspond very closely to the three classical zones of mosaic decoration as laid down by the iconologists. The narrative element, instead of being restricted to the middle layer, invades them all.

§ Basilican Plans

Another factor which tended to produce similar results, and which was, indeed, connected with the first, was the gradual re-emergence in later Byzantine architecture of the longitudinal ground-plan. Even in those cases where the centralized cross-in-square scheme with its dominating cupola was preserved either above a basilican ground-plan, as at Mistra, or as an annex to it, as in Sicily, the basilican space could not but have a profound effect on the distribution of the whole decoration. Basilican ground-plans always tended towards narrative decoration (45). The flat unbroken walls could hardly serve to carry a hierarchically staggered system of icons. They provided no niches, no articulations for receiving and grouping single icons. The most organic arrangement of pictures on such walls was, and still is, a long horizontal strip divided by vertical partitions into a series of narrative scenes. Whether these scenes illustrated the Old or the New Testament, they necessarily threw the remaining system out of gear. The narrative cycle ceased to be a part of the hierarchical system and became the main object of interest. In addition, the optical unity of the middle Byzantine decorative system was of necessity deeply affected by being applied to basilican ground-plans. The arrangement in concentrically widening circles descending from the central cupola—an arrangement in which every icon of a single cycle was, ideally at least, placed at an equal distance, both vertical and horizontal, and from the centre of the space—was supplanted by an arrangement dominated by the principle of succession in space and time. The beholder of a basilican decorative scheme has to follow the line of continuous narrative from west to east and back again from east to west. No simultaneous view can be achieved except that towards the apse—a view in which the main part of the decoration is either invisible or too foreshortened to be intelligible. The beholder is not invited to glance round in gradually descending circles; he is forced to walk the length of the nave in order to follow the succession of scenes. The simultaneity of the optical system, with its spatial refinements, gave way in basili-

can decoration to rhythmic succession. By this change the individual pictures were themselves deeply affected. Their internal composition could no longer aim at iconic independence in spatial receptacles. The main thing now was the establishment of a connecting rhythm. In every picture the formal movement from left to right had to be stressed in order to urge the beholder on to the next scene. The old Byzantine device in the sphere of narrative composition on a flat surface—the translation of action into movement—could serve this end very well, if most of this movement was directed from left to right. The chief actors in narrative pictures in such cycles are therefore shown as moving, even running, in the direction which the eye of the beholder is supposed to follow. They move through the series much as the heroes of early European novels travel along the roads from one adventure to the next, keeping the "story" moving by movement. Especially in the cycles of the late twelfth century do we find a swift "streamlined" narrative in which the main stress is laid on the smooth mechanism of action, to the detriment of its paradigmatic value and its human message. The landscape settings of the compositions are used by the Greek mosaicists of King William II in Monreale, for instance, as a means of connecting successive scenes in the cycle; to mark the connection in time; to shape a continuum where two or more consecutive scenes are to be understood as forming a temporal or spatial series, as with the two Rebecca and the two Isaac scenes; or to mark a definite discontinuity between pictures not immediately connected in time and space—for example, between Jacob's leave-taking and his dream. In some cases the landscape is even used to create the impression of movement itself: the rolling contour of the horizon in Rebecca's journey conveys the idea of travel, in contrast to the quiet horizontal line, signifying rest and stability, in the preceding scene at the well (46, 47). In these narrative cycles an entirely new art is emerging; an art of composition almost diametrically opposed to the quiet, dignified statuarism of the classical Byzantine era.

§ Provincial Influences

There was yet another factor active in the dissolution, or transformation, of the hieratic system, though one which is not easy to assess in view of the lack of metropolitan cycles in the twelfth century: namely, the influence of provincial art. Provincial art cannot have failed gradually to affect Constantinople itself.

THE PROVINCES

It is to be assumed that the refinements of tenth- and eleventh-century metropolitan art were only imperfectly understood in the provinces. Even Constantinopolitan artists could hardly live up to their metropolitan standards

when working abroad; they had to put up with strange and unsuitable buildings, and with the interference of foreign patrons. The Byzantine artists, for instance, who worked in Sicily[49] in the service of the Norman kings had both these disadvantages to reckon with. Their work may serve as an example of Greek twelfth-century mosaics in the provinces. Their first task, the mosaic decoration of the apse of Cefalù Cathedral (48) (about 1148), involved the application of a cupola scheme to an apse. The Pantocrator of the medallion was made to fit the conch, which necessitated immense enlargement. The rest of the programme, containing Mary with Angels and Apostles, figures which in cupolas of the Ascension type were ranged round in one continuous row, had to be broken up into three superimposed layers—a procedure which necessarily impaired the coherence of the series. The designer tried, it is true, to perform his task as far as possible in accordance with the middle Byzantine principle of hierarchical arrangement: he placed Mary and the Angels in the top tier, in larger figures, Peter, Paul and the Evangelists in the next, and the rest of the Apostles in the third, marking thus their differences in rank. The hierarchic differentiation is carried even further, for the figures of highest rank stand nearest to the middle axis of the apse. The lower its rank, the further is the figure removed from the Pantocrator in the top centre. The staggering in size, on the other hand, could not be carried through with consistency. The two rows of Apostles had to be equal in size, since a differentiation between them would have broken up the series.

§ Sicily: The Twelfth Century

The scheme at Cefalù was, on the whole, a successful attempt to adapt a cupola decoration to an apse. It became the model for at least two other Sicilian apses, that of the Palatine Chapel at Palermo (decorated in two phases, one in the forties, the other in the sixties of the twelfth century, with a change of plan intervening) and that of Monreale (after 1180). The artist responsible for planning the apse of Monreale (49) widened the spatial unit at his disposal by including the vault and the walls of the adjacent presbytery in order to provide for the large programme imposed by the patrons—King William II, Matteo d'Ajello and the Benedictine monks. To mark the boundaries of the new spatial unit he placed on the outer faces of the triumphal arch pictorial representations (in the form of Stylites) of the real, plastic columns which in his model, Cefalù, terminate the apse proper in front. He even imitated the colour scheme of these real columns, which are encrusted in green and reddish brown. Inside this larger compound we find an eclectic fusion of parts from various programmes, mainly from Pantocrator and Ascension cupolas and from apsidal schemes, arranged and staggered in size in accordance with the hierarchical rank of the figures. The Prophets in the medallions of the arch which frames the conch are treated as belonging to a separate unit whose centre is the medallion of the

Emmanuel in the zenith: the figures turn towards the centre and upwards, thus establishing a spatial connection in the Byzantine sense already described. The image of the Pantocrator in the conch complies with the laws of middle Byzantine spatial æsthetics; His ample gesture, much broadened in comparison with Cefalù, actually does embrace the entire semicircle of the niche. Those parts of the figure (arms, hands, book) which, owing to the curvature of the niche, are seen foreshortened, were enlarged and drawn out in order to counteract the perspective effect.

The Greek character of the decoration is brought home even more effectually by the way in which the designer has dealt with the vertical edges and corners of the enlarged "apse". These angles and corners tended to interrupt the continuity of the row of Apostles on either side of the Virgin. This row, for which there was not sufficient space in the cylindrical niche itself (by reason of the inclusion of Saints, even Holy Women below, in accordance with the prescribed programme), had to be continued on the adjacent presbytery walls. This may, indeed, have been the main reason for the ingenious plan of enlarging the apse and treating the entire eastern part of the presbytery as one spatial whole. The problem was now to place and arrange the Apostles so as to underline the spatial unity in spite of the angles and corners. Not all the Apostles are represented in strict frontality; like the figures in middle Byzantine cupolas, they are imagined as surrounding the central figure of Christ, who appears above, and the Virgin in the central axis. The Angels, St. Peter, and St. Paul, who are placed in the depth of the apse, confronting the beholder, turn slightly towards the Virgin. The next pair, Mark and Luke, whose figures already appear as turning towards the Virgin by virtue of the curving of the wall, are represented in full face. The most revealing figures, however, are those of John and Mark, who come to stand on the orthogonal faces of the apsis frame. Had they too been represented in a frontal attitude, their connection with the rest of the Apostles would have been severed and the spatial unity of the arrangement, with all the Apostles turning towards the centre of the imaginary cupola, disrupted. They were given, therefore, in an attitude approaching, as closely as was possible for Byzantine hieratic art, the profile. This makes the two figures turn towards the centre of the semicircle in the actual spatial layout. The rest of the figures on the two side walls (north and south) are again rendered *en face*, with slight variations, as at Daphni, which make for contact within the series. The two "profile" figures of Matthew and John show how, even at so late an epoch, the Byzantine artists reckoned with the position of the figures in actual space. The rendering is the result of the projection of an actual situation in physical space— a semicircle—on to angularly broken surfaces. The situation in physical space of these surfaces themselves determined the mode of projection; a "profile" figure on a "frontal" wall was understood as having the same position in the spatial scheme as a "frontal" figure on a "profile" wall. The projected attitude

corrected the position of the picture surface in physical space and vice versa. All the Apostles in reality turn towards Mary and Christ.

The correctness of this interpretation is corroborated by the arrangement of the Saints below. These figures were not parts of a spatial scheme, but were to be seen separately, and were, for this reason, represented all and sundry in strict frontality, without regard to the situation of the walls in space.

Monreale contains yet other traces of the survival of the middle Byzantine spatial system. It has been pointed out already that in the narrow side-chapels the strips of scenes belonging to a single hierarchically homogeneous series (legends of SS. Peter and Paul) were staggered in size in order to counteract the perspective foreshortening of the upper layers. A similar procedure is to be seen in the nave, where the figures of the top tiers are larger than those of the bottom; moreover, the size of the figures in each tier increases from west to east, so as to counteract some of the diminishing effects of perspective in the view from the west.

An iconographical reminiscence of the centralized middle Byzantine system is to be found in the form of the inscriptions to the Christological scenes in the middle part of the church. While most of the pictures are headed by inscriptions which either give a short narrative account in the past or present tense or else introduce one or more of the persons as speaking, some of them, fifteen in all, have as inscriptions simple titles in the form of nouns—Annunciatio, Crucifixio, and so on. These fifteen pictures, although interspersed in the general narrative sequence, form a cycle by themselves, made up of the original festival icons of the middle Byzantine system, from the Annunciation to the Pentecost. This, too, shows that the men who arranged this programme had not as yet lost all connection with the great Byzantine traditions of the classical era.

So far the fact has been stressed that some reminiscences of the optical and iconographic principles of middle Byzantine decoration survived even in provincial works of the end of the twelfth century. But this is only one side of the medal; there is another to be considered also. It is almost superfluous to draw attention to the many intentional alterations or unintentional blunders which make Sicilian mosaics so different from those of the central Byzantine area. It is hardly possible to overlook the fact that the general atmosphere of Sicilian taste is profoundly different from that which prevails in Byzantine churches of the eleventh century. In Sicily the mosaic is not set, island fashion, in coloured marble lining. It is used as a precious all-over incrustation covering as much as possible of the whole interior. Other materials—carved and gilded or painted wood, sculptured stone and *opus sectile*—concur with the mosaic to produce an effect of the utmost romantic splendour. The Nordic west and the Islamic south-east combine with the Byzantine element to form a new ensemble. These elements, especially the Islamic, intrude even into the sphere of the mosaics themselves. The decorative trees, for instance, which fill so much of the wall space

66

in all Sicilian decorations, owe their inclusion to Saracenic influence. Even the ensembles which from the Byzantine point of view are the purest, such as that of the Martorana, take on a strange and un-Byzantine aspect on this foreign soil. Although the Greek workmen who set these mosaics tried to follow Greek prototypes, Sicilian or Eastern, as closely as possible, they betrayed in their very copying their failure to grasp the essentials of Byzantine decoration. The Apostles in the vaults of the Martorana transepts, for instance, slavishly copied from Cefalù, were taken over with the actual measurements of their models, measurements which did not at all fit the new emplacements (50). The figures are much too large for their new environment; they actually dwarf the cupola above. In the cupola itself (51), which closely follows a Byzantine prototype preserved in provincial examples,[50] the four adoring Angels are intolerably short-legged; indeed, they are so thoroughly out of proportion that they look crippled and dwarfed. This forms a strange contrast to the anti-perspective corrections in middle Byzantine art. But the reason of this inconsistency is once more to be found in the thoughtless copying of Byzantine prototypes in a different iconographic context. In the Greek prototype of this cupola composition the four Angels were represented in the attitude of kneeling, not standing, as in the Martorana. In the kneeling posture their proportions were perfect, even with full regard to anti-perspective corrections. The copyists changed the attitude from kneeling to standing, evidently for iconographic reasons, without, however, changing the main outlines and the proportions of the bodies. Such a blunder throws a sharp light on the artistic situation of this colonial sphere of Byzantine mosaic painting in the twelfth century.

Although the Martorana mosaics stand at the beginning, and those of Monreale almost at the end, of the great epoch of mosaic painting in Norman Sicily, it is the second of these monuments which, in spite of the handicaps imposed by the basilican ground-plan, is the more true to the principles of middle Byzantine decoration. This fact should act as a warning to scholars against assuming a continuity in the evolution of Sicilian mosaic art, leading from a purely Greek to a local style. As it happened, the evolution was broken and often reversed by new influxes of Byzantine art and by new transplantations of Greek artists. This was the case throughout the Byzantine colonial world.

§ Venice: The Thirteenth Century

The history of Venetian mosaic art offers as complicated a picture as does that of Sicilian. True, it begins with the work of Greek artists and turns, in the course of the twelfth and thirteenth centuries, towards a gradual fusion of Byzantine, Romanesque and local Venetian styles. But this seemingly logical development was several times interrupted by fresh impulses from Constantinople or the Byzantine provinces which served to establish a close connection with the

central Byzantine evolution itself. However far the Venetian development swerved at times from the metropolitan evolution, it was brought back again and again by new Byzantine influences, and may be taken, for this reason, as presenting a parallel to the Byzantine evolution proper until finally it branched off into a specifically Venetian "Byzantino-gothic" line.

Venice also, therefore, may serve as an example which helps to elucidate dark stretches of the central Byzantine evolution. The beginnings, so far as they can be traced in view of the many losses, are to be found in the main apses of Torcello (the Apostles only)[51] and of St. Mark's, and in the Apostles of the main doorway of St. Mark's.[52] The Torcello Apostles, which must have been set about 1100 or even earlier,[53] observe the Greek anti-perspective principles in the broadening of the figures near the edges of the semi-cylindrical wall (22). The oldest figures of St. Mark's follow a similar scheme. But with the main decoration of the interior of St. Mark's, which was begun considerably later, towards the end of the twelfth century, Venetian art entered on a new phase. The architectural type of the church, which followed to a certain extent the model of the Church of the Apostles at Constantinople, was responsible for the introduction of a certain parallel influence from the mosaic decoration of the famous metropolitan church. But this influence was only superficial; it applies exclusively to the western cupola and its arches (with the Pentecost and the Martyria of the Apostles). The purely narrative scheme of the Church of the Apostles was too antiquated to exert a deeper influence at the end of the twelfth century. It could not break the sway of the still-surviving middle Byzantine system. Neither could the latter be applied in its pure form. We have pointed out that the middle Byzantine system employed only three alternative schemes for cupola decoration (Pantocrator, Ascension, and Pentecost), and that in classical decorations the first two were never used side by side. But the mosaicists of St. Mark's were faced with the problem of filling five cupolas. They placed these three standard schemes in the cupolas of the main axis of the church without regard to the fact that in so doing they mingled two different programmes and, to a certain extent, duplicated the dogmatic content (6, 8, 9). The two remaining cupolas in the transept were filled in an almost casual and haphazard way with scenes from the legend of St. John the Evangelist[54] and with four single figures of Saints.[55] These two compositions do not fit in either formally or iconographically. It is evident that the theologians and the artists were at a complete loss how to solve the problem. The three main cupolas themselves betray an equally uncertain attitude (8). The master of the Pentecost cupola,[56] while taking over the general scheme of the seated Apostles, with rays descending radially from the Hetoimasia in the centre, placed the sixteen representatives of the Phylai and Glossai not in the pendentives, as was usual in Byzantium, but in the drum between the windows. Having thus used up the motifs appropriate to the pendentives in the cupola itself, he could think of no better solution for the

pendentives than to fill them with four stereotyped figures of Angels, which are much too large in comparison with the Apostles above. The Apostles themselves are also arranged in a way far removed from the organic compositions of Byzantine cupolas. The easy rhythm of Hosios Lukas (1), for instance, is replaced by a rigid geometrical design. Four frontal figures, the Evangelists, are placed in the diagonal axes, separating four pairs of Apostles in dialogue-groups. This rigid scheme, in which the rays are strict diameters, each radius continuing that diametrically opposite, as in a geometrical pattern, does not allow of accents being laid on the main group, consisting of SS. Peter and Paul—accents which were provided in Hosios Lukas by putting a wider gap between these two figures. The rigidity of the Pentecost composition in St. Mark's is further enhanced by the continuous ring of the inscription which forms one of the many concentric circles of the pattern. The whole is Romanesque rather than Byzantine.

The central cupola, on the other hand, has all the ease and all the nervous liveliness of an original Byzantine composition (6). All the traits enumerated above as characteristic of the Byzantine cupola scheme are to be found in this Ascension cupola. The master, who, on the evidence of his style, was no more Greek than the master of the preceding cupola, must either have worked under the direction of a Byzantine supervisor or have had a solid grounding in these matters himself. He also followed middle Byzantine prototypes in arranging the Evangelists in the pendentives, although they are somewhat too large. The Virtues and Beatitudes[57] between the windows, on the other hand, have no parallel in Byzantine schemes: the iconographical programme and the figures themselves were taken from Western sources, probably from Romanesque sculptured portals, and it must be regarded as a return to their proper and original sphere when these figures were later copied in the sculptures of the main portal of the façade of St. Mark's.

The third cupola of the main axis (9), above the altar,[58] attempts to vary the ideological content of the Byzantine Pantocrator scheme by substituting the figure of Emmanuel for that of the Pantocrator. The scheme, in this form, is alien to middle Byzantine programmes. A definitely Western trait is the placing of the Evangelists' symbols in the pendentives, and Western likewise—that is, without regard to the principle of anti-perspective correction—are the proportions of all the figures except the Jeremiah, which was renewed by a Byzantine master after the fire of 1231.[59] The difference between this figure and the others—the Isaiah next to it, for instance—provides an excellent object lesson in the deep gulf which separated the Venetian from the Byzantine artists.

The three main cupolas are not very distant from each other in date. The work may actually have been carried out at the same time, or have overlapped. Nevertheless, they exhibit not only three different styles, but three different attitudes towards the Byzantine canon: the first, an energetic geometrizing of the layout; the second, a faithful following as regards the compositional principles

though not as regards the style; and the third, an iconographical variation coupled with a crude provincial copying of Byzantine forms. The only part of the decoration of the cupolas in St. Mark's which is genuinely Byzantine, as regards both macrocosmic and microcosmic aspects of style, is the figure of Jeremiah in the third cupola.

A similar variation is manifest in the attitude of the Venetian artists who set the mosaics of the arches carrying the cupolas (52). The scenes from the Temptation to the Last Supper on the south-eastern arch[60] were taken from miniatures, but were stripped of all but the most necessary elements of scenery. They are friezes rather than pictures; not framed, but held together by a certain linear rhythm and arranged one on top of the other as in fresco decorations. The closest approach to the Byzantine conception of the festival icon is found in the Anastasis and the Crucifixion, set on the arch between the central and the western cupolas[61] by a master who seems to have worked under the guidance of the Ascension master. But the masters who set the other scenes of the same arch relinquished the tradition. The Passion and Resurrection scenes (53) below and between the two icons show an almost complete emancipation from the Byzantine idea of the festival icon. The scene of the Holy Women at the Tomb is so arranged in the zenith of the arch that its axis lies at a right angle to the axes of the scenes below; in other words, the figures are drawn across the arch, and would have struck the Byzantine beholder, not as standing up, but as recumbent. The Passion scenes[62] below the Crucifixion present another interesting trait. In conformity with the Byzantine tendency of the late twelfth and early thirteenth centuries, the compositions stress the narrative flow, the junctions between two consecutive scenes. But the means by which this continuity is achieved are different from those employed in Monreale or in other purely Byzantine works. The Betrayal of Judas and the Ecce Homo (which is combined with the Judgment of Pilate, the Mocking of Christ and the Way to Golgotha, in one concise group) are joined in a peculiar way. The last figure to the right of the Betrayal —in Byzantine iconography one of the fleeing Apostles—is represented as a bearded Pharisee turning towards Pilate—the first figure of the next scene—with a challenging gesture and a scroll in his hand inscribed with the word *Crucifigatur*. In this way the figure which formally and by iconographical origin belongs to the Betrayal is linked thematically with the following picture, the Ecce Homo. The gap in space and time between the two scenes has been breached—very effectively, it is true, but in a way which was not used in Byzantium. This Western—Venetian—method was brought in the scenes of the Apostles' Martyria[63] in the arches of the western cupola to a pitch of perfection which is not even surpassed in conciseness by the inscriptions, such as *Mars ruit, anguis abit, surgunt, gens Scythica credit*, which sums up the whole history of the mission of the Apostle (54). All that the inscription says, and more, is packed into one coherent group in the mosaic.

These last specimens already belong to the thirteenth century—a period extremely fertile for the mosaics of St. Mark's. The development of the new narrative style can be followed in the narthex, where the story of Genesis, from the Creation to the Life of Moses, is told in mosaics which follow an early Byzantine prototype closely akin to the Cotton *Genesis* of the British Museum.[64] It is interesting to note the changing methods by which the Venetian masters refashioned the ancient model. The first cupola, south of the main entrance,[65] the mosaics of which were set about 1220, shows hardly any attempt to adapt the miniature models to the new formal conditions of cupola decoration (55). It is as if the designer had been taken unawares. The little panels, thronged with figures and landscape motifs, are arranged in three concentric circles which cover the whole surface of the cupola from zenith to rim. The images and figures of the upper ring are slightly smaller than those of the bottom circle, in direct contradiction to Byzantine usage. The awkwardness is even more patent in the lunette[66] beneath the cupola, where compact little pictures stand side by side with scenes whose figures are widely drawn apart so as to lose almost all coherence. The next cupola[67] shows a great advance in the adaptation of the model to the new conditions (56). The scenes (the story of Abraham) are arranged in one band only, at the bottom. Care is taken that this band should appear as a continuous sequence without completely destroying the separate identities of the single scenes. Elements of setting are economically used for this purpose; where they were not sufficient, a simple line in the golden ground indicates the separation of two scenes. Thus the story moves round the circumference of the cupola. The main actors are turning towards the right, in order to fix the direction of the narrative. The little figures are still closely packed together; indeed, the whole looks like a close procession rather than a series of scenes following each other in time. In the following cupola, the first of the Life of Joseph,[68] the pattern is woven more loosely; the figures are fewer and larger, and the golden ground invades the compositions, which are connected rhythmically with each other. The dividing lines have disappeared as such; divisions are governed by the scenery, which itself is reduced to a thin network of lines. The movement is leisurely and, in spite of the comparative smallness of the figures, somehow monumental. Byzantine principles have to a certain extent reasserted themselves. The spandrels, too, are filled in perfect harmony with the Byzantine canon. They contain, as also in the preceding cupola, medallions with Prophets. Even the scrolls of the Prophets help to bring out the rising curvature of the pendentives.

But this "Byzantine phase" did not last long. The perfect equilibrium which is manifest in the mosaics of this cupola was soon to be disturbed again by native Venetian forces. Some ten or fifteen years before the middle of the thirteenth century, the work in the narthex of St. Mark's was interrupted—possibly because the northern part of the entrance hall was not yet finished in its

present form[69]—and the mosaicists were made to work in other churches. When they returned again, about 1260, to carry out the decoration of the remaining cupolas, their style had changed. The fourth cupola, the second of the Life of Joseph,[70] already shows the new trend (57). The figures have become considerably larger, their poses are statuesque, and they are enclosed, singly or in small groups, in baldachins, much like Romanesque statues. The classicism of Italian Dugento sculpture has ousted the Byzantine rule of taste, although the single figures and scenes still follow the early Byzantine prototype of the Cotton *Genesis*. The golden ground, which played so important a part in the foregoing cupola, has now been reduced to a minimum. The central motif in the zenith of the cupola, in the earlier domes a linear design of intersecting circles, is now fashioned like a Romanesque circular window with intersecting arches on plastically modelled columns. The pendentives contain scenic representations instead of the "Byzantine" medallions.

But the Byzantine factor was too strong in Venice to be ousted for good. After the interlude of the fourth cupola it gradually reasserted itself. The fifth (58), the last of the Life of Joseph,[71] again has medallions in the pendentives, now even enriched by Byzantine acanthus scrolls, and the medallion in the zenith of the cupola has again become a linear design without any relation to architectural or plastic motifs. The golden ground resumes its important rôle, the groups become livelier and more numerous, the architectural framework loses its baldachin character and recedes into the background, becoming scenery once more. There is a new and growing tendency towards the coalescence of several groups and scenes into picture-like units. In the sixth and last cupola and its lunette, which illustrate the Life of Moses,[72] this tendency has become a dominating principle (59, 60a).

In this last phase of the mosaic decoration of the narthex there is no sign of wavering between two traditions, no trace of experiment. A new art has been born which is perfectly sure of its aims and means. The cupola is composed of large picture-like units with elaborate landscape and architectural settings. The figures are subordinated to these settings and move in space—no longer in the physical space of the hollow cupola, but in a picture-space created by spatial motifs strung together in a logical if not realistic way. These motifs, whether they are hills, walls, houses or river-beds, provide a series of oblique niches, open towards the front and connected with each other by a continuous background. Even the empty golden ground assumes a spatial quality, becoming sky or air.

The forms of the pictorial units in the Moses cupola make it clear that the new arrangement did not originate in the sphere of cupola decoration. The cupola appears to be divided into several compartments instead of being filled with a garland of figures. The triangular shape of these compartments suggests that the framework in which this mode of decoration originated was that of the cross-groined vault with its four triangular spandrels. In fact, we find not only

the same arrangement but also a similar setting and a similar style in the mosaics of the cross-vaults of the Kahrieh Djami in Constantinople (6ob).[73] It is unnecessary to assume that this greatest artistic monument of the Palæologan epoch was the actual model for the Venetian mosaics; created at the beginning of the fourteenth century, it may even be somewhat later than the cupola in St. Mark's, which may have been executed in the last decade of the thirteenth. But the Venetian work is certainly an echo of the new artistic activity in the Byzantine metropolis, an activity which must have produced a considerable number of decorations before it reached its peak in the mosaics of the Kahrieh. To our scanty knowledge, however, these mosaics seem to mark an entirely new phase in the evolution of Byzantine art.[74]

THE IMPRINT OF THE SYSTEM
ON LATER ART

THE IMPRINT OF THE SYSTEM ON LATER ART

VARIOUS theories have been propounded to account for what was believed to be the sudden appearance of a new style of Byzantine art[1] in the Palæologan era. The phenomenon of the Kahrieh and kindred monuments was explained in various ways: as the result of a new classicist renaissance, taking its impulse mainly from late antique and Byzantine secular art and freed from the inhibitions of ecclesiastical iconography; as a movement inspired by the revival of Oriental—Syrian and Anatolian—traditions which took on added force because they were no longer counterbalanced, during the Latin occupation, by the classicism of the metropolis; as an outgrowth of a popular movement among the Slav peoples of the Balkans; or, lastly, as an echo of the Italian evolution of the thirteenth century. All these factors may have played their part, and this is not the place to assign them their various and highly hypothetical rôles in the evolution of the neo-Byzantine style. Our concern in this chapter is to inquire whether the Byzantine monumental system of the tenth and eleventh centuries, which in the Palæologan epoch was a thing of the past, left any imprint on the art of the fourteenth and following centuries, and if so, to discover what continuity there was in the evolution of this art and what were the static factors in the development of Byzantine decoration.

THE RE-EMERGENCE OF PICTORIAL SPACE

At first sight there seems to be little or no connection between the monumental style of late Byzantine art, as we see it in the Kahrieh, and the decorative system of the classical middle Byzantine epoch. Judged by middle Byzantine standards the decoration of an Athonite church,[2] for instance, is apt to seem a more or less disorderly profusion of pictures, jumbled together haphazard. Apart from a certain articulation in zones, there seems little order in the bewildering multitude of pictures which cover the vaults, cupolas and walls of the interior, in some cases even the exterior, of churches and monastic buildings. The decoration is seen as a sum of separate items rather than as a unified whole. The reason for this is not only the apparent lack of any ordering principle. There is also the positive fact that the separate pictures have taken on a new rôle, by insisting, as it were, on being seen individually—a claim to which it is difficult to submit in the face of the multitude of single items, seen concurrently

without an adequately isolating framework. The pictures seem to jostle each other. They are not content with their share in the common physical space of the naos, but each carries its own picture-space.[3] They knock holes in the walls. The picture-spaces of the single icons vary in depth, rapidity of recession and intensity. If two or more pictures are seen at one glance—and this is hardly to be avoided—disturbing interferences appear in our vision. We must suppose, however, that the artists who produced these decorations and the worshippers for whom they were produced saw in them a perfect expression of the æsthetic principles of their own time. The discovery that dramatic action could be represented in *pictorial space* must have had so deep a charm for artists and beholders that everything else was of small account. The single picture began to hold the gaze with an intense fascination quite different from that of the past, and that not only with regard to form, for there is also a new intensity of feeling in these pictures, a novel appeal to pity and piety which was foreign to the grand old statuesque decorations of the middle Byzantine era. Nor is the thematic interest restricted to the mechanism of the narrative, as in the twelfth century; it is the human message which now clamours to be heard, no longer the dogmatic meaning, as in the eleventh century, or the historical message, as in the twelfth.

The chief means by which it was sought to realize this new aim was the introduction of picture-space. By this means, each single icon becomes a world in itself, with its own laws and its own atmosphere, which completely envelops the beholder and draws him into a magic circle of a new kind. Seen against the background of middle Byzantine decoration, this is a new development. At the same time, it contains elements drawn from the past. First, there is the background coulisse which had never completely dropped out of the repertory of Byzantine art and which was used with masterly skill, in the twelfth century, in order to link together figures or groups, to convey movement and with it a notion of relief-space stretching from left to right; figures could be overlapped by these coulisses and thus appear to stand behind them. This was the most primitive way of implying picture-space. Secondly, there is the sloping terraced ground, on which the figures and architectural features stand, a heritage from late antique Hellenism, probably handed on by the copying of early illuminated books (61b). Thirdly, there are the architectural motifs, placed obliquely in space and by their arrangement or shape forming niches, in or in front of which the figures and groups stand; and lastly, there is a peculiar means of conveying spatial impressions which we might describe as the opening-up of the physical space in front of and below the picture plane. Of these four spatial elements the last two are closely connected with the monumental system of middle Byzantine decoration, and it is in this way that fourteenth- and fifteenth-century painting in Byzantium is clearly recognizable, for all its new characteristics, as a continuation of the earlier development.

THE SPATIAL NICHE

The growth of the niche-like architectures which give so energetic a tension to the picture-space of late Byzantine paintings can be traced back to the twelfth century and even further. In the later twelfth century the originally flat back walls which appeared to shut off the narrow stages in miniatures began to be transferred into monumental decoration. But they were not taken over unchanged. They were arranged in tripartite units so as to form a "spatial" niche in which the two side sections provide not only the framing motives for a flat composition, but also the "wings" of a spatial stage with a receding centre part. This configuration appears quite frequently in the latest mosaics of Monreale—the Christological scenes of the transepts.[4] The "background" gradually becomes the "stage" (3). This process is, in a sense, the logical outcome of the evolution which began with the inclusion of physical space in the niche-like receptacles of eleventh-century decoration. When pictures originally placed in actual spatial niches, isolated and framed by plastic motifs, had to be transferred to the flat walls of the twelfth-century churches, the painters attempted to make up for the loss of the actual spatial receptacles by representing in the pictures themselves architectonic frameworks with a niche-like character. These fictitious niches which filled the whole extent of the surface within the frame became the substitutes for the original real niches. The side wings of the tripartite backgrounds played the part of the side walls of the niches. The linear arrangement, light, shade and colour, bring out quite clearly the recession in imaginary space. On the other hand, the spatial character of this kind of setting must not be overstressed. What it calls into being is only an implication of space, not a "correct" or perspective rendering of a three-dimensional locality. The setting appears as a tripartite screen without much plastic solidity; the middle part is strictly parallel to the picture plane, not at an oblique angle to it—a step yet to be taken.

Single figures too were given niche-like backgrounds as a substitute for real niches. Good examples are preserved in a few Byzantine icons of the thirteenth century which were painted perhaps on Italian soil but certainly by Greek artists in the purest metropolitan tradition.[5] To this group belongs the enthroned Virgin of the Duveen (Hamilton) collection in New York (32a). The panel is later and in some respects more advanced than the mosaic-scenes of Monreale. The figure is no longer framed as a whole by the niche. A "flat" golden ground appears in the upper part, contrasting vigorously with the energetic curvature of the throne. But the niche-like throne still provides a spatial receptacle for the greater part of the figure, and the original scheme of the Madonna enthroned in the real niche of the curved apse can still be felt as the point of departure for the new arrangement. It was certainly this original scheme which induced the

artist to give so much prominence to the curving side walls of the throne. It was the lingering reminiscence of the figure in the apse which thus found expression.

The juxtaposition of flat and curved, or flat and angular, grounds leads in the course of the development to an ever-increasing spatial differentiation. The spatial characteristics—receding lines, curves, etc.—tend to be overstressed and the motifs to shrink. The curves develop a "springy" quality. One expects them to snap back like steel springs. They convey in this manner a tension which the beholder interprets in spatial terms.

These shrunken niches, which now took up, singly, only a part of the whole, instead of framing it as in Monreale, found their way into the larger compositions of the late thirteenth and early fourteenth centuries. Their appearance in the Venetian mosaics of the thirteenth century has already been pointed out. The mosaics of the Kahrieh Djami go a step further. They display spatial compositions using the revived Hellenistic picture-space, the terraced or sloping ground; and on to this ground, in this independently existing space, are set the shrunken niches in the shape of small structures, curved or angular, placed obliquely in space, just as the figures themselves with their three-quarter views are placed obliquely to the picture plane. The niches open up in an angle of 45 degrees to the picture plane. The niches do not create the spatial framework of the pictures, as they did at Monreale; they only provide spatial accents and highlights in a picture-space already existing, heighten the impression of spatial tension, and serve as resonances for single figures or groups. They belong to those figures and groups whose oblique positions they echo. But they are not really receptacles, for they do not pretend to enclose figures or groups. They open up behind them in such a way that only a part of the group receives appropriate shelter: they are too small to enclose or frame the whole. This smallness is a result of the over-tension of the spatial characteristics. In the "Handing of the Purple to Mary" in the Kahrieh Djami, for instance (61a), the three High Priests sit on a gently curving bench placed obliquely in space. The back of this bench, a high, curved wall, with windows, side towers and colonnades, is curved much more energetically than the bench itself. Translated into terms of ground-plan it would appear to have a much smaller radius. The bench seems to have slipped out, as it were, from the compressed curved space of the wall niche, in which there would not have been room enough for the three seated figures. The contracted semicircle of the niche gives spatial resonance to the whole group and, beyond that, to the whole left half of the composition. In the right half, this vigorous accent is responded to by a rectangular structure, another reduced niche, almost a slit, which, with its deep shadow and oblique position, stresses the figure of the first Temple Virgin, the Leader of the Chorus. The two structures are connected by walls which are placed in different strata of depth. The whole—and this is an early and comparatively simple example

of late Byzantine spatial composition—does not convey the impression of a homogeneous space, but rather one of several spaces set against each other. This is one of the features which are so bewildering in this late phase of Byzantine art: the multiplicity of the parts which do not compose a simple and unified whole.

A Byzantine composition of the fourteenth or fifteenth centuries, however, is not to be measured by standards of Western compositional unity. It is composite just as the ideal "icon" of the Byzantine eleventh century was composite, embracing as it did the whole interior of the church. To realize this is to open up new possibilities of appreciating late Byzantine paintings. The beholder must wander through a single picture just as he must wander through a Byzantine church, with glance ever shifting from one culminating point to the other. He must try to read the picture discursively; then, slowly, a kinematic unity will disclose itself to his searching eyes—the highly composite unity which does not reveal itself to the first glance, just as the decorative system of middle Byzantine churches was not intended to be seen at one glance from a fixed point, but rather from a number of points arranged along certain axes and lines. In late Byzantine pictures the spatial accents created by the niches stand out as the centres of a complicated net of tensions. These accents do not create a unified space, as does the principle of centralized perspective. The result is an agglomeration of individual spaces set into the vague and almost neutral *ambiente* of the Hellenistic stage-landscape. The impression on the Western mind will always be one of a disturbed process of crystallization, with several crystallized bodies embedded in a semi-amorphous mass.

PHYSICAL SPACE AND FLAT COMPOSITION

This semi-amorphous mass, the vaguely spatial *ambiente* of the sloping landscape ground, often possesses in itself one special quality, the fourth of the factors enumerated above. It suggests space in front of and below the picture plane. The "slope" of the ground does not cease at the bottom of the picture; no barrier stops the downward rush beyond its limits. The falling or prostrate apostles, for instance, in fourteenth-century representations of the Transfiguration (62a) seem to be precipitated out of the picture into bottomless space.[6] In other instances the figures are depicted as hurrying, not only from left to right, as in earlier representations of movement on flat surfaces, but from the depth of the picture-space towards the front, and, since the ground is sloping, downwards. This seems to be a reminiscence of the fact that in the monumental paintings of the middle Byzantine era the spatial icons communicated with the space in front and below. The process of which this arrangement was the outcome is essentially the same as that by which the actual niche became a pictorial niche

81

within the picture-space: a part of the physical space in front of and below the icon is now included in the picture-space. Quite frequently this process goes so far that hands, feet and parts of garments actually overlap the bottom frame of the picture.

This feature in late Byzantine painting must not, of course, be mistaken for a realistic projection of a *di sotto in sù* kind as in the European Renaissance. It has nothing to do with the exterior viewpoint. The figures on the sloping ground are seen rather from above than below, although this too is not to be taken as a realistic projection. All it means is that the picture-space is opening out below in order to communicate with the beholder, who is still assumed to be standing beneath the picture—even in the case of miniatures, on which his glance actually falls from above—so strong was the reminiscence of the relation between picture and beholder as it existed in the classical era of middle Byzantine decoration. It imparts to Byzantine space-representation a dynamic quality, an effect which is deeply disturbing for Western eyes, and hardly to be understood if it is not seen in connection with the expiring monumental tradition.

SPATIAL COMPOSITIONS IN FLAT PROJECTION

Beside these subtle influences of middle Byzantine monumental art on the spatial composition of later Byzantine painting, there were other more tangible ones. Certain compositions which had taken shape in the sphere of monumental decoration never lost the character which they had taken on in this sphere. Among them are, in the first place, the specific cupola-subjects which, when transferred to flat ground, never disavowed their origin in the domed space. The representation of the Pantocrator with His cortège of Angels and Prophets was hardly ever transferred to flat grounds[7]—this is one of the most remarkable inhibitions of even the latest Byzantine artists—and this left only the Ascension and the Pentecost, which, as festival icons, were indispensable to any Christological cycle, whether in illuminated books, ivories, portable icons or frescoes on flat walls.

§ The Ascension

The flat compositions of the Ascension of Christ are deeply influenced by the cupola compositions of the same theme. But the artists did not attempt to unroll the cupola frieze mechanically: they sought to preserve something of the arrangement in real space. In many instances they arranged the Apostles in the picture-space of their flat compositions as if they stood in a circle. As an arrangement in a foreshortened circle would have demanded a clearer conception of pictorial space than Byzantine artists ever had at their command, the

Apostles were usually strung up in two rows, one in front and one behind, with an effect of crowding and with "near-profile" figures at the outer ends (62b).[8] Some hint of a circular arrangement was thus included, sufficient probably to recall the impression of the cupola. The dome of the cupola itself was actually represented in one of the earliest examples of the Ascension, in the Rabula Gospels of 586, which must have been painted under the direct influence of one of the Palestinian cupolas.[9]

§ The Pentecost

In the case of the Pentecost,[10] the relation of the flat compositions to the cupola scheme is still closer. The flat compositions of this subject were from the ninth century onwards not only influenced by the corresponding cupola scheme; this had already been the case as early as the sixth century in the Rabula Gospels, where the dome is indicated above the standing apostles.[11] They were actual projections of the spatial layout of the cupola.[12] An analysis of this mode of projection should give some insight into the manner in which the Byzantines themselves saw their spatial icons.

The problem before the artists was to work out a scheme which, though on a flat surface, nevertheless evoked a reminiscence of the spatial icon and preserved the established relationship, formal and spiritual alike, between all the parts of the composition, from the Hetoimasia in the zenith of the cupola down to the Phylai and Glossai of the pendentives. The earliest-known attempts at this scheme seem to be the full-page miniature in the Paris Codex (Gr. 510), the Homilies of Gregory of Nazianzus of 886,[13] and the prototype of the Leningrad Gospels No. XXI (64),[14] which was probably not much later in date. The Paris miniature contains all the iconographic motifs of the cupola representation: the Hetoimasia in a circular medallion, the group of Apostles seated below in attitudes of conversation, the rays of light descending on them from the Hetoimasia, and the Phylai and Glossai standing below in the corners and looking upwards. The figure of the Virgin, still present in the earlier type of the Rabula Gospels and in the prototypes underlying Carolingian representations of the theme,[15] is absent from the Paris Gregory as it is absent from the cupola scheme.

The most interesting features are those of the composition proper. The Apostles are seated on a curved bench, the curve being open at the bottom,[16] and turn towards the centre of an imaginary semicircle,[17] so that the middle figures are seated frontally, the outer figures almost in profile.[18] On to their heads descend the heavenly rays, in curves which evoke the spatial impression of a cupola cut in half. The estrade on which the Apostles are seated forms a semicircle curving downwards like the bench, though with a smaller radius, and continued by horizontal lines towards the edges. The whole arrangement looks like an architrave broken by a rising arc. No attempt is made at drawing this

arc in spatial projection; nor is it actually meant to represent a semicircular estrade on horizontal ground. The semicircle is nothing but the projection of the vertical arch which carries the cupola, and of the empty space underneath the arch, which is indicated by golden ground and occupies more than a third of the miniature. In the bottom corners appear the Phylai and Glossai, in the exact place where they appear in the pendentives of the cupola. The whole arrangement is a kind of elevation of the cupola scheme. It preserves the hierarchical relation between the several parts and something of the optical reality of the cupola view, an achievement which a scheme following the flat composition of the cupola—the ground-plan—could never have produced.

But the dome-like arrangement of the rays, the garland of the seated Apostles and the view of the void below are not the only optical features worked into the elevation scheme. The early examples of the subject contain other motifs which were dropped later on (63), when the iconographic formula became more independent of its origin. These motifs are the pillar-like structures in the upper corners, and their original meaning can be understood if it is realized that the corners of the pillars in front of the cupola in the actual space of the church are projected, to the oblique view from below, on to the sides of the dome and above the heads of the Apostles, whose figures are embedded between the two pillars. Even photographs render this projection quite faithfully.[19] The upper corners of the pillars seem to cut into the dome. What is represented in the Paris Gregory and the Leningrad Gospels is the salient optical feature, namely, the angle formed by the faces of the pillars and their receding flanks. It is a curious mixture of schematic and optical projection which makes up the composition of the Pentecost on flat surfaces.

CONCLUSION

The case is typical of the Byzantine manner of seeing and projection. Neither the schematic nor the optical mode of projection reigns supreme. Oriental art would have stuck to the first, Hellenistic art to the second; middle Byzantine art seeks to combine the two. In this way no completely logical rendering of space could be achieved. The allurement of optical impression clouded the clear geometrical scheme, and, on the other hand, the systematic trend broke up the unity of the optical view. For the Byzantine artist there was no clear distinction between the world of abstract schemes and symbols and that of optical experiences. Both were to him equally strong realities, and he could not rid himself of one in order unreservedly to embrace the other. His twofold heritage—from Greece and from the Orient—would not let him go either way. So he went on combining the two modes, mutually exclusive as they were.

Seen from the Western point of view, Byzantine representational art through-

out its evolution had to overcome one obstacle after another which it encountered in its search for a method of achieving unity within the picture. The very foundation of post-Iconoclastic art rendered this achievement difficult, for the primary aim of the middle Byzantine painter was to establish a relation between the image and the beholder. The single figure was alone wholly suited to this condition. Any aggregation of figures and motifs within the same icon raised essential difficulties, and something of the close relation between the figure and the worshipper had to be sacrificed in order to achieve some contact among the figures themselves. But this theoretical difficulty was not the only one. Parallel with it there must have been a special disposition in the make-up of the Byzantine artist, causing him to "see" things singly and making it difficult for him to create a complex whole which would be at once organically consistent and spatially continuous. The world picture of Hellenism had gone to pieces long ago, and the middle Byzantine artist tried to put those pieces together in vain. Only during the short classical period of middle Byzantine art, when the artist knew how to enlist the help of physical space in his endeavour to relate the various figures of the single icons to each other, as also to relate the icons among themselves and each to the beholder; in the period when the spatial conception of the icon allowed the figures to turn both towards the worshipper and towards each other—only in this period could the artist create pictures which were themselves organic wholes while remaining integral parts of an all-embracing unit. Within this system the Byzantine artist could control the effects of the spatial medium; he could correct them and harness them to his purposes. But once this conception had broken down, once the artist was confronted with the task of himself building up a system of relations in pictorial space, he was again confronted with the unredeemed multiplicity of the visible world. The means to which he then resorted—the intensification of movement and gesture, the dynamic accompaniment of the figures with a landscape setting, the provision of spatial accents and centres of tension—could not re-establish the unity which had been achieved for a time by the spatial *ambiente* of the naos. And when, at last, some sort of fusion of his passionate energies seemed drawing near, the evolution of Byzantine art in its own sphere was cut short by the fall of Constantinople.

NOTES

I

[1] J. Sauer, *Die Symbolik des Kirchengebäudes und seiner Ausstattung in der Auffassung des Mittelalters*, Freiburg i. B., 1902.

[2] For a summary of this doctrinal controversy, see K. Schwarzlose, *Der Bilderstreit, ein Kampf der griechischen Kirche um ihre Eigenart und Freiheit*, Gotha, 1890; L. Bréhier, *La querelle des images*, Paris, 1904; N. Melioransky, "Filosofskaya storona ikonoborchestva", *Voprosy Filosofii*, etc., II, 1907, p. 149 ff.; L. Duchesne, "L'iconographie byzantine dans un document grec du IXe s.", *Roma e Oriente*, vol. V, 1912–13, pp. 222 ff., 273 ff., 349 ff.; A. v. Harnack, *Dogmengeschichte*, Tübingen, 1922, p. 275 ff.; G. A. Ostrogorski, "La doctrine des saintes icones et le dogme christologique" (Russian), *Seminarium Kondakovianum*, I, Prague, 1927, p. 35 ff.; *Idem*, "Die erkenntnistheoretischen Grundlagen des byzantinischen Bilderstreites" (Russian with German résumé), *Ibid.*, II, Prague, 1928, p. 48 ff.; *Idem, Studien zur Geschichte des byzantinischen Bilderstreites*, Breslau, 1929; *Idem*, "Rom und Byzanz in Kampfe um die Bilderverehrung" (Russian with German resumé), *Sem. Kondak.*, VI, Prague, 1933, p. 73 ff.; E. J. Martin, *History of the Iconoclastic Controversy*, London, 1930; G. Ladner, "Der Bilderstreit und die Kunstlehren der byzantinischen und abendländischen Theologie", *Zeitschrift für Kirchengeschichte*, III. F., I, vol. 50, 1931, p. 1 ff.; V. Grumel, "Récherches récentes sur l'iconoclasme", *Échos d'Orient*, XXIX, 1930, p. 99 ff.—What follows here is a very simplified summary of the main Christological arguments used in the controversy.

[3] This thought can be traced back to the writings of Germanos, at the end of the seventh century. See Ostrogorski, *La doctrine*, etc., *loc. cit.*, p. 36.

[4] Both ideas, that of magical identity and that of venerability, had become firmly established in one branch of popular religious art in the fifth and sixth centuries, long before the beginning of the Iconoclastic controversy. See K. Holl, "Der Anteil der Styliten am Aufkommen der Bilderverehrung", *Philothesia, P. Kleinert zu seinem 70. Geburtstag*, Berlin, 1907, p. 54 ff. The popular belief was that the spiritual force of the venerated Stylites and their power to aid were immanent in their representations. This seems to have been the origin of the belief in the miracle-working power of images.

[5] The problem is similar to that of representing an action on the stage. But there the solution is rendered easier by the fact that the figures are in motion.

[6] The more recent bibliography on this subject will be found in the article "Kreuzkuppelkirche", by W. Zaloziecky, in Wasmuth's *Lexikon der Baukunst*, and in various papers by N. Brunov (*Byz. Zeitschrift*, 27, 1927, p. 63 ff.; 29, 1929–30, p. 248; 30, 1930, p. 554 ff., etc.).

[7] Few things, indeed, have kept their form so perfectly and unchangingly as the Byzantine cross-in-square church. An analogy from a different field may illustrate this stationary perfection and completion: the violin, whose shape, once perfected, could not be improved upon. Its form is not affected by its scale, whether simple violin or double-bass, just as the form of the Byzantine church remains the same throughout its whole range, from tiny chapel to vast cathedral.

[8] See, for example, the 18th Homily of Gregory of Nazianzus, and Procopius's description of the Haghia Sophia in Constantinople.

[9] See T. Whittemore, *The Mosaics of St. Sophia at Istanbul, First prel. report*, Oxford, 1933, p. 12; *Idem, Second prel. report*, 1936, p. 10.

[10] G. Millet, *Le monastère de Daphni*, Paris, 1899. *Idem, Récherches sur l'iconographie de l'Évangile*, Paris, 1916.

[11] See Simeon of Thessalonike, in Migne, *Patrologia Graeca*, tom. 155, col. 338 ff.

[12] Γερμανοῦ ἀρχιεπισκόπου Κωνσταντινοπόλεως ἱστορία ἐκκλησιαστικὴ καὶ μυστικὴ θεωρία, ed. Rome, 1556. The conch of the apse is the cave of Bethlehem and also the Sepulchre of Christ;

the altar is the table of the Last Supper; the ciborium signifies Golgotha and the Holy Sepulchre, and so on.

[13] Migne, *Patr. Gr.*, tom. 155, col. 305 ff., esp. 340, where the Bema is identified with Heaven, the Synthronos with the Ascension of Christ; the Prothesis signifies the cave of Bethlehem (col. 347), etc.

[14] The sources of this interpretation are quoted in G. Millet, *Récherches*, *loc. cit.*, p. 25 ff.

[15] For the Western conception, see the writings of A. Schmarsow, especially his "Kompositionsgesetze in den Reichenauer Wandgemälden", *Rep. für Kunstwiss.*, vol. XXXVII, 1904, p. 261 ff., and *Kompositionsgesetze in der Kunst des Mittelalters*, Leipzig, 1915.

[16] This division of the architectural decoration into horizontal zones is in strict accordance with Byzantine and early Christian, as opposed to antique, cosmography. See D. Ainalov, *Ellenisticheskiya osnovy vizantiyskago iskusstva*, St. Petersburg, 1900; and *Rep. für Kunstwiss.*, XXVI, 1903, p. 36.

[17] A. Heisenberg, *Grabeskirche und Apostelkirche*, II, Leipzig, 1908. The Pantocrator programme of the central cupola was the result of later changes. See N. Malicky, "Remarques sur la date des mosaiques de l'église des Stes Apôtres à Constantinople", *Byzantion*, III, 1926, p. 123 ff. with bibliography.

[18] E. Diez and O. Demus, *Byzantine Mosaics in Greece: Hosios Lucas and Daphni*, Cambridge, Mass., 1931, p. 110 with bibliography; A. C. Orlandos, *Monuments byzantins de Chios*, 2 vols., Athènes, 1930–31.

[19] T. Schmit, "Kahrieh Djami", *Izvestiya Russk. Arch. Inst. v Konst.*, VIII–IX, 1902 and 1906.

[20] An echo of the type of Chios is to be found in the apse of Sta. Francesca Romana in Rome. See R. van Marle, *The Development of the Italian Schools of Painting*, I, The Hague, 1923, fig. 80.

[21] O. Demus, *Die Mosaiken von San Marco in Venedig, 1100–1300*, Wien, 1935, figs. 2, 4, 9, 12.

[22] N. A. Bees, "Kunstgeschichtliche Untersuchungen über die Eulaliosfrage und den Mosaikschmuck der Apostelkirche", *Rep. für Kunstwiss.*, vol. XL, 1917, p. 59.

[23] T. Schmit, "Mozaiki monastyrya prepodobnago Luki", *Sbornik Kharkovskago Ist.-Filol. Obshchestva*, XXI, 1913–14, p. 318 ff.; *Idem*, *Die Koimesiskirche von Nikaia: Das Bauwerk und die Mosaiken*, Berlin, 1927, p. 52 ff. O. Demus, in Diez and Demus, *op. cit.*, p. 42 ff.

[24] For example, in El Nazar, Queledjlar, Quaranleq, Tchareqlé, Elmalé, Analipsis in Gueurémé; see G. de Jerphanion, *Les églises rupestres de Cappadoce*, Paris, 1925 ff., passim.

[25] For example, in Venice and, as a reminiscence in combination with the Pantocrator scheme, in the apses of Cefalù and Monreale.

[26] For example, in Nereditzy, where the central cupola contains a combination of the Ascension and the Glory of the Pantocrator. See N. Sychev and V. K. Myasoyedov, *Freski Spasa Nereditzy*, Leningrad, 1925, Pls. III–XIV.

[27] T. Schmit, *Mozaiki*, *loc. cit.*, and *Nikaia*, *loc. cit.*, argues that the main reason why the Pantocrator scheme was substituted for the Ascension was the diminution in scale of the Byzantine cupolas from the eleventh century onwards. These smaller cupolas had room for eight windows only, between which the twelve Apostles could not easily be placed, whereas the sixteen Prophets fitted the given space. In addition, the increased height of the cupolas suggested, according to Schmit, the inclusion of the Choir of Angels. This argument, however, is not conclusive, because the Pantocrator scheme was already developed in the ninth century. The reasons for the change seem to have been mainly iconographical, the substitution of the dogmatic symbol for the Gospel narrative.

[28] Diez and Demus, *op. cit.*, plan after p. 117 and fig. 1.

[29] Daphni, Nicaea, Nereditzy, Monreale, etc.

[30] O. Wulff, *Die Koimesiskirche in Nicaea und ihre Mosaiken*, Strassburg, 1903, p. 202 ff. Diez and Demus, *op. cit.*, p. 73.

[31] For example, in Nereditzy (Sychev, *op. cit.*, Pl. LXVII), Vladimir (I. Grabar, *Die Freskomalerei der Dimitrikathedrale in Vladimir*, Berlin, 1926), Kiev (Monastery of St. Cyril), Pereyaslavl and Staraya Ladoga.

[32] In St. Angelo in Formis, Torcello and originally also in St. Mark's, Venice.

[33] A reminder that the festival scenes of the Ascension and the Pentecost, later supplanted by the Pantocrator and the Hetoimasia, originally had their place in cupolas, can be seen in the fact that the favourite sites for these two scenes from the twelfth century onwards were the vaults of the transept or the chapels preceding the two side apses (Cappadocia, Mistra, the Capella Palatina at Palermo, etc.).

[34] To Russia (Kiev, Nereditzy) and Italy (Torcello, Murano).

[35] As originally in the Nea. This meaning is also preponderant in the figure of the Hodegetria above the northern side apse in the Palatina, Palermo.

[36] Simeon of Thessalonike; Migne, *Patr. Gr.*, tom. 155, col. 347.

[37] Diez and Demus, *op. cit.*, plans after p. 117.

[38] G. Millet, *Récherches*, *op. cit.*, p. 16 ff., with texts.

[39] *loc. cit.*, with texts from pseudo-Cyrillus and Germanus.

[40] Apparent in the writings of Theodore of Andida and Nicholas Kabasilas; Millet, *op. cit.*, p. 27 ff.

[41] Or to very flat niches, as at Chios.

[42] This is likewise the reason why the baldachin in the Presentation in Hosios Lukas was not placed in the centre of the squinch, but moved to the left. It would have appeared contorted had it been left in the centre, as was normal in flat compositions.

[43] Diez and Demus, *op. cit.*, fig. 5, and ground plan.

[44] The same is true of the Entry into Jerusalem in Daphni; *op. cit.*, fig. 92.

[45] After Photius's description of the Nea of Basil I. See O. Wulff, *Altchristliche und byzantinische Kunst*, II, Potsdam, 1924, p. 551.

[46] In the twelfth century SS. Peter and Paul were also represented in this way (Monreale).

[47] This is true not only of the pendentives of the main cupolas but also of the spandrels of the typically Byzantine vaults with continuous pendentives (corbel vaults) as, for example, in the narthex of Nicaea. See O. Wulff, *Die Koimesiskirche*, *op. cit.*, Pl. III.

[48] See the Holy Women at the Sepulchre, in the apex of the vault between the Ascension and the Pentecost cupolas. Part of the mosaic is visible in fig. 12 of Demus, *Die Mosaiken*, *op. cit.*, For a description see A. Robertson, *The Bible of St. Mark*, London, 1898, p. 273.

[49] This would correspond to Wickhoff's "complettierender Darstellung" and not to his "continuierender Darstellung". See F. Wickhoff, *Römische Kunst. Die Wiener Genesis*, Wien, 1895, *passim*.

[50] We apply this analytical kind of optical perception even to flat projections like photographs, and much more so in actual space.

[51] Examples can be found in the apses of Torcello, Kiev, Seres, etc.

[52] Diez and Demus, *op. cit.*, Pl. XII, figs. 2, 10, 11.

[53] I am obliged for this communication to Dr. J. Wilde. The chapel, founded by Pierfrancesco Borgherini, was decorated 1516–24. The relevant drawings by Sebastiano which show the marked broadening of the proportions, are: 1st, an elaborate drawing of St. James in the Transfiguration (for the lunette, right corner) at Chatsworth (A. Popham, *Italian Drawings Exhibited . . . at Burlington House*, 1931, Pl. CC); 2nd, a drawing of St. Peter (for the apse-like niche, left corner) in the Uffizi (*Old Master Drawings*, vol. 14, nos. 54–56, 1939–40, Pl. 23). The books on Sebastiano (I have not seen Dussler's book, recently published in Bâle) make no mention of the preventive distortions.

[54] T. Whittemore, *American Journal of Archæology*, April–June 1942, p. 169, Pls. I and IV.

[55] T. Whittemore, *The Mosaics of St. Sophia, etc.*, *First Report*, *op. cit.*, Pl. XII ff.

[56] A. Schmarsow has pointed out the analogy between the firmly "stepping" rhythm of Western interior decorations and the couplet of the Western epics of chivalry, as against the free, circling rhythm of centralized Eastern decorations which recalls the structure of the antique strophe.

[57] O. Wulff, "Das Raumerlebnis des Naos im Spiegel der Ekphrasis", *Byz. Zeitschr.*, 30, 1930, p. 531 ff.

[58] See the description of the cupola of St. Sophia by Procopius (Wulff, *loc. cit.*), who attributes to the overflowing light of the windows its effect of weightless hovering.

[59] Forerunners of this can be found as early as the twelfth century. Most examples, however,

belong to the fourteenth and the following centuries, e.g. Mistrà Peribleptos Church, Volotovo, etc. See P. Muratov, *La peinture byzantine*, Paris, 1935, Pls. 253, 257, 258, etc.

[60] E. Diez, in Diez and Demus, *op. cit.*, p. 90, quotes examples from Hosios Lukas, interpreting them, however, in too realistic a way, as if the modelling had been arranged with regard to the actual direction of the light which falls through the windows.

[61] Blue and purple for Mary; blue and gold for Christ in the scenes before the Crucifixion, white for His garments in the Transfiguration, and purple and gold in the scenes after the Resurrection; blue and beige for St. Peter, light green and blue for St. Paul, etc.

[62] Diez and Demus, *op. cit.*, fig. 101 (cheek of Mary).

[63] Something of this kind can be seen in the Christ of the apse in Cefalù, especially in the large folds of the lower part of the bust (V. Lazarev, "The Mosaics of Cefalù", *Art Bulletin*, vol. XVII, No. 2, 1935, p. 184 ff., fig. 2).

[64] See also the Pantocrator in Arta, Panaghia Parigoritissa. Wulff, *Byz. Kunst*, *op. cit.*, fig. 399.

[65] T. Schmit, "Kahrieh Djami", *Izvestiya*, *loc. cit.*, 1906; D. Ainalov, *Vizantiyskaya zhivopis 14. stoletiya*, Petrograd, 1916.

[66] P. Muratov, *La peinture*, *op. cit.*, Pls. CCVII ff.

II

[1] W. H. Goodyear, *Greek Refinements*, New Haven, 1912; G. Hauck, "Die subjektive Perspektive und die horizontalen Kurvaturen des dorischen Stils", *Festschrift der technischen Hochschule Stuttgart*, 1879; Giovannoni, in *Jahrbuch des Deutschen Archäologischen Instituts in Rom*, vol. XXIII, 1908, p. 109 ff.; A. von Gerkan, in *Mitteilungen des Deutschen Arch. Inst., Röm. Abt.*, vol. XL, 1925, p. 167 ff., etc. The curvatures of the Greek temple were first observed by J. Hoffner and J. Pennethorne in 1837; but doubts as to their very existence could still be maintained in 1910 (J. Durm, *Die Baukunst der Griechen*, 3rd ed., Leipzig, 1910, p. 120 ff.). Scholars are not agreed on the interpretation of the curvatures; the explanation that the curves are intended to correct optical illusions seems to have been refuted (Goodyear, *op. cit.*, p. 48 ff.) in its primitive form. The theory, on the other hand, by which it was for some time superseded—that the irregularities are "temperamental expressions of a dislike for monotony and formalism, and temperamental devices of artists who realized the disastrous results of mechanical methods" (*op. cit.*, p. 213)—fights shy of Vitruvius's statement (Book III, 4–5, and III, 5–8), and does not explain the optical consistency of the devices. The latest hypothesis attempts, as far as I am aware, to explain the Greek refinements as the result of an over-compensation inherent in the optical apperception of the Ancients (Giovannoni). For similar devices in mediæval architecture see W. H. Goodyear, in *Memoirs of Arts and Archæology*, Museum of Brooklyn Institute of Arts and Sciences. Vol. I, Nos. 1, 2, New York, 1901 f.

[2] J. Burckhardt, *Griechische Kulturgeschichte*, ed. Kröner, Leipzig, vol. 2, p. 298.

[3] Proclus, *In Euclidem*, ed. Friedlein, Leipzig, 1873, p. 40, quoted by E. Panofsky, "Die Perspektive als symbolische Form", *Vorträge der Bibliothek Warburg*, 1924–25 (p. 265 ff.), p. 302: "σκηνογραφικήν . . . δεικνύουσαν πῶς ἂν τὰ φαινόμενα μὴ ἄρυθμα ἢ ἄμορφα φαντάζοιτο, ἐν ταῖς εἰκόσι παρὰ τὰς ἀποστάσεις καὶ τὰ ὕψη τῶν γεγραμμένων . . ." ("Perspective [is the practice] which teaches the artist how to ensure that something in his work should not appear distorted by distance or height.") This phrase, it is true, has been interpreted by R. Delbrück (*Beiträge zur Kenntnis der Linearperspektive in der griechischen Kunst*, Bonn, 1899, p. 42) as applying to the perspective rendering of three-dimensional objects in two-dimensional projections; but this interpretation cannot be seriously defended. If Proclus had meant to convey this meaning he would have written not τῶν γεγραμμένων (the painted forms) but τῶν πραγμάτων (the objects) or τῶν φαινομένων (the visible things, appearances). Proclus's interpretation of *skenographia* as the art of anti-perspective correction is, moreover, foreshadowed in the writings of Geminus (Panofsky, *op. cit.*, p. 302), as the third of three purposes of "perspective" enumerated in the chapter which bears the title: Τί τὸ σκηνογραφικόν : "Τοιοῦτος δ'ἔστι λόγος καὶ τῷ κολοσσοποιῷ, διδοὺς τὴν φανησομένην τοῦ ἀποτελέσματος συμμετρίαν ἵνα πρὸς τὴν ὄψιν εὔρυθμος εἴη . . . οὐ γὰρ οἷα ἔστι τὰ ἔργα τοιαῦτα φαίνεται ἐν πολλῷ ἀναστήματι

τιθέμενα." ("Definition of perspective: '. . . The laws which teach the monumental sculptor what his finished work will look like, so that it will be eurhythmic to the eye of the beholder . . . for works which are destined to be seen from a great distance do not appear as they really are . . .' "). It is characteristic of Proclus's "Byzantine" character that he retains this alone of the three definitions or purposes of perspective given by his predecessor Geminus.

[4] M. I. Rostovtzev, "Dura and the Problem of Parthian Art", *Yale Classical Studies*, vol. V, New Haven, 1934, p. 238 ff., esp. p. 240.

[5] C. Hopkins, "A Note on Frontality in Near Eastern Art", *Ars Islamica*, III, 2, 1936, p. 187.

[6] F. Cumont, *Fouilles de Doura*, Paris, 1926, Pl. XXXII ff.; "Excavations of Dura Europos: Preliminary report", vol. VI; E. Diez, in *Belvedere*, VI, 30, 1924, p. 200 ff.

[7] J. H. Breasted, *Oriental Forerunners of Byzantine Painting*, Chicago, 1924.

[8] N. Toll, "L'art Parthe comme un des éléments de la formation du style byzantin", *Bulletin de l'Inst. arch. Bulgare*, X, Sofia, 1936, p. 207 ff.

[9] M. van Berchem et E. Clouzot, *Mosaiques Chrétiennes du IVe au Xe siècle*, Genève, 1924, pp. 1 ff., 11 ff.

[10] *loc. cit.*, p. 97 ff.

[11] *loc. cit.*, p. 171 ff.

[12] *loc. cit.*, p. 125 ff.

[13] A. Baumstark, "I mosaici di S. Apollinare Nuovo e l'antico anno liturgico Ravennate", *Rassegna Gregoriana*, IX, 1–2, Rome, 1910.

[14] A. Heisenberg, *Grabeskirche und Apostelkirche*, op. cit., vol. II, *passim*; Idem, "Die alten Mosaiken der Apostelkirche und der Agia Sophia", *Byz. Zeitschr.*, XXI, 1912, p. 134 ff.; N. A. Bees, *op. cit.*; A. Heisenberg, "Die Zeit des byzantinischen Malers Eulalios", *Philol. Wochenschr.*, 1921, No. 43, p. 1024 ff.; N. Malicky, *op. cit.*; S. Poglayen-Neuwall, in *Zeitschr. für Kirchengeschichte*, 1921, XI.

[15] The same applies to St. Sergius at Gaza. See the description by Choricius, ed. Boissonade, Paris, 1846.

[16] Van Berchem and Clouzot, *op. cit.*, p. 145 ff.

[17] J. Quitt, *Der Mosaikenzyklusvon San Vitale in Ravenna. Eine Apologie des Diophysitismus aus dem 6. Jahrhundert. Byzant. Denkmäler*, III, Wien, 1903. Quitt attempted to interpret the décor as a pictorial refutation of the Monophysite heresy. A. Ühli, *Die Mosaiken von Ravenna*, Basel, 1924, met with failure similar to Quitt's with regard to S. Apollinare Nuovo.

[18] Van Berchem and Clouzot, *op. cit.*, p. 159 ff.

[19] *op. cit.*, p. 73 ff.

[20] Ch. Diehl, *Manuel d'art byzantin*, 2e édit., Paris, 1925, p. 365 ff.

[21] J. Strzygowski, *Der Ursprung der christlichen Kirchenkunst*, Wien, 1920.

[22] Constantine Porphyrogenitus, *De Caerimoniis*; Digenis Acritas; the writings of Theodore of Studium and John of Damascus, etc. See also N. Yorga, "Le nouvel Héllenisme et l'Iconoclasme", *L'Acropole*, I, 1926, p. 5 ff.; A. Grabar, "L'iconographie sacrée des empereurs byzantins et l'art des Iconoclastes", *Bull. Inst. Arch. Bulgare*, X, 1936; J. Ebersolt, *Les arts somptuaires de Byzance*, Paris, 1923; Idem, *Le Grand Palais de Constantinople et le livre des cérémonies*, Paris, 1910.

[23] The Stanza di Ruggiero in the Palace of Palermo and the Zisa. L. Anastasi, *L'arte nel Parco Reale Normanno di Palermo*, Palermo, 1935; G. U. Arata, *L'architettura arabo-normanna in Sicilia*, Milano, 1914.

[24] A. N. Grabar, "Les fresques des escaliers à Ste. Sophie de Kiev et l'iconographie Impériale byzantine", *Semin. Kondakov.*, VII, p. 103, with bibliography.

[25] E. de Lorey, in *Monuments Piot*, XXX, 1930; M. van Berchem, in K. A. C. Creswell, *Early Muslim Architecture*, I, Oxford, 1932, p. 229.

[26] Van Berchem-Creswell, *op. cit.*, p. 149.

[27] W. Harvey *et al.*, ed. R. W. Schultz, *The Church of the Nativity at Bethlehem*, London, 1910; V. Vincent et F. M. Abel, *Bethléhem, le Sanctuaire de la Nativité*, Paris, 1914.

[28] E. de Lorey, "L'Hellénisme et l'Orient dans les mosaiques de la mosquée des Omayades", *Ars Islamica*, 1934, vol. I, Part 1, p. 24 ff. Closely akin to the mosaics of Damascus are the recently excavated pavement mosaics in the Islamic Palace of Khirbet el Mafjer, near Jericho.

[29] For the religious interpretation of floral and animal motifs see J. Strzygowski, *op. cit.* (Engl. edition, London, 1923), and other writings by the same author (*Die bildende Kunst des Ostens*, Leipzig, 1916; *Die Baukunst der Armenier und Europa*, Wien, 1918, etc.).

[30] See, for example, Haghia Irene in Constantinople, Haghia Sophia at Salonica, and the Church of the Koimesis at Nicaea. In the two latter the Cross was subsequently supplanted by the Virgin. On the Cross in the decorations of the Iconoclasts see G. Millet in *Bulletin de Correspondance hellén.*, 1910, p. 96 ff.

[31] O. Wulff, *Die Koimesiskirche, op. cit.*, p. 195 ff.

[32] *loc. cit.*, p. 274 f.

[33] *loc. cit.*, p. 236 (with quotations from Theodore of Studium).

[34] On the building and its date (third decade of the eighth century, Leo III), see M. Kalliga, *Die Hagia Sophia von Thessalonike*, Würzburg, 1935. For the mosaics: F. Le Tourneau et Ch. Diehl in *Monuments Piot*, XVI, 1909, p. 43; Diehl, Le Tourneau et Saladin, *Les monuments Chrétiens de Salonique*, Paris, 1918, p. 117 ff.

[35] The correct date, 886, of the cupola mosaics (which are homogeneous) is given by O. Wulff (Review in *Rep. für Kunstwiss.*, XXIII, 1900, p. 337 ff.) and Lazarev (*Byz. Zeitschr.*, XXIX, 1929–30, p. 283) as against the above-mentioned authors, most handbooks (eleventh century), and J. Kurth, "Die Mosaikinschriften von Salonik", *Mitteilungen des archäol. Inst. Athen*, vol. 22, 1897, p. 465 ff. (eighth century).

[36] J. Smirnov in *Vizantiyskiy Vremennik*, 1898, V, p. 365 and 1900, VII, p. 60.

[37] There is not the faintest reason why this figure should be dated at an earlier period. The mosaics of the cupola are thoroughly homogeneous.

[38] Photius, *Descriptio Ecclesiae Novae*. In the Bonn edition of Codinus, p. 194 ff.

[39] See, for instance, the mosaics in the San Zeno chapel of Sta Prassede, the most "Byzantine" monument of the ninth century in Rome.

[40] For the Ascension cupolas of Jerusalem see A. Heisenberg, *Grabeskirche, op. cit.*, passim; T. Schmit, in *Svetilnik*, 1914, vol. 7, p. 12 ff.; H. Schrade, in *Vorträge der Bibliothek Warburg*, 1928–29, p. 66 ff. On the Pentecost: A. Baumstark, "Il mosaico degli Apostoli nella chiesa Abbaziale di Grottaferrata", *Oriens Christianus*, IV, 1904, p. 121 ff.

[41] See above, p. 36.

[42] Van Berchem and Clouzot, *op. cit.*, fig. 82.

[43] Earlier examples are preserved in fresco decorations and ivories.

[44] T. Schmit, *Kievskiy Sofiyskiy Sobor*, Moscow, 1914, with bibliography.

[45] D. Ainalov, "Die Mosaiken des Michaelsklosters in Kiew", *Belvedere*, 9–10, 1926, p. 201 ff., fig. on p. 201.

[46] A. Riegl, *Die Spätrömische Kunstindustrie*, 2nd ed., Wien, 1927, p. 248; O. Wulff und M. Alpatov, *Denkmäler der Ikonenmalerei*, Hellerau, 1923, p. 66 ff.

[47] See C. R. Morey, *The Painted Covers of the Washington MS. of the Gospels*, 1914, p. 77.

[48] See the Third Part of the *Painters Guide of Mt. Athos, Distribution of Subjects* (Ed. Didron, Paris, 1845).

[49] On the Sicilian mosaics, see V. Lazarev, *The Mosaics of Cefalù, op. cit.*, with bibliography, and a forthcoming book by the present writer.

[50] For instance, the cupola paintings in the church of the Hierotheos monastery near Megara. See G. Lambakis, *Mémoire sur les antiquités Chrétiennes de la Grèce*, Athènes, 1902, fig. 145.

[51] O. Demus, *Die Mosaiken, op. cit.*, p. 83; *Idem*, "Studies among the Torcello Mosaics", I–III, *Burlington Magazine*, 1943–44, Nos. 483, 491, 497; *Idem*, "The Ciborium Mosaics of Parenzo", *Ibid.*, 1945, No. 511.

[52] Demus, *Die Mosaiken, op. cit.*, p. 12 f.

[53] The Madonna in the conch is a later addition, probably replacing a seated figure of Christ.

[54] *loc. cit.*, fig. 4.

[55] *loc. cit.*, figs. 25, 26.

[56] *loc. cit.*, fig. 2.

[57] Demus, *Burlington Magazine*, No. 483.

[58] Demus, *Die Mosaiken, op. cit.*, figs. 9–11.

[59] The two other figures renewed at the same time, the Obadiah and the Habakkuk, were set by a different master. See *op. cit.*, pp. 23, 62, 86.

[60] *loc. cit.*, figs. 5–8.

[61] *loc. cit.*, figs. 15, 16, upper parts.

[62] *loc. cit.*, figs. 15, 16, lower halves.

[63] *loc. cit.*, fig. 17.

[64] J. J. Tikkanen, *Die Genesismosaiken von San Marco und die Cottonbibel*, Helsingfors, 1889; Demus, *op. cit.*, pp. 42 ff., 98; Ainalov, *Vizantiyskaya zhivopis, op. cit., passim.*

[65] Demus, *loc. cit.*, fig. 27.

[66] *loc. cit.*, fig. 29.

[67] *loc. cit.*, fig. 28.

[68] *loc. cit.*, fig. 31.

[69] G. Gombosi, "Il Portico della Basilica di San Marco", *Estr. dalla Miscellanea in onore di Alessio Petrovics*, Budapest, 1934, p. 9 ff.; L. Marangoni, "L'architetto ignoto di San Marco", *Archivio Veneto*, serie V, vol. XIII, 1933; Demus, *loc. cit.*, p. 45; *Idem*, "Über einige Venezianische Mosaiken des 13. Jahrhunderts", *Belvedere*, Oct. 1931, p. 87 ff.

[70] Demus, *Die Mosaiken, op. cit.*, fig. 46.

[71] *loc. cit.*, fig. 47.

[72] *loc. cit.*, figs. 50, 49.

[73] T. Schmit, *Kahrieh Djami, op. cit.*

[74] K. Weitzmann, "Constantinopolitan Book-illumination in the period of the Latin conquest", *Gazette des Beaux Arts*, April 1944 (série VI, vol. XXV, No. 926), p. 193 ff.

III

[1] The various views are set forth in Ainalov's *Vizantiyskaya zhipovis, loc. cit.* For a new hypothesis as to the rôle of the thirteenth century, see Weitzmann, *op. cit.*

[2] G. Millet, "Les Monuments du Mt. Athos" (*Monuments Byzantins*, V), Paris, 1927; K. Brockhaus, *Die Kunst in den Athosklöstern*, Leipzig, 1891; K. Fichtner, *Die Wandmalereien der Athosklöster*, Berlin, 1931; R. Byron and D. T. Rice, *The Birth of Western Painting*, London, 1930.

[3] For an account of the genesis of mediæval picture-space see M. Schild-Bunim, *Space in Mediæval Painting*, New York, 1940.

[4] See, for instance, the Last Supper, the Washing of the Feet, the Doubting of Thomas and the Disciples at Emmaus.

[5] B. Berenson, "Due dipinti del decimosecondo secolo venuti da Costantinopoli", *Dedalo*, II, 1921, p. 285; R. van Marle, *The Development, op. cit.*, vol. I, fig. 292. V. Lazarev (in *Burlington Magazine*, Dec. 1933, p. 291, Pl. IIa) sees in the main panel (Duveen) a Sicilian work of the late thirteenth century. The niche-like throne occurs also in the two mosaics in San Gregorio and the Museo Nazionale at Messina (*loc. cit.*, Pl. I, c, d).

[6] See, for instance, Paris, Bibl. Nat., Cd. Gr. 1242, Opuscula Monachi Joasaph (Ch. Diehl, *La peinture byzantine*, Paris, 1933, Pl. LXXXIX), or the fresco in the Uspenskiy cathedral at Vladimir (Tolstoi-Kondakov, *Russkiya drevnosti v pamyatnikakh iskusstva*, pt. 6, St. Petersburg, 1899, fig. 97, p. 60).

[7] The Virgin with Angels and Apostles was frequently represented, but preferably on circular discs, as in the so-called Patene of Pulcheria in Xeropotamou, Athos (Diehl, *Manuel, loc. cit.*, II, fig. 355). The figures are arranged radially round the Virgin in the centre.

[8] For instance, the ivory, Weitzmann-Goldschmidt, *Byz. Elfenbeinskulpturen*, II, No. 24a.

[9] See Diehl, *La peinture, op. cit.*, Pl. LXXI.

[10] See K. Künstle, *Ikonographie der christlichen Kunst*, I, Freiburg, 1928, p. 517 ff., with bibliography; E. Sandberg-Vavalà, *La Croce dipinta Italiana e l'iconografia della Passione*, Verona, 1929, pp. 375–81; Baumstark, *Il mosaico, op. cit.*, p. 121 ff.; Diez and Demus, *op. cit.*, p. 72 f.; Demus, *Die Mosaiken, op. cit.*, p. 84; A. N. Grabar, "Le schèma iconographique de la Pentecôte" (Russ. with French résumé), *Semin. Kondakov.*, II, 1928, p. 223.

[11] C. R. Morey, "Notes on East Christian Miniatures", *Art Bulletin*, vol. XI, No. 1 (1929), fig. 86.

[12] How close the connection was can be seen in the miniature of the Vatican Homilies, Cd. Gr. 1162 (Diehl, *Manuel, op. cit.*, fig. 199), which was shown by Heisenberg (*Apostelkirche, op. cit.*, p. 199 ff., Pls. I, X) to be a representation of the Church of the Apostles at Constantinople. The main subject of the miniature is the Ascension; it appears in an architectural framework representing a five-cupola church; in the central cupola which is cut open appears the Pentecost in the type described above.

[13] Morey, *op. cit.*, fig. 88.

[14] *op. cit.*, fig. 85.

[15] Grabar, *op. cit.*, p. 223 ff.

[16] The shape of this curve, with the ends pointing downwards, not upwards, seems to contradict the normal optical projection of the cupola ring. In a photograph (Diez-Demus, *op. cit.*, fig. 1) the curve of the seated Apostles points the opposite way. For the feelings of spatial arrangement, however, the Byzantine projection is much more convincing than the correct one. It brings home the hollow bell shape of the cupola. A proof that the Byzantine artists "saw" the projection in this way is furnished by the miniature in the Vat. Gr. 1162 quoted above (Note 12).

[17] There is a certain resemblance between this scheme and the current representations of the Last Supper with the C-shaped table. This resemblance is, however, fortuitous. The main feature in the Pentecost scheme is the open arch at the bottom.

[18] A similar scheme, actually taken from the Pentecost scheme, was used for representations of Councils, as for example, in the Paris Gregory (No. 510; C. R. Morey, *op. cit.*, fig. 89) and in the Vatican Menologium (Diehl, *op. cit.*, fig. 308). The scheme was, in the first place, adopted for theological reasons—the gathering of the Apostles at Pentecost being taken as the prototype of the Councils of the Church. The architectonic schematism is, of course, less consistent in these second-hand adaptations than in the original Pentecost schemes.

[19] See Diez and Demus, *op. cit.*, fig. 4, Interior of Hosios Lukas. But there is one thing which the photograph cannot give: the kinetic element of the impression.

INDEX

95

INDEX

PLATES

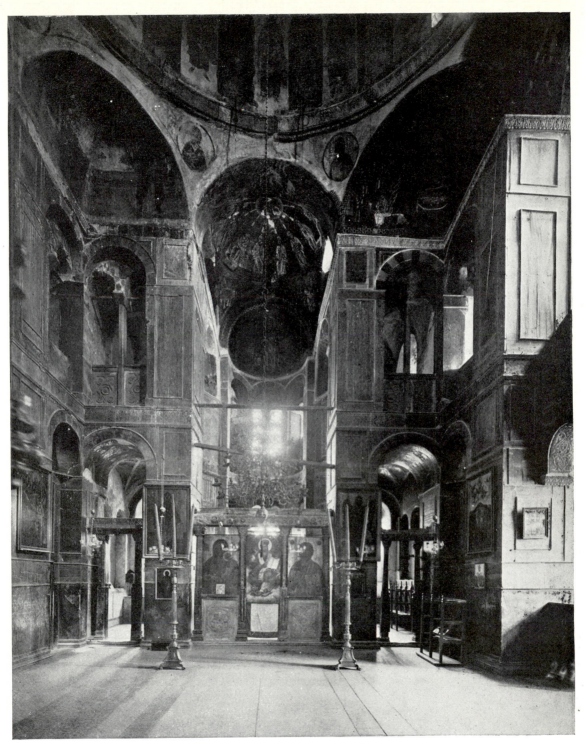

1. Hosios Lucas, Catholicon : Interior.
After Diez-Demus.

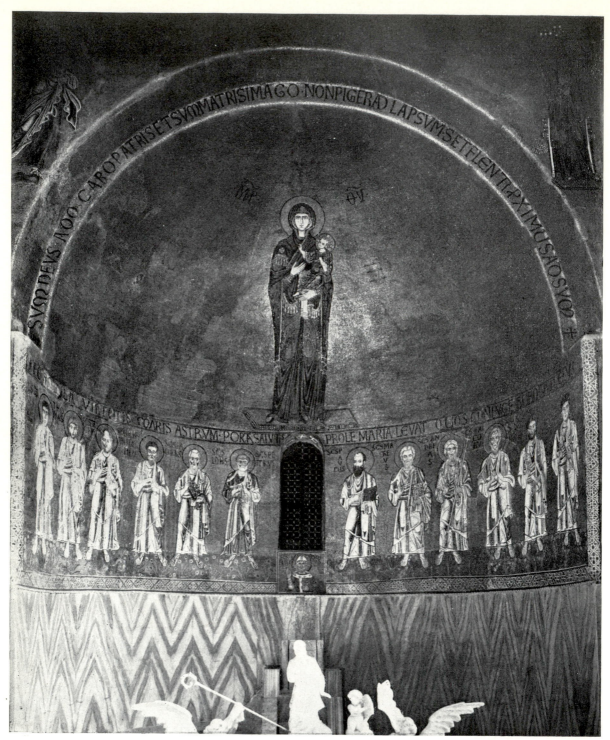

2. Torcello, Cathedral : Main apse.
Photo Alinari.

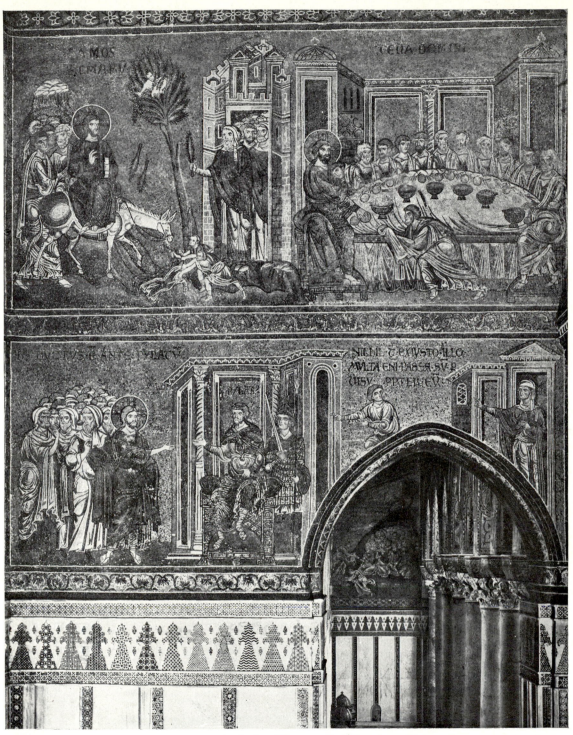

3. Monreale, Cathedral : West wall of Southern Transept.
Photo Alinari.

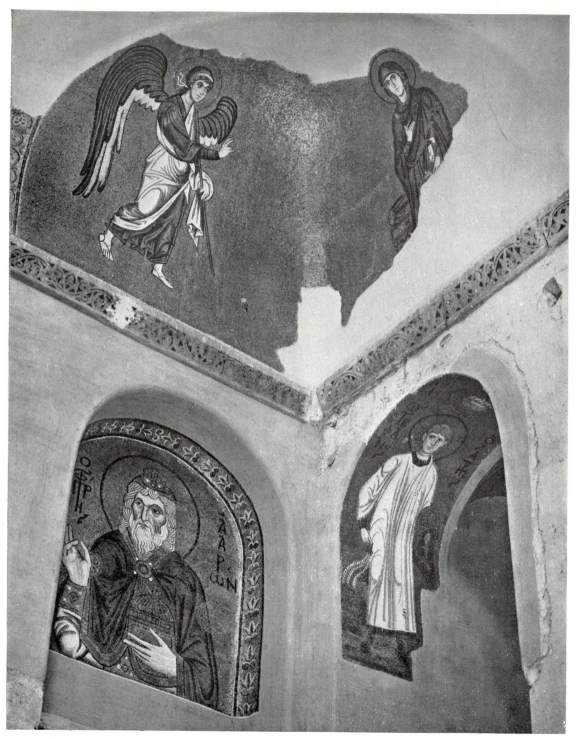

4. Daphni, Catholicon : Annunciation and Saints.
Photo Alinari.

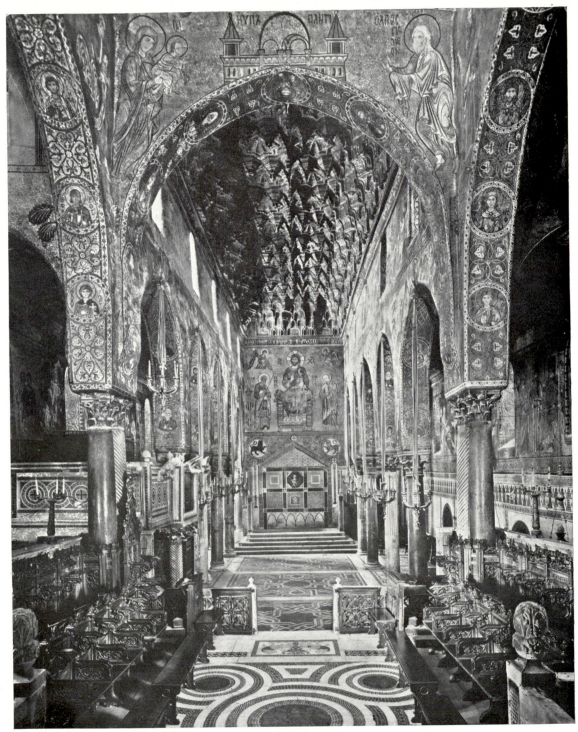

5. Palermo, Palatine Chapel : Interior towards west.
Photo Anderson.

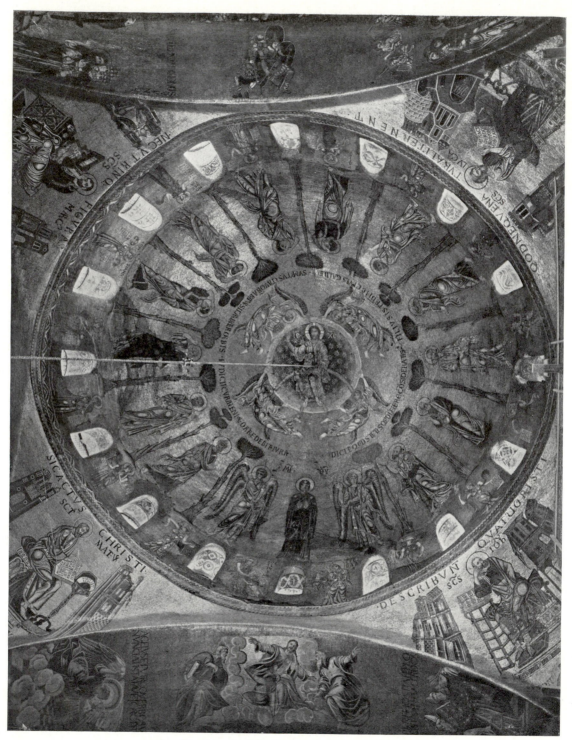

6. Venice, St. Mark's : Ascension cupola.
Photo Alinari.

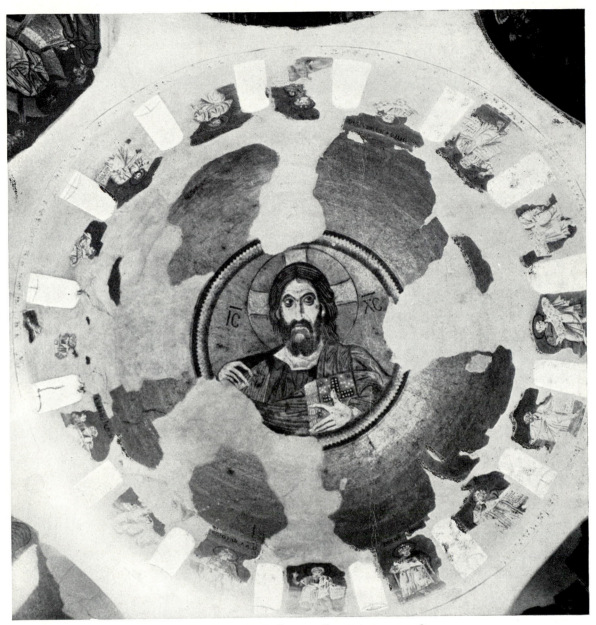

7. Daphni, Catholicon : Pantocrator cupola.
Photo Demus.

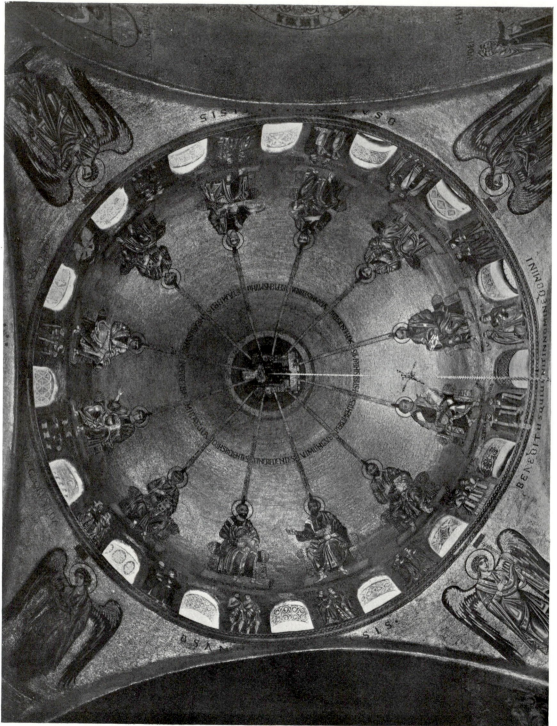

8. Venice, St. Mark's : Pentecost cupola.

Photo Alinari.

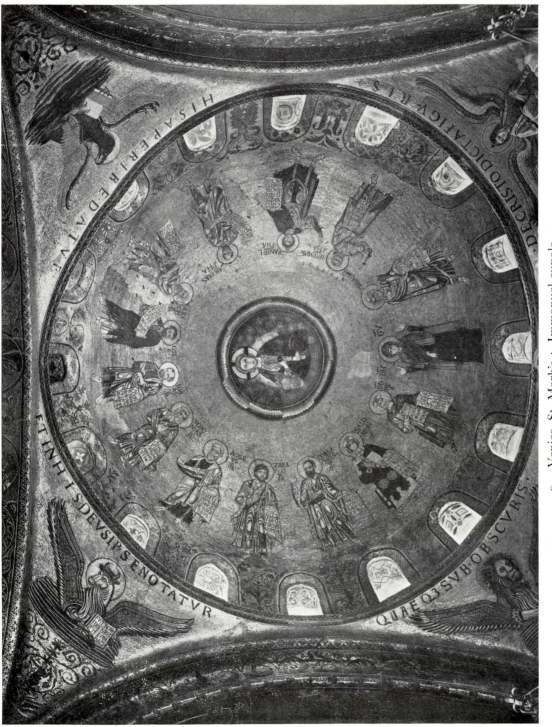

9. Venice, St. Mark's : Immanuel cupola.
Photo Alinari.

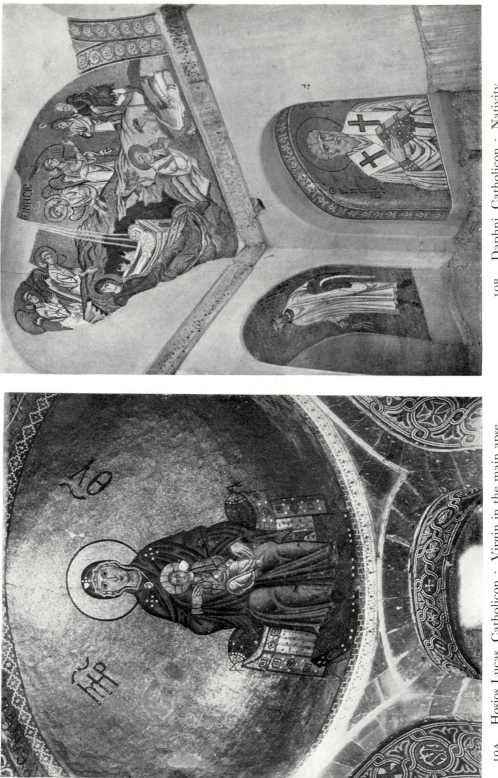

10B. Daphni, Catholicon : Nativity.
Photo Alinari.

10A. Hosios Lucas, Catholicon : Virgin in the main apse.
After Diez-Demus.

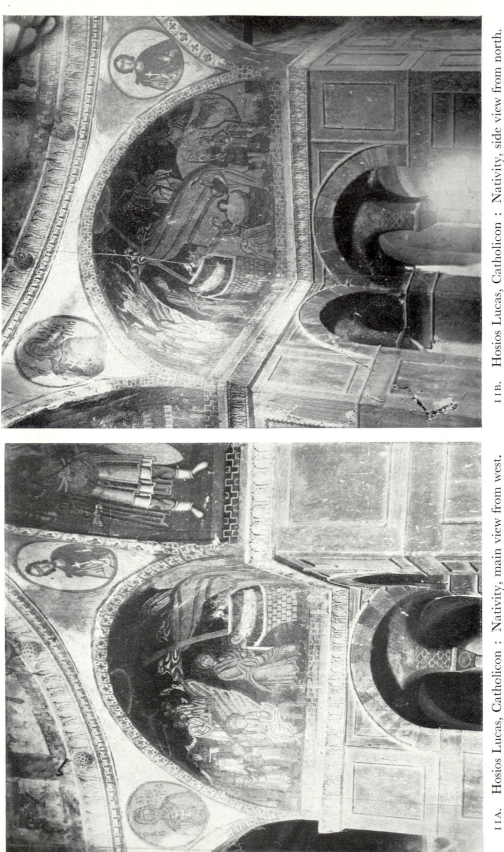

11B. Hosios Lucas, Catholicon : Nativity, side view from north.
After Diez–Demus.

11A. Hosios Lucas, Catholicon : Nativity, main view from west.
After Diez–Demus.

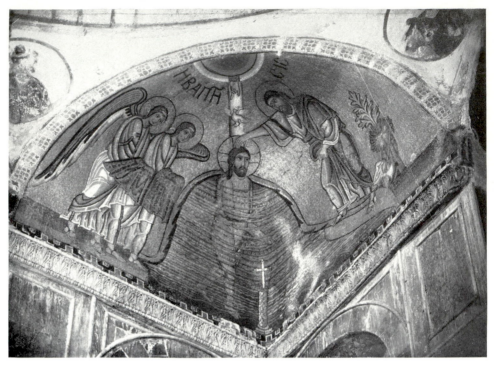

12A. Hosios Lucas, Catholicon : Baptism.
After Diez-Demus.

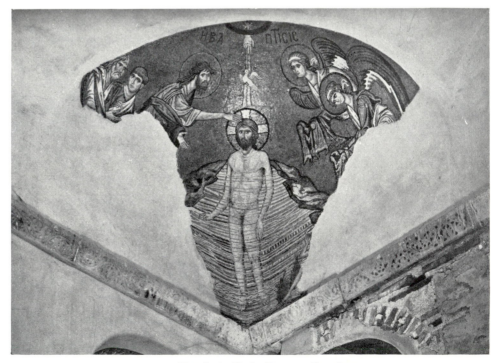

12B. Daphni, Catholicon : Baptism.
Photo Alinari.

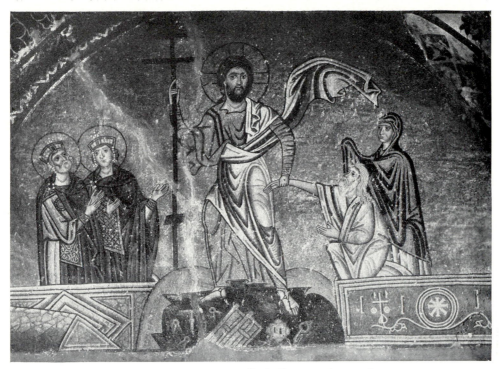

13A. Hosios Lucas, Catholicon : Anastasis.
After Diez-Demus.

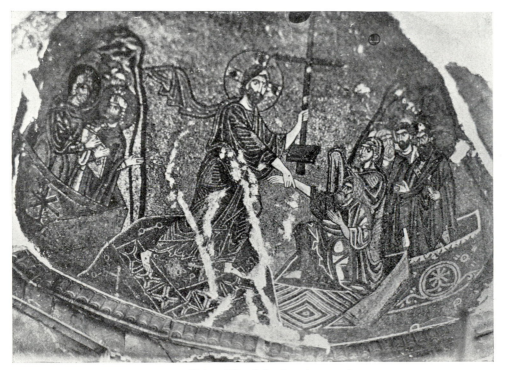

13B. Chios, Nea Moni : Anastasis.
After Diez-Demus.

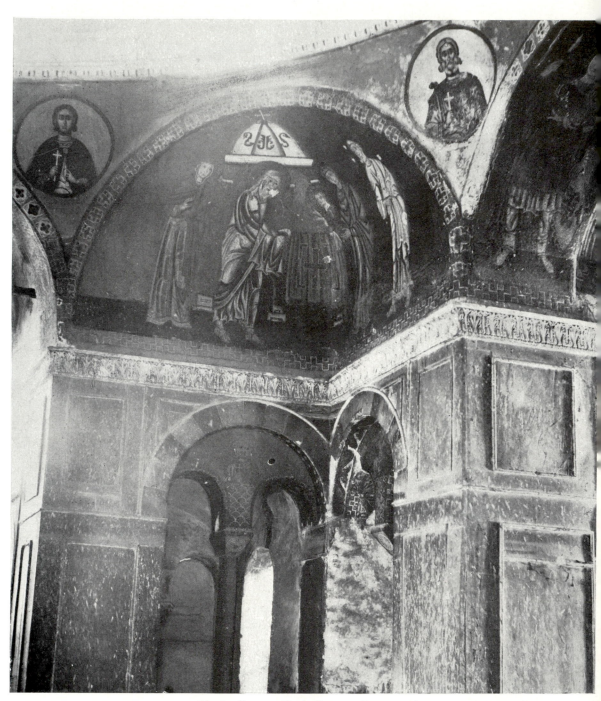

14. Hosios Lucas, Catholicon : Presentation.
After Diez-Demus.

15. Daphni, Catholicon : Vaults with figures of Saints.
After Diez-Demus.

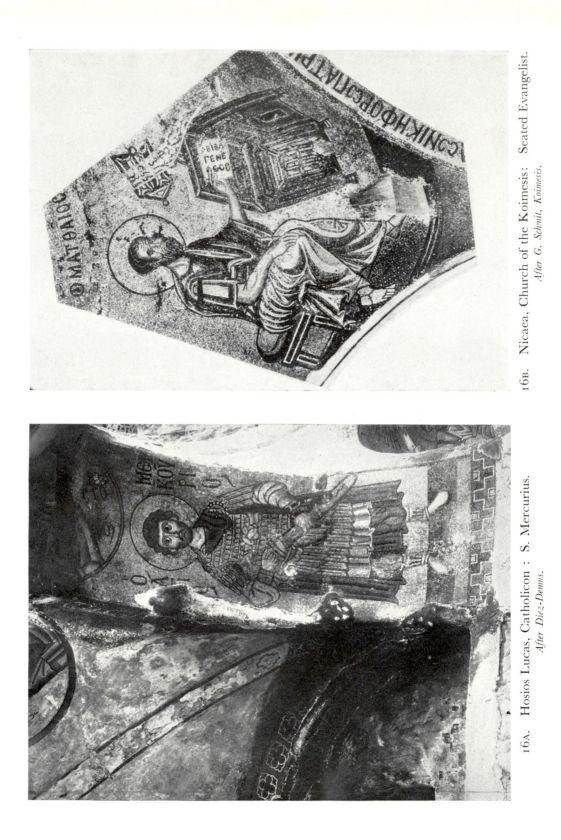

16B. Nicaea, Church of the Koimesis: Seated Evangelist.
After G. Schmit, Koimesis.

16A. Hosios Lucas, Catholicon : S. Mercurius.
After Diez-Demus.

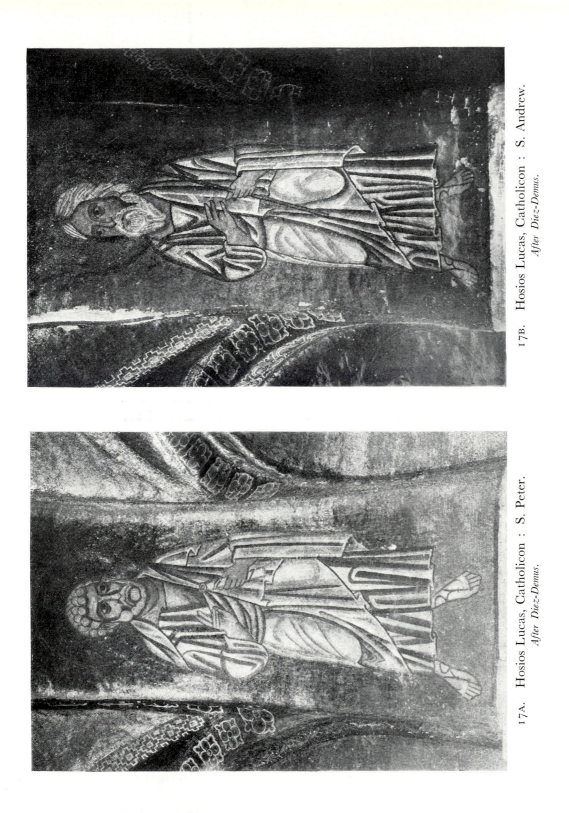

17B. Hosios Lucas, Catholicon : S. Andrew.
After Diez-Demus.

17A. Hosios Lucas, Catholicon : S. Peter.
After Diez-Demus.

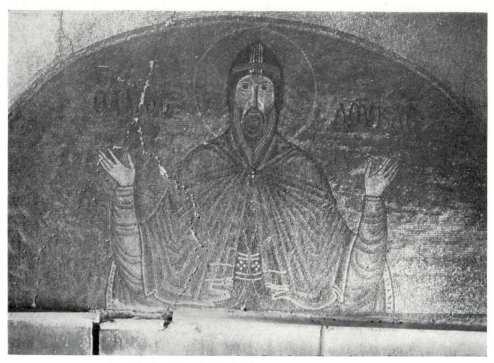

18A. Hosios Lucas, Catholicon : S. Luke Stiriotes.
After Diez-Demus.

18B. Hosios Lucas, Catholicon : SS. John and Kyros.
After Diez-Demus.

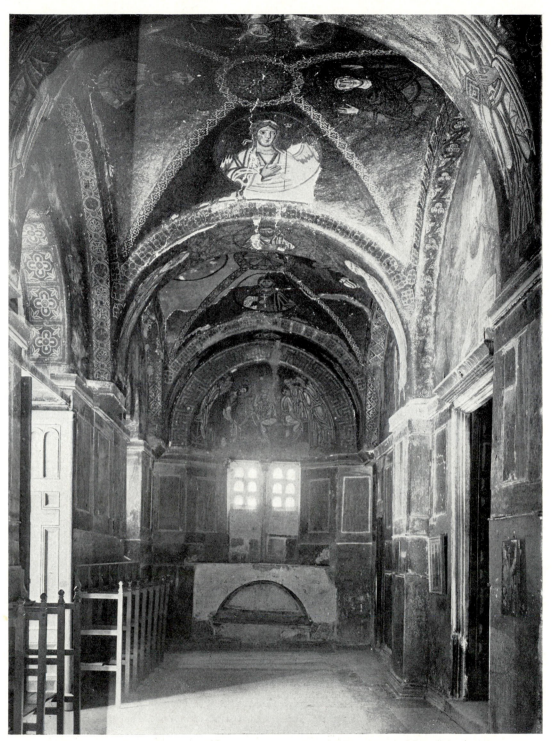

19. Hosios Lucas, Catholicon : Narthex towards north.
After Diez-Demus.

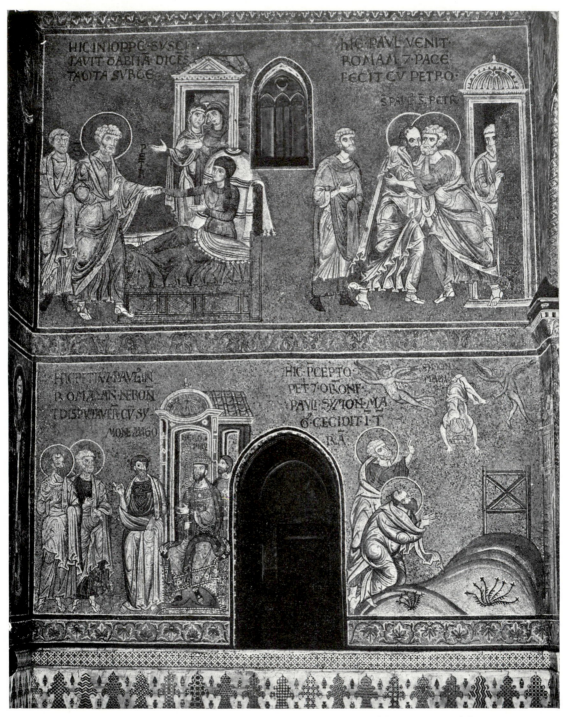

20. Monreale, Cathedral: Scenes from the Lives of SS. Peter and Paul.
Photo Anderson.

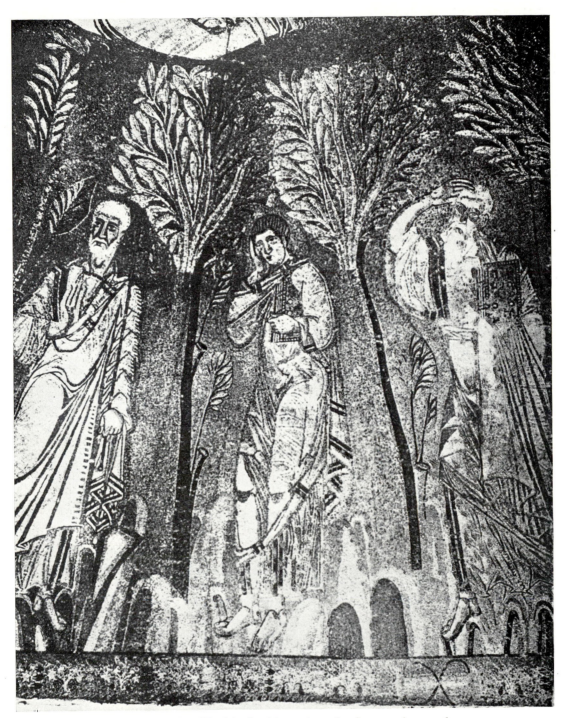

21. Salonika, Haghia Sophia : Apostles from main cupola.
After Diehl, Le Tourneau, Saladin.

22. Torcello, Cathedral : Apostles in the main apse.

Photo Alinari.

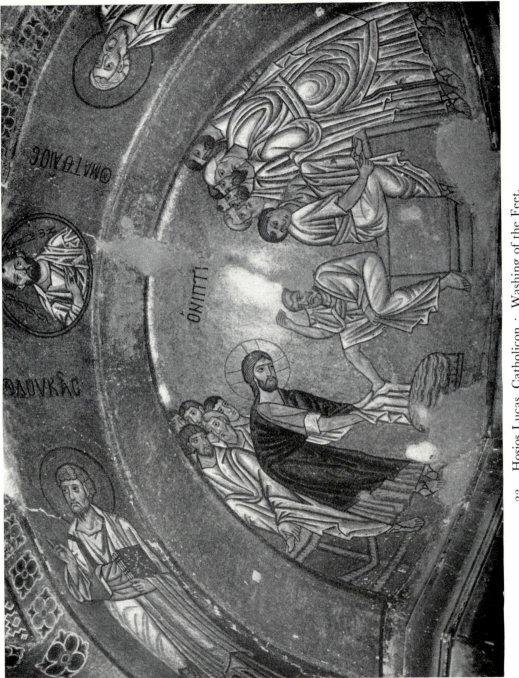

23. Hosios Lucas, Catholicon : Washing of the Feet.
After Diez-Demus.

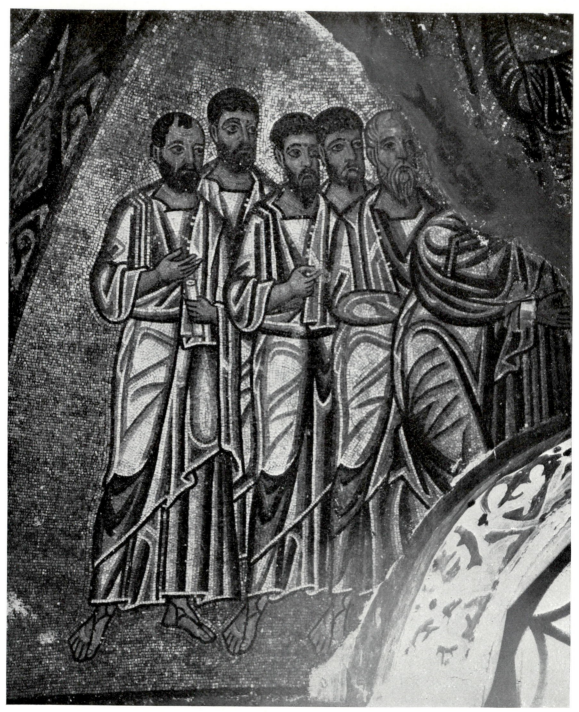

24. Hosios Lucas, Catholicon : Incredulity of Thomas, detail.
After Diez-Demus.

25. Constantinople, Haghia Sophia : Angel in presbytery vault, detail.
After Whittemore, Am. Journ. of Archaeology, 1942.

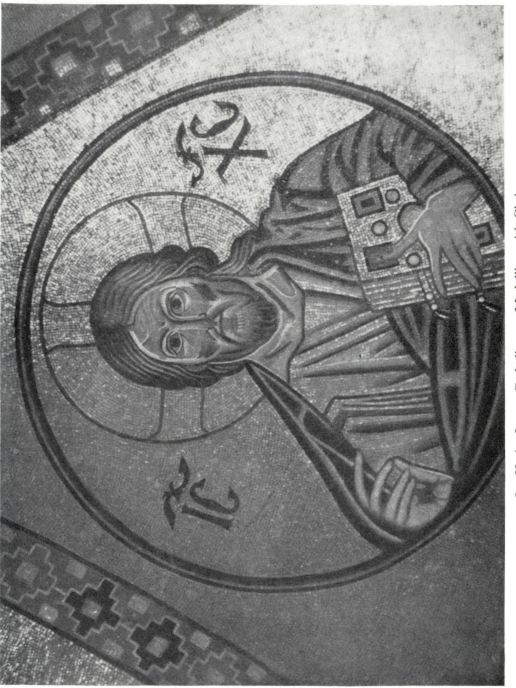

26. Hosios Lucas, Catholicon : Medallion with Christ.

After Diez-Demus.

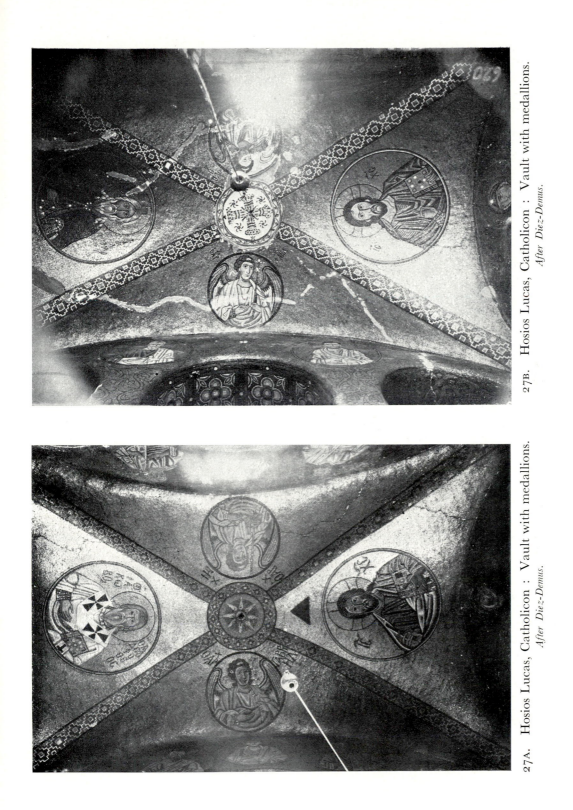

27A. Hosios Lucas, Catholicon : Vault with medallions.
After Diez-Demus.

27B. Hosios Lucas, Catholicon : Vault with medallions.
After Diez-Demus.

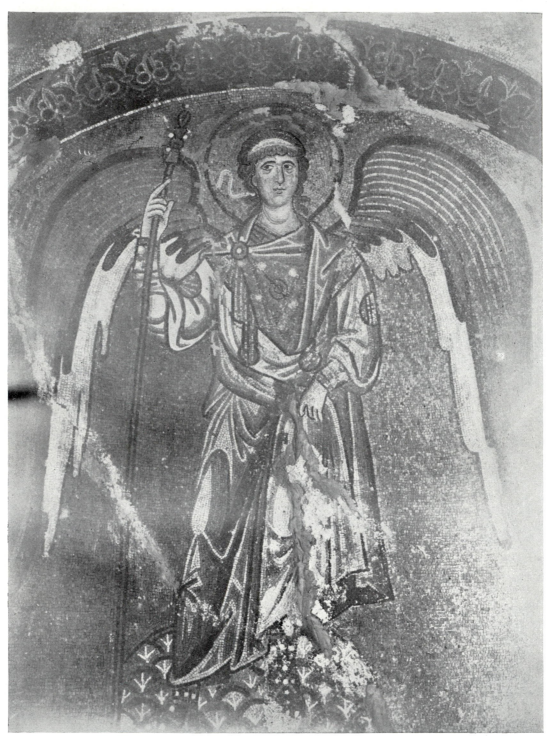

28. Daphni, Catholicon : S. Michael in Bema.
After Diez-Demus.

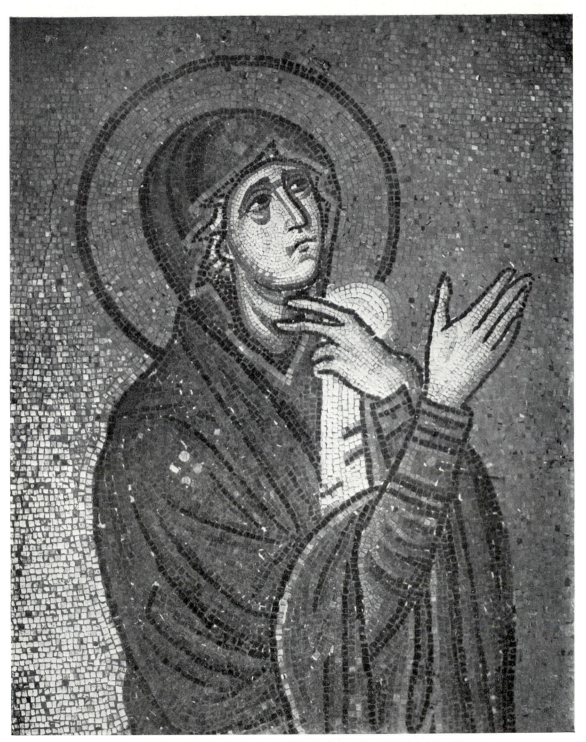

29. Daphni, Catholicon : Virgin from Crucifixion, detail.
After Diez-Demus.

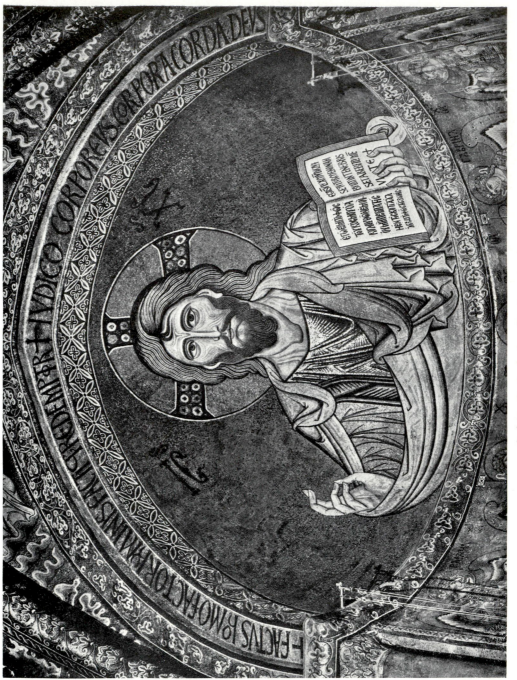

30. Cefalù, Cathedral : Pantocrator in apse.
Photo Anderson.

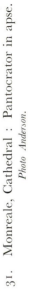

31. Monreale, Cathedral : Pantocrator in apse.

Photo Anderson.

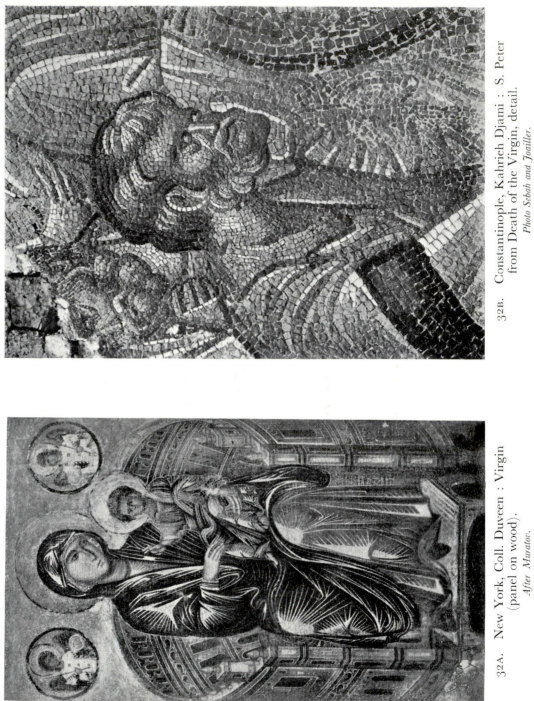

32B. Constantinople, Kahrieh Djami : S. Peter
from Death of the Virgin, detail.
Photo Sebah and Joailler.

32A. New York, Coll. Duveen : Virgin
(panel on wood).
After Muratov.

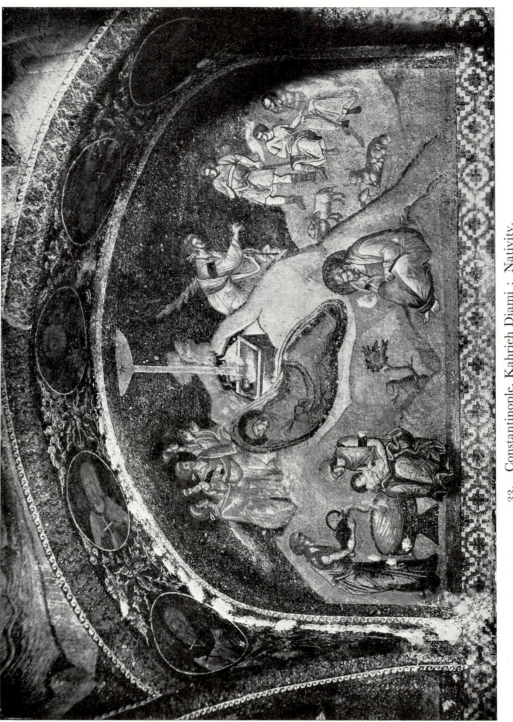
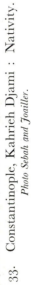

33. Constantinople, Kahrieh Djami : Nativity.
Photo Sebah and Joaïller.

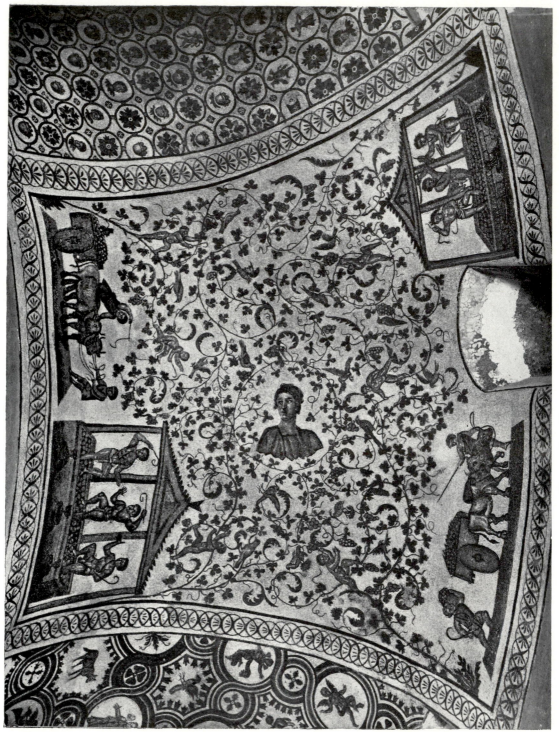

34. Rome, Sta. Costanza : Decoration of ring-vault.
Photo Anderson.

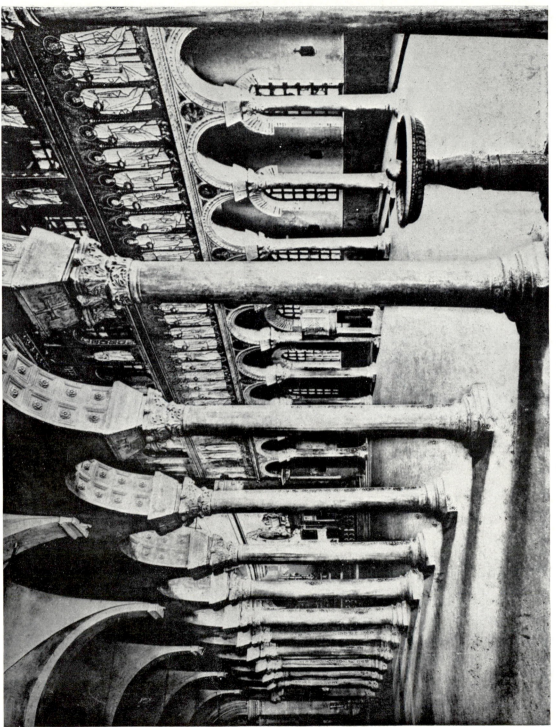

35. Ravenna, St. Apollinare Nuovo : Interior.
After Peirce and Tyler.

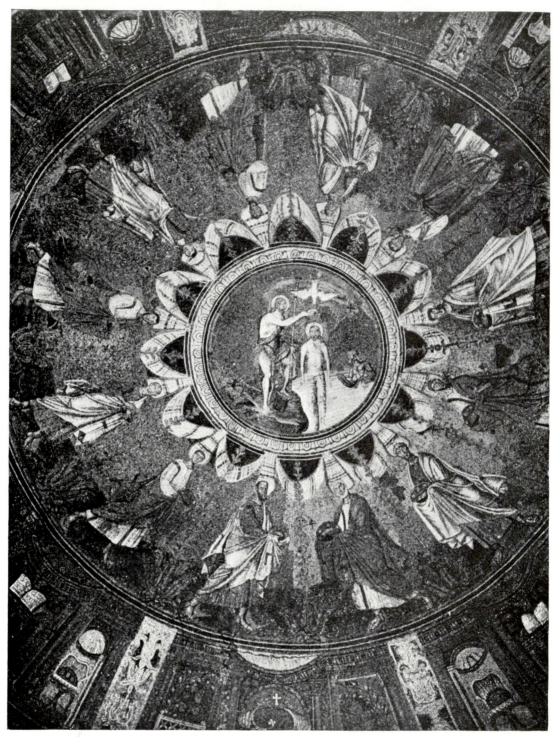

36. Ravenna, Baptistery of Neon : Cupola.
After Colasanti.

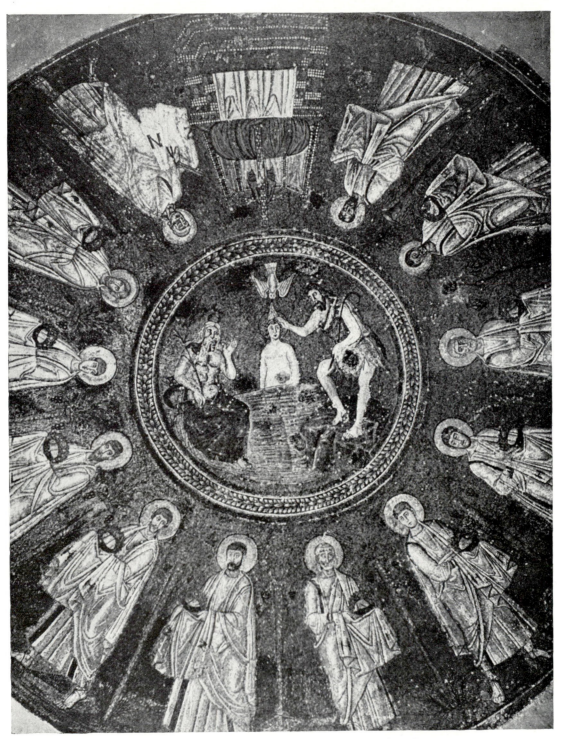

37. Ravenna, Baptistery of the Arians : Cupola.
After Colasanti.

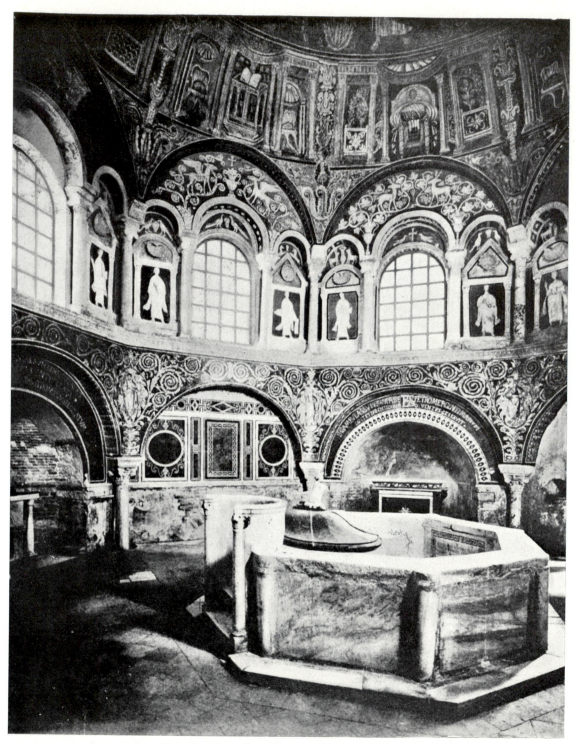

38. Ravenna, Baptistery of Neon : Interior.
After Peirce and Tyler.

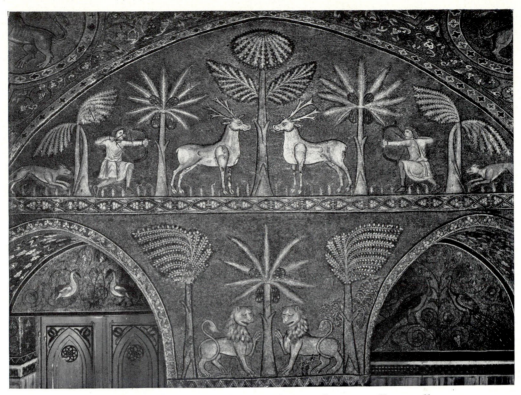

39A. Palermo, Royal Palace, Norman Stanza : East wall.
Photo Anderson.

39B. Damascus, Great Mosque : Décor in courtyard.
After de Lorey.

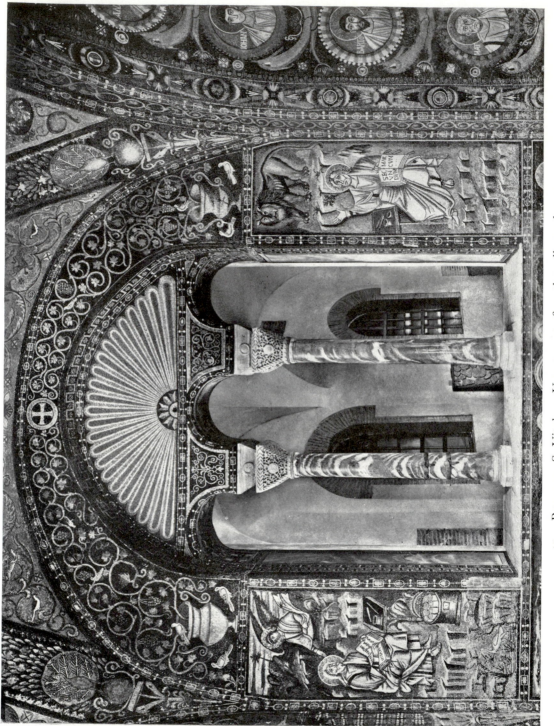

40. Ravenna, S. Vitale : Upper part of south wall, presbytery.
Photo Anderson.

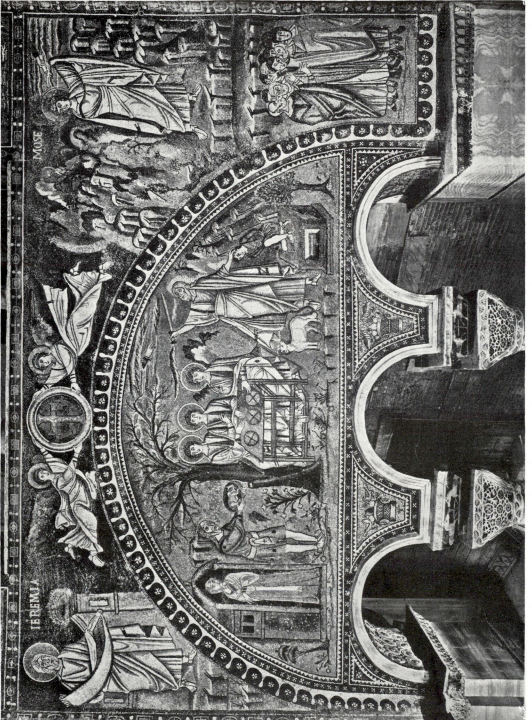

41. Ravenna, S. Vitale : Lower part of north wall, presbytery.

Photo Anderson.

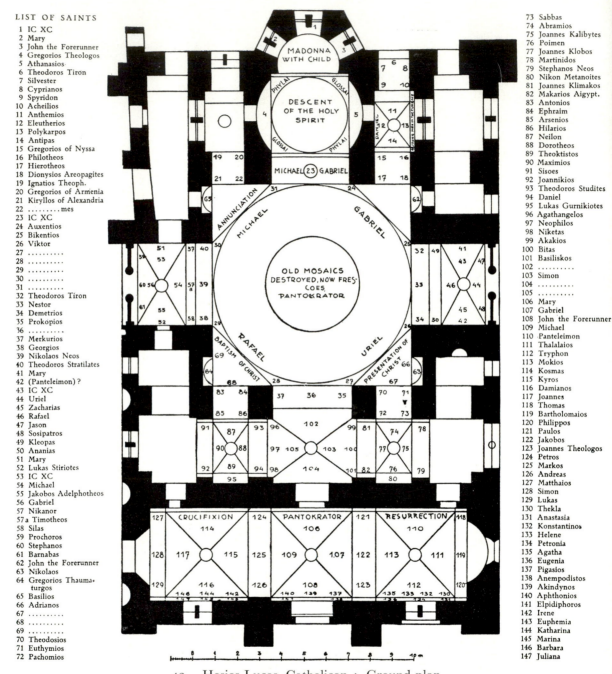

LIST OF SAINTS

1 IC XC	73 Sabbas
2 Mary	74 Abramios
3 John the Forerunner	75 Joannes Kalibytes
4 Gregorios Theologos	76 Poimen
5 Athanasios	77 Joannes Klobos
6 Theodoros Tiron	78 Martinidos
7 Silvester	79 Stephanos Neos
8 Cyprianos	80 Nikon Metanoites
9 Spyridon	81 Joannes Klimakos
10 Acheilios	82 Makarios Aigypt.
11 Anthemios	83 Antonios
12 Eleutherios	84 Ephraim
13 Polykarpos	85 Arsenios
14 Antipas	86 Hilarios
15 Gregorios of Nyssa	87 Neilon
16 Philotheos	88 Dorotheos
17 Hierotheos	89 Theoktistos
18 Dionysios Areopagites	90 Maximios
19 Ignatios Theoph.	91 Sisoes
20 Gregorios of Armenia	92 Joannikios
21 Kiryllos of Alexandria	93 Theodoros Studites
22mes	94 Daniel
23 IC XC	95 Lukas Gurnikiotes
24 Auxentios	96 Agathangelos
25 Bikentios	97 Neophilos
26 Viktor	98 Niketas
27	99 Akakios
28	100 Bitas
29	101 Basiliskos
30	102
31	103 Simon
32 Theodoros Tiron	104
33 Nestor	105
34 Demetrios	106 Mary
35 Prokopios	107 Gabriel
36	108 John the Forerunner
37 Merkurios	109 Michael
38 Georgios	110 Panteleimon
39 Nikolaos Neos	111 Thalalaios
40 Theodoros Stratilates	112 Tryphon
41 Mary	113 Mokios
42 (Panteleimon)?	114 Kosmas
43 IC XC	115 Kyros
44 Uriel	116 Damianos
45 Zacharias	117 Joannes
46 Rafael	118 Thomas
47 Jason	119 Bartholomaios
48 Sosipatros	120 Philippos
49 Kleopas	121 Paulos
50 Ananias	122 Jakobos
51 Mary	123 Joannes Theologos
52 Lukas Stiriotes	124 Petros
53 IC XC	125 Markos
54 Michael	126 Andreas
55 Jakobos Adelphotheos	127 Matthaios
56 Gabriel	128 Simon
57 Nikanor	129 Lukas
57a Timotheos	130 Thekla
58 Silas	131 Anastasia
59 Prochoros	132 Konstantinos
60 Stephanos	133 Helene
61 Barnabas	134 Petronia
62 John the Forerunner	135 Agatha
63 Nikolaos	136 Eugenia
64 Gregorios Thauma- turgos	137 Pigasios
65 Basilios	138 Anempodistos
66 Adrianos	139 Akindynos
67	140 Aphthonios
68	141 Elpidiphoros
69	142 Irene
70 Theodosios	143 Euphemia
71 Euthymios	144 Katharina
72 Pachomios	145 Marina
	146 Barbara
	147 Juliana

42. Hosios Lucas, Catholicon : Ground plan.
After Diez-Demus.

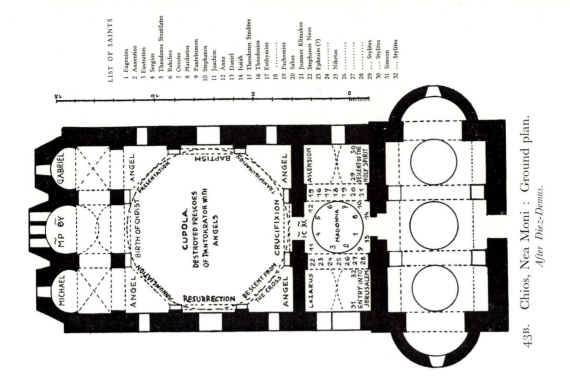

43B. Chios, Nea Moni : Ground plan.
After Diez-Demus.

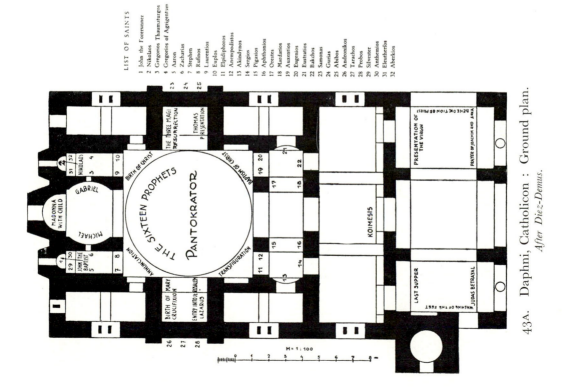

43A. Daphni, Catholicon : Ground plan.
After Diez-Demus.

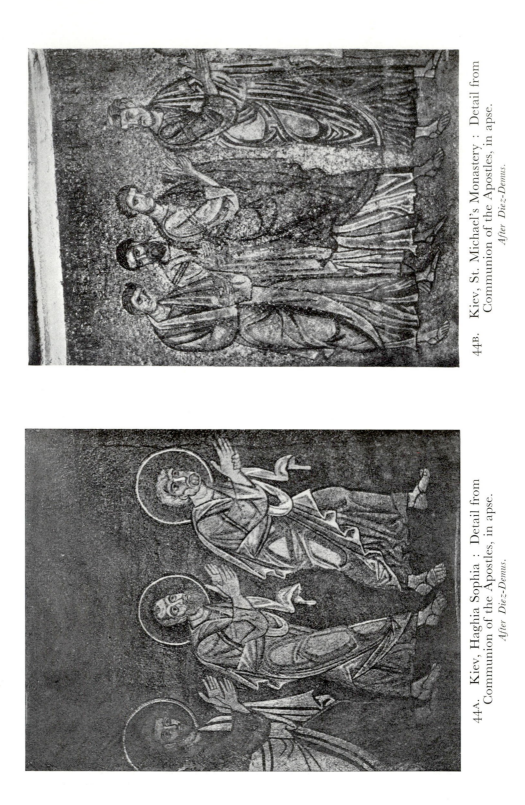

44B. Kiev, St. Michael's Monastery : Detail from
Communion of the Apostles, in apse.
After Diez-Demus.

44A. Kiev, Haghia Sophia : Detail from
Communion of the Apostles, in apse.
After Diez-Demus.

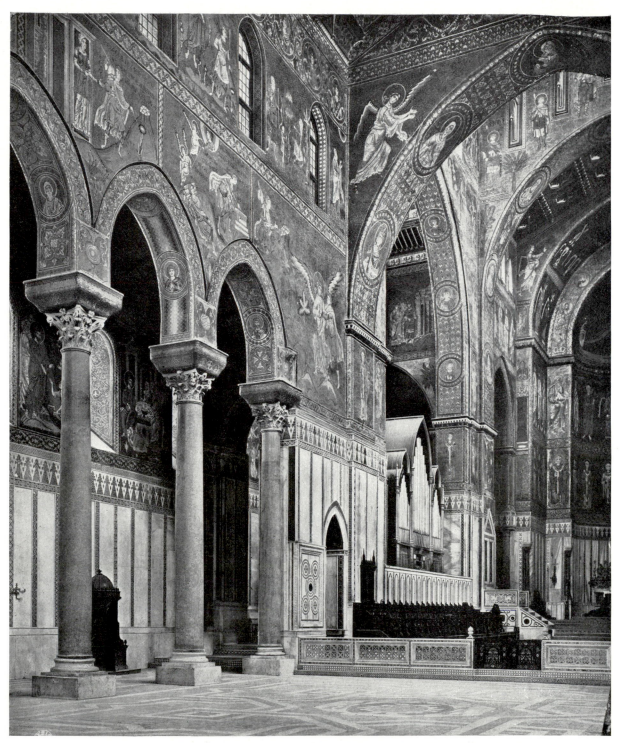

45.　Monreale, Cathedral : Interior towards north-east.
Photo Anderson.

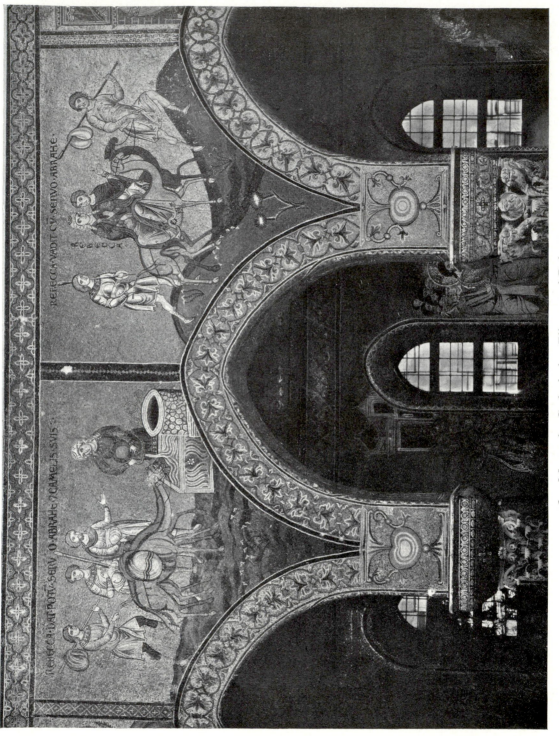

46. Monreale, Cathedral : Elieser and Rebecca.
Photo Anderson.

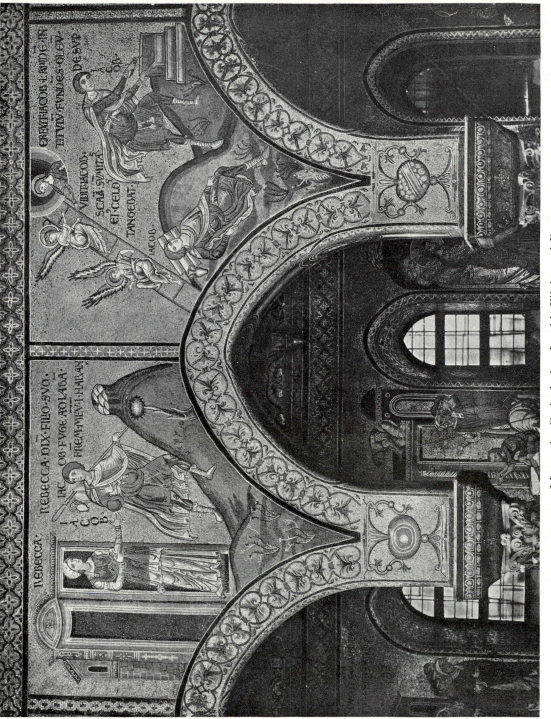

47.　Monreale, Cathedral : Jacob's Flight and Dream.

Photo Anderson.

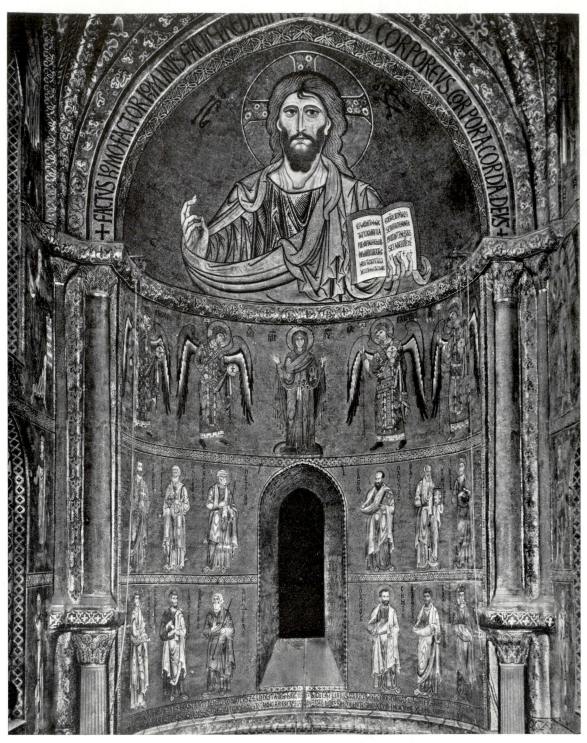

48. Cefalù, Cathedral : Apse.
Photo Anderson.

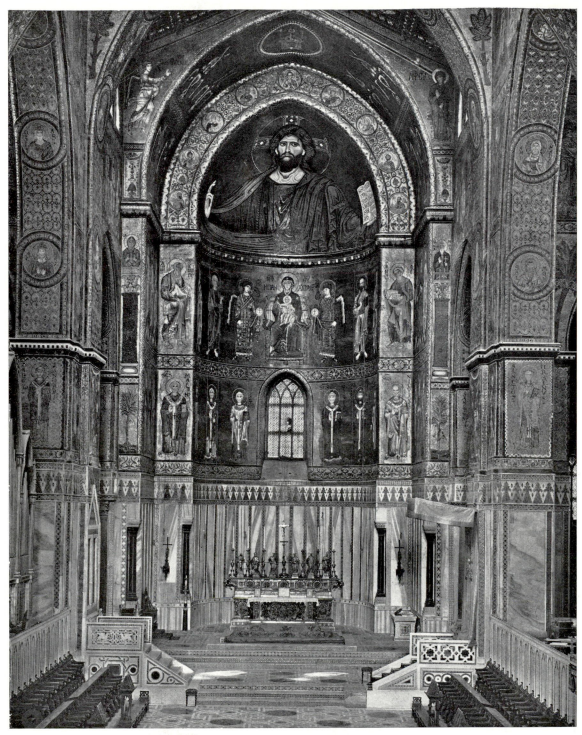

49. Monreale, Cathedral : Presbytery.
Photo Anderson.

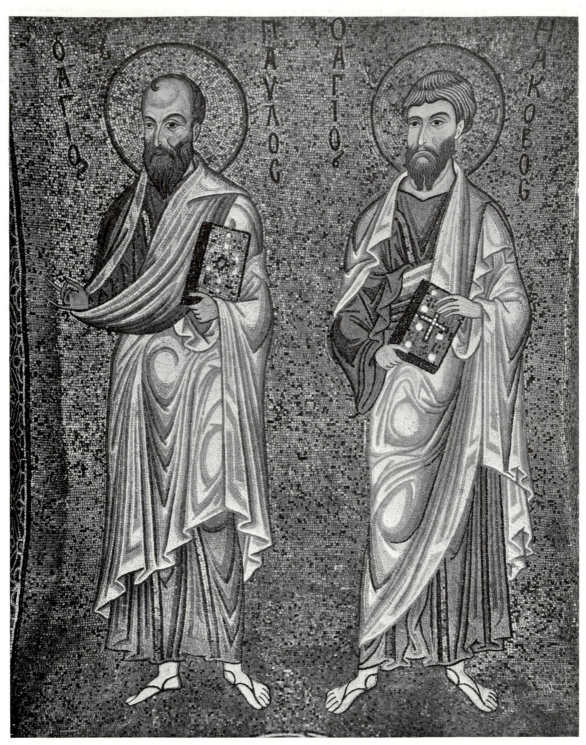

50. Palermo, Martorana : Apostles Paul and James.
Photo Anderson.

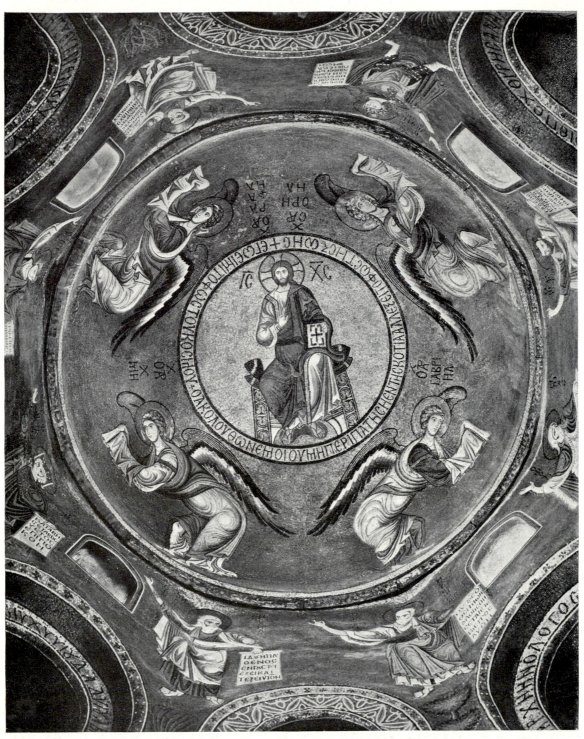

51. Palermo, Martorana : Cupola.
Photo Anderson.

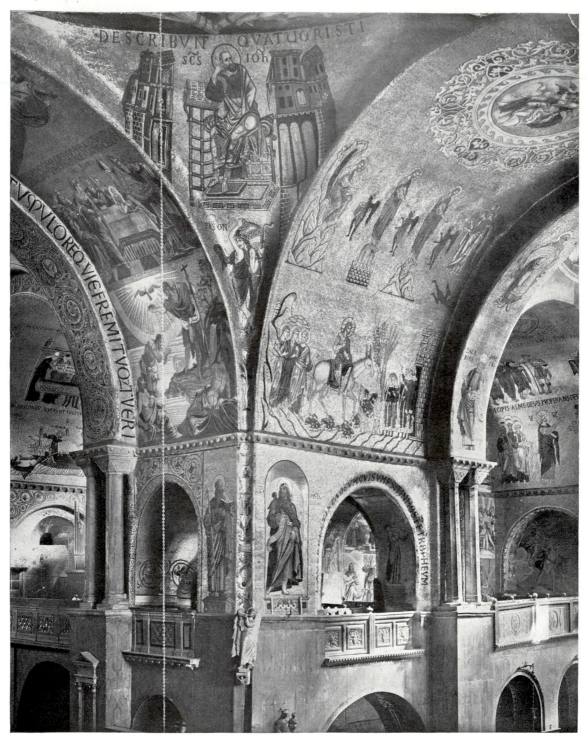

52. Venice, St. Mark's : View towards south-east from central square.
Photo Anderson.

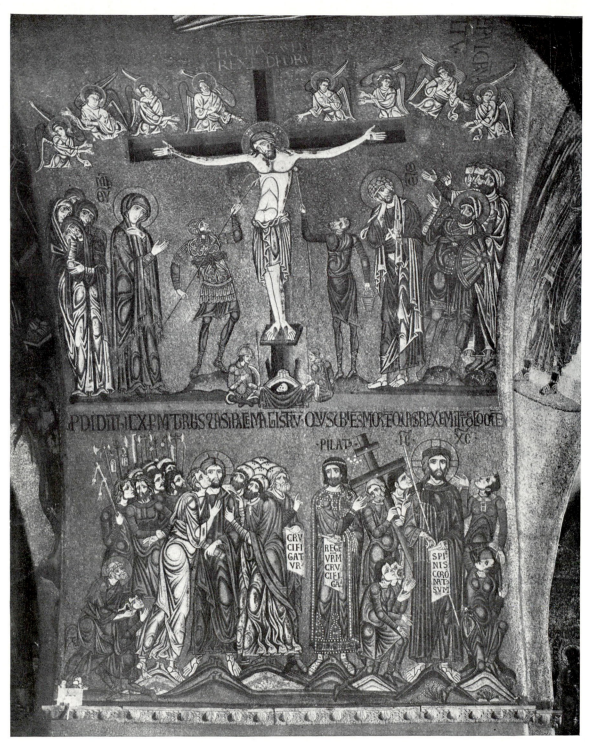

53. Venice, St. Mark's : Scenes from the Passion.
Photo Alinari.

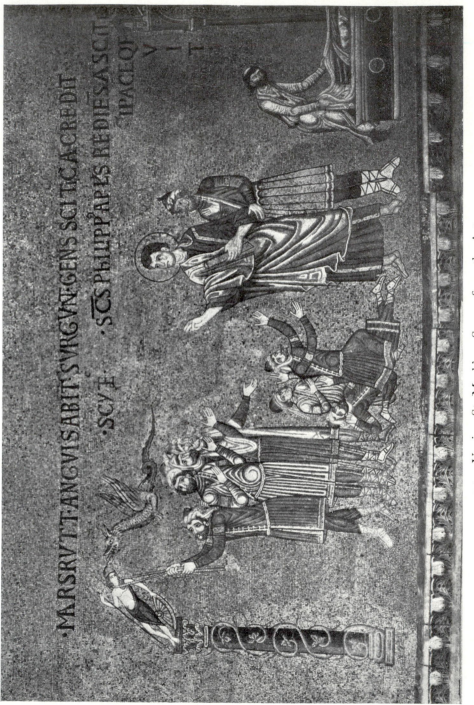

54. Venice, St. Mark's : Scenes from the Acts.
Photo Alinari.

55. Venice, St. Mark's, Narthex : Cupola with scenes from the Creation.

Photo Alinari.

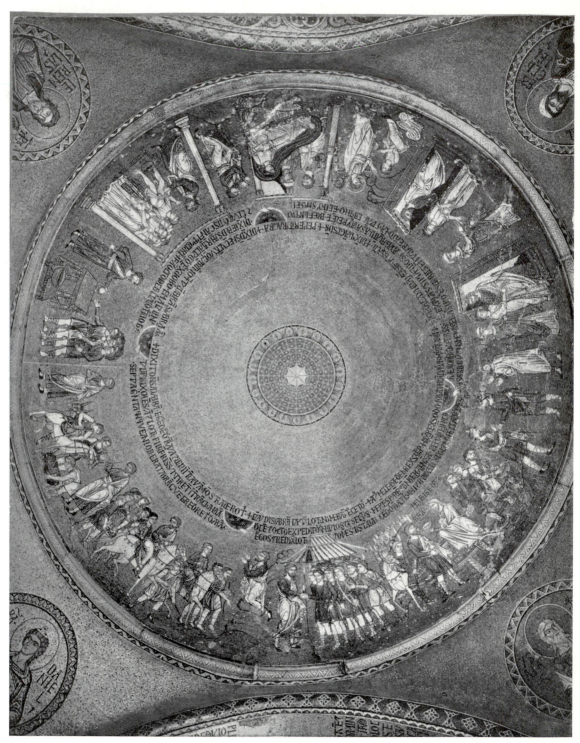

56. Venice, St. Mark's, Narthex : Cupola with scenes from life of Abram.
Photo Alinari.

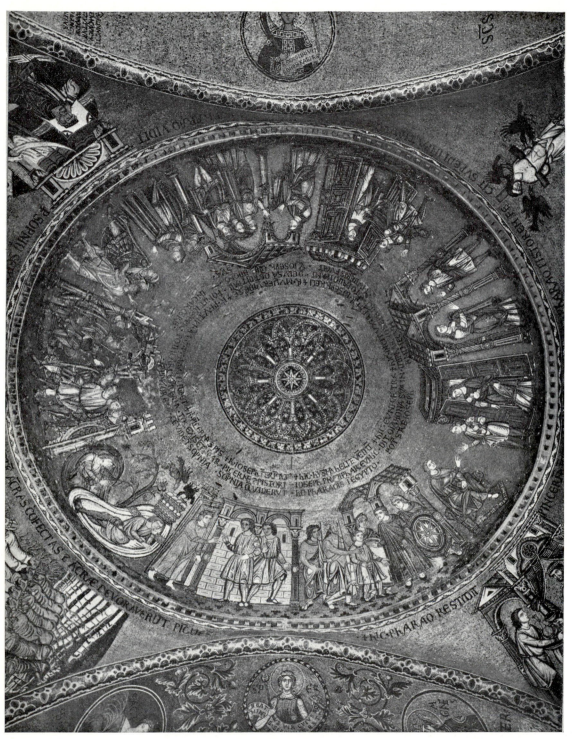

57. Venice, St. Mark's, Narthex : Cupola with scenes from the story of Joseph (2nd part).
Photo Alinari.

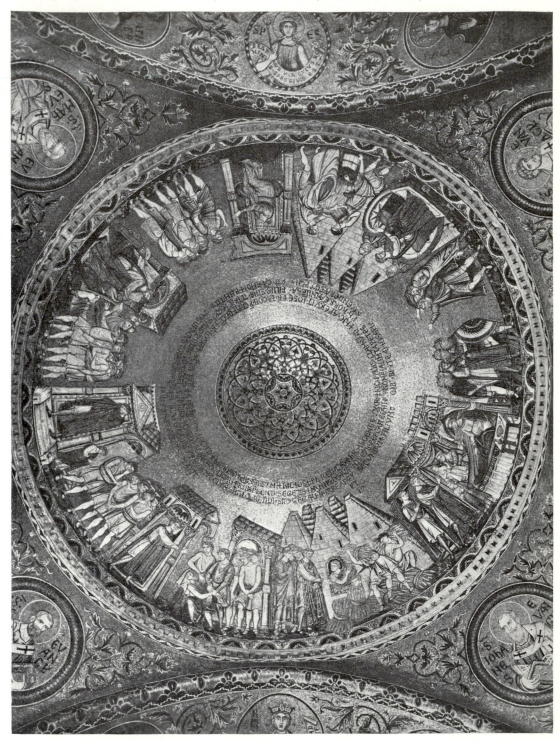

58. Venice, St. Mark's, Narthex : Cupola with scenes from the story of Joseph (3rd part).
Photo Alinari.

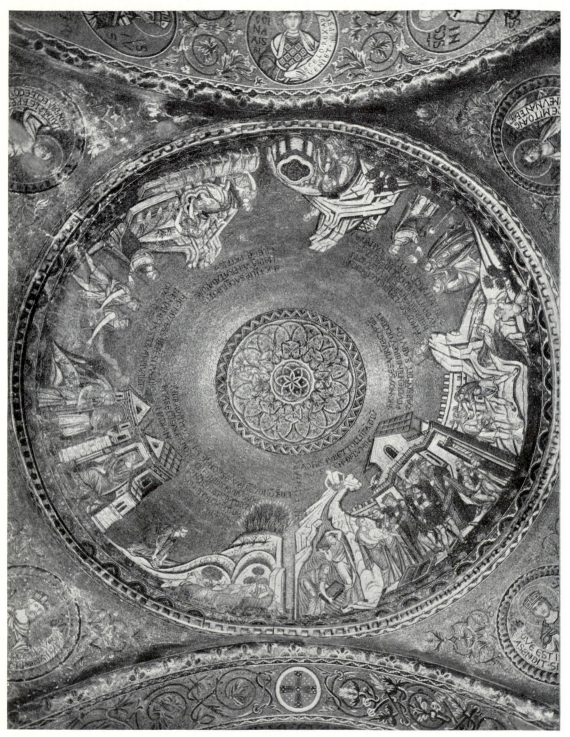

59. Venice, St. Mark's Narthex : Cupola with life of Moses.
Photo Alinari.

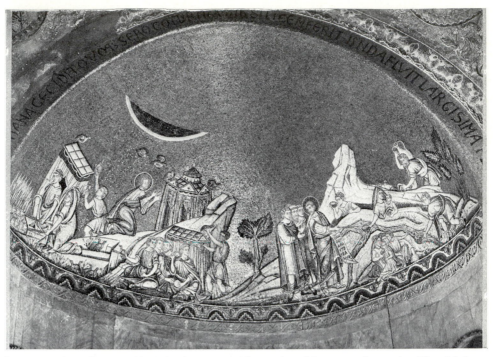

60A. Venice, St. Mark's, Narthex : Half cupola with scenes from the life of Moses.
Photo Alinari.

60B. Constantinople, Kahrieh Djami : Mary received in the Temple.
Photo Sebah and Joailler.

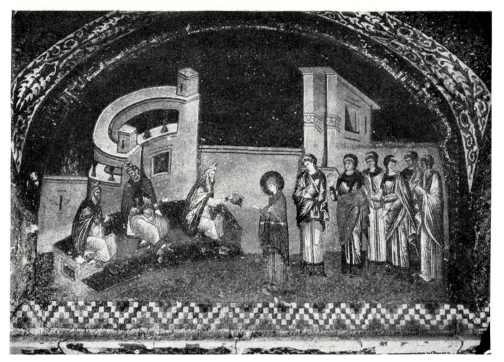

61A. Constantinople, Kahrieh Djami : Mary receiving the purple.
Photo Sebah and Joailler.

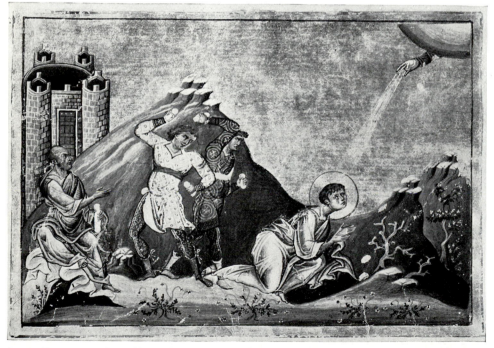

61B. Rome, Vatic. Libr. Menologium of Basil II, fol. 279 : Stoning of S. Stephen.
After Codices e Vatic. selecti.

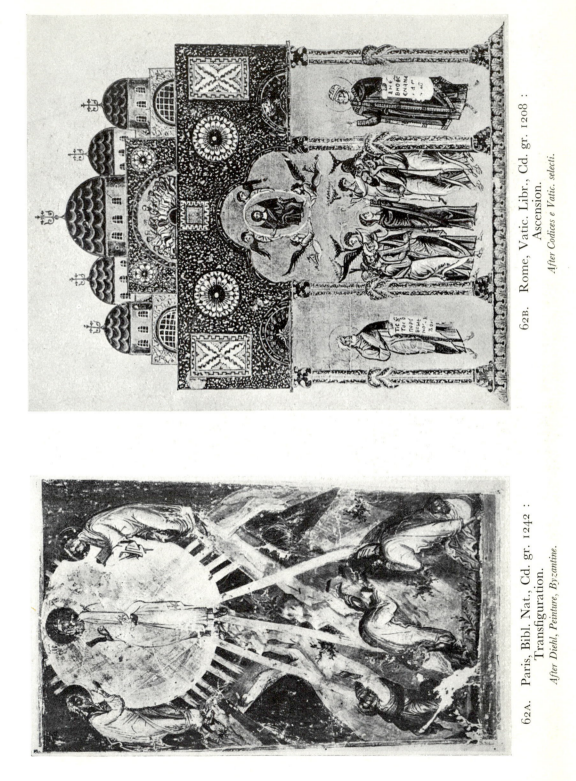

62B. Rome, Vatic. Libr., Cd. gr. 1208 :
Ascension.
After Codices e Vatic. selecti.

62A. Paris, Bibl. Nat., Cd. gr. 1242 :
Transfiguration.
After Diehl, Peinture, Byzantine.

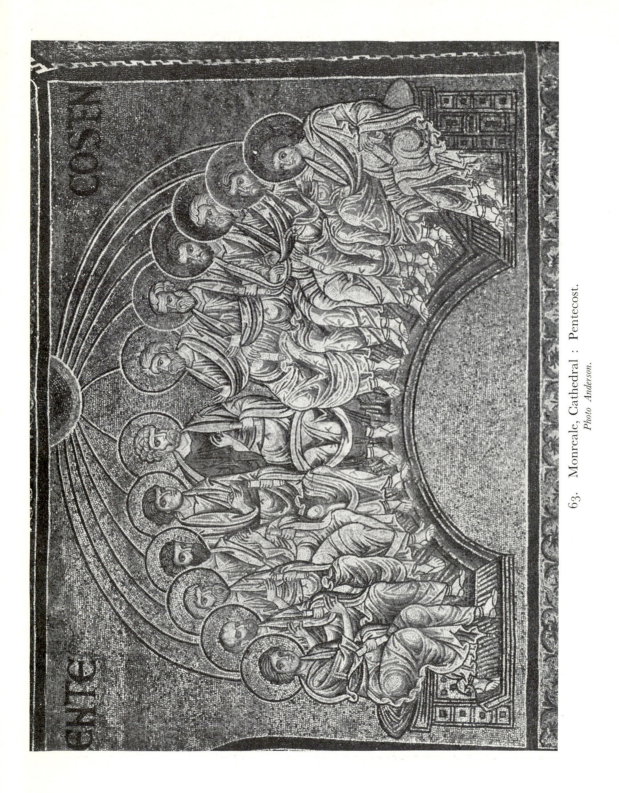

63. Monreale, Cathedral : Pentecost.
Photo Anderson.

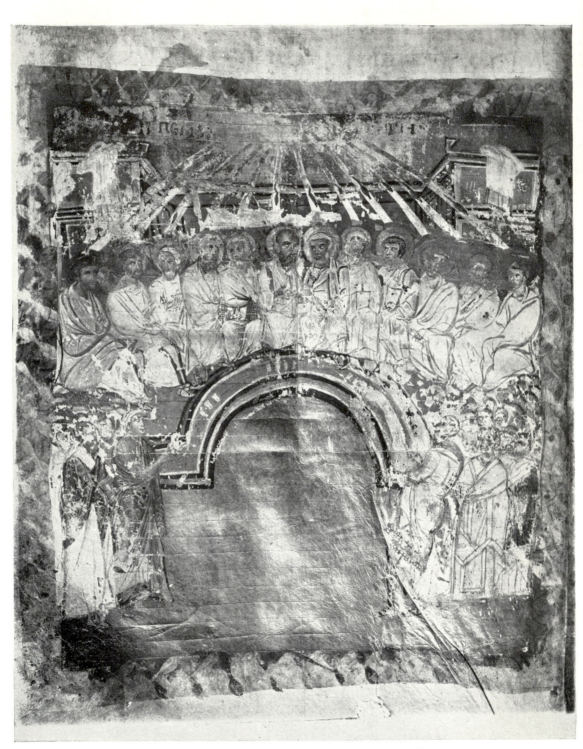

64. Leningrad, Public Library, Cd. Petrop. 21 : Pentecost.
After Morey.